Vincent van Gogh

Text: Victoria Charles

Cover and page layout: Stephanie Angoh

© Confidential Concepts, worldwide, USA
© Sirrocco, London, 2004 (English version)

Published in 2004 by Grange Books
an imprint of Grange Books Plc
The Grange
Kingsnorth Industrial Estate
Hoo, nr Rochester
Kent ME3 9ND
www.Grangebooks.co.uk

ISBN 1-84013-568-9

Printed in Singapore

Vincent van Gogh

Grange
BOOKS

Contents

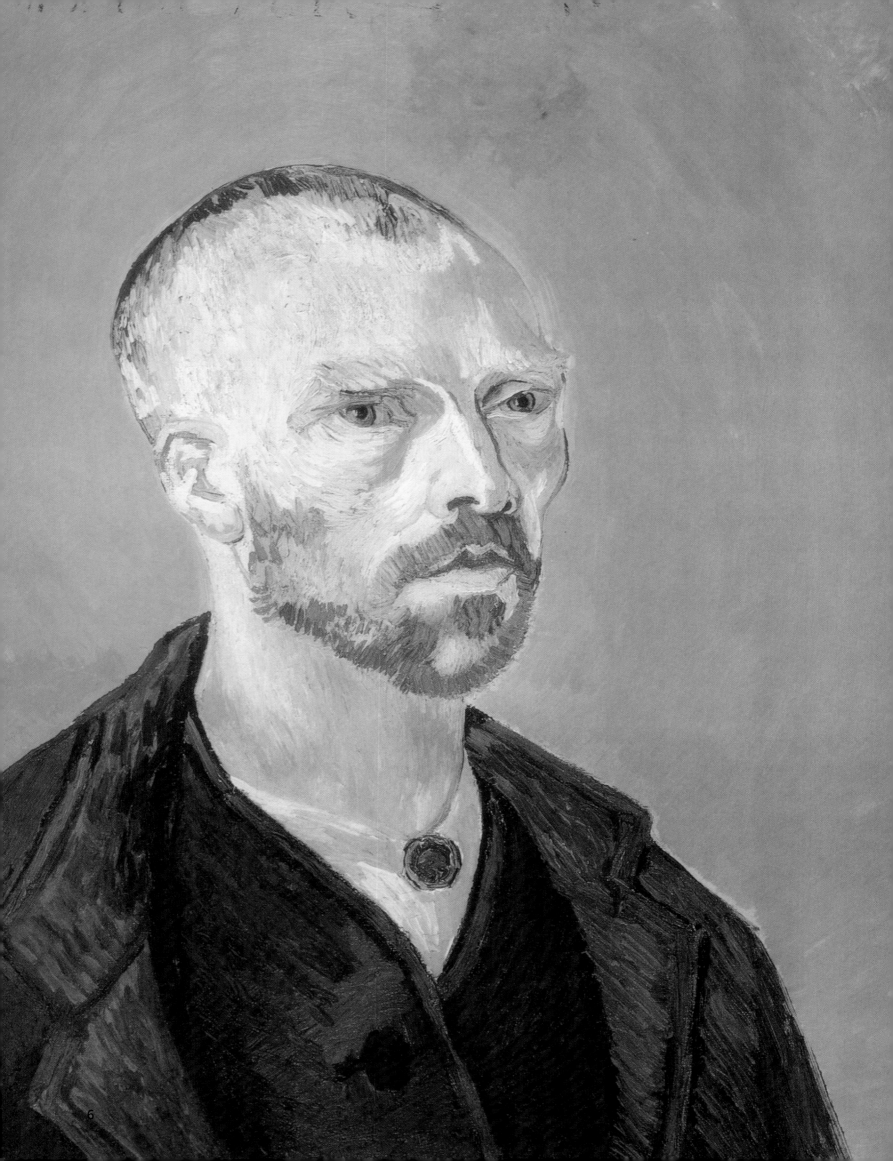

H
e sat on that chair. His pipe lies on a reed seat next to an open tobacco pouch. He slept in that bed, lived in that house. It was there that he cut off a piece of his ear. We see him with a bandaged head, the pipe in the corner of his mouth, looking at us.

Vincent van Gogh's life and work are so intertwined that it is hardly possible to see his pictures without reading in them the story of his life: a life which has been described so many times that it is by now the stuff of legend. Van Gogh is the incarnation of the suffering, misunderstood martyr of modern art, the emblem of the artist as an outsider.

In 1996, Jan Hulsker, the famous van Gogh scholar, published a corrected catalogue of the complete works in which he questioned the authenticity of 45 paintings and drawings. What concerned Hulsker were not only the forgeries, but also canvases which were falsely attributed to van Gogh. In a similar vein, the British art historian Martin Bailey claimed to have recognized more than one hundred false 'van Goghs,' among them the *Portrait of Dr. Gachet* which exists in two versions. One of these was purchased in 1990 by a Japanese industrialist for 82.5 million dollars – the highest price ever paid for a painting. The new owner then shocked the public by announcing that after his death he wanted to be burned with the picture. Out of respect for the feelings of European art lovers, he later changed his mind and decided to build a museum to house his collection. If someone should prove that the *Portrait of Dr. Gachet* is a fake, however, public interest in this painting would disappear.

1. *Self-Portrait*
 (dedicated to Paul Gauguin)
 Arles: September 1888
 Oil on canvas, 62 x 52 cm
 Cambridge, Massachussetts: Fogg Art
 Museum, Havard University.

It became apparent early on that the events of van Gogh's life would play a major role in the reception of his works. The first article about the painter was published in January 1890 in the *Mercure de France*. The author of the article, Albert Aurier, was in

7

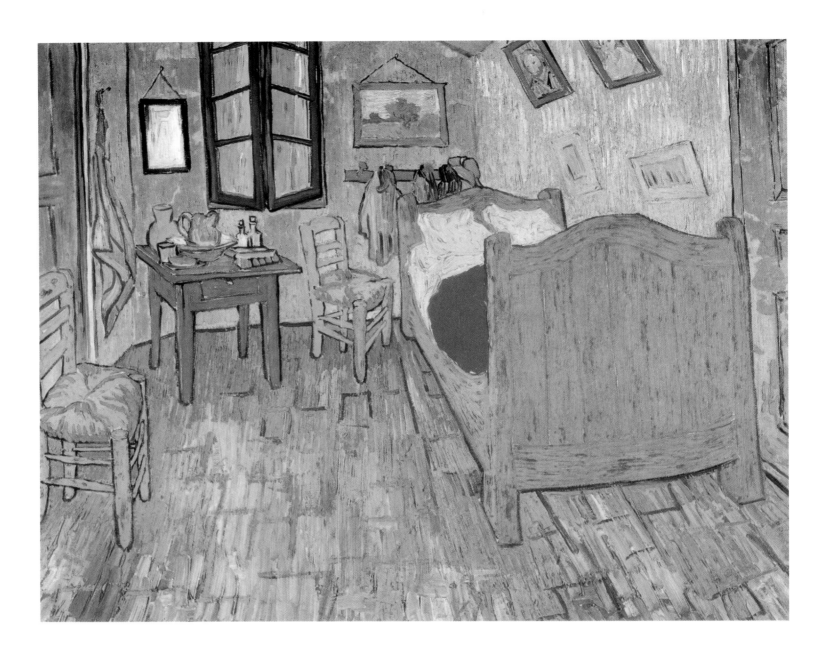

contact with a friend of van Gogh named Emile Bernard, from whom he learned the details of van Gogh's illness. At the time, van Gogh was living in a mental hospital in Saint-Rémy, near Arles. The year before, he had cut off a piece of his right ear. Without explicitly revealing these facts from the artist's life, Aurier nevertheless introduced his knowledge of the apparent insanity of the painter into his discussion of the paintings themselves. Thus, for example, he used terms like "obsessive passion"[1] and "persistent preoccupation."[2] Van Gogh seemed to him a "terrible and demented genius, often sublime, sometimes grotesque, always at the brink of the pathological."[3] Aurier regarded the painter as a "Messiah […] who would regenerate the decrepitude of our art and perhaps of our imbecile and industrialist society."[4]

With this characterization of the artist as a mad genius, the critic laid the foundation for the van Gogh myth which began to emerge shortly after the death of the painter. After all, Aurier did not believe that van Gogh would ever be understood by the general public: "But whatever happens, even if it became fashionable to buy his canvases – which is unlikely – at the prices of M. Meissonier's little infamies, I don't think that much sincerity could ever enter into that belated admiration of the general public."[5]

A few days after van Gogh's funeral in Auvers-sur-Oise, Dr. Gachet, who looked after the painter at the end of his life, wrote to van Gogh's brother Theo: "This

2. *The Bedroom*
Saint-Rémy: early September 1889
Oil on canvas, 73.6 x 92.3 cm
Chicago: The Art Institute of Chicago.

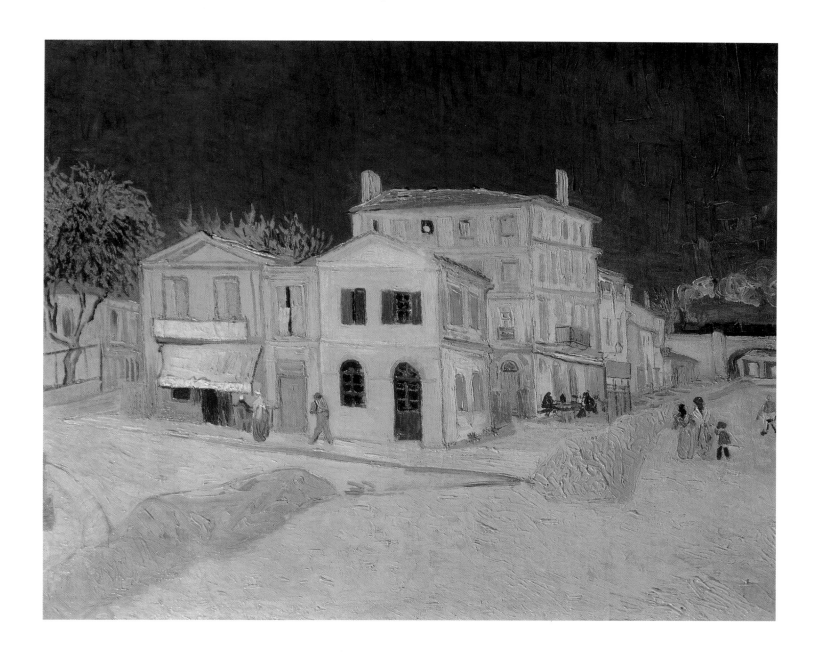

sovereign contempt for life, doubtless a result of his impetuous love of art, is extraordinary […] If Vincent were still alive, it would take years and years until the human art triumphed. His death however, is, so to speak, the glorious result of the fight between two opposed principles: light and darkness, life and death."[6]

Van Gogh neither despised life nor was he its master. In his letters, nearly seven hundred of which have been published, he often wrote about his desire for love and safety: "I should like to be with a woman for a change, I cannot live without love, without a woman. I would not value life at all, if there were not something infinite, something deep, something real."[7] On several occasions he stressed that it would be "more worthwhile to make children than pictures."[8]

Van Gogh's rather bourgeois dreams of hearth and home never materialized. His first love, Ursula Loyer, married someone else. His cousin Kee, already a mother and widow, refused him partly for material reasons: van Gogh was unable to care for her and her child. He tried to build up a family life with a prostitute named Sien. He finally left her because his brother Theo, on whom he depended financially, wanted him to end the relationship. Van Gogh's relationship with the twenty-one-year-old Marguerite Gachet is only known by rumour: a friend of Marguerite maintained that they had fallen in love, but the usually freethinking Dr. Gachet barred van Gogh from then on.

3. *Vincent's House in Arles*
(The Yellow House)
Arles: September 1888
Oil on canvas, 72 x 92 cm
Amsterdam: Rijksmuseum Vincent
van Gogh, Foundation van Gogh.

9

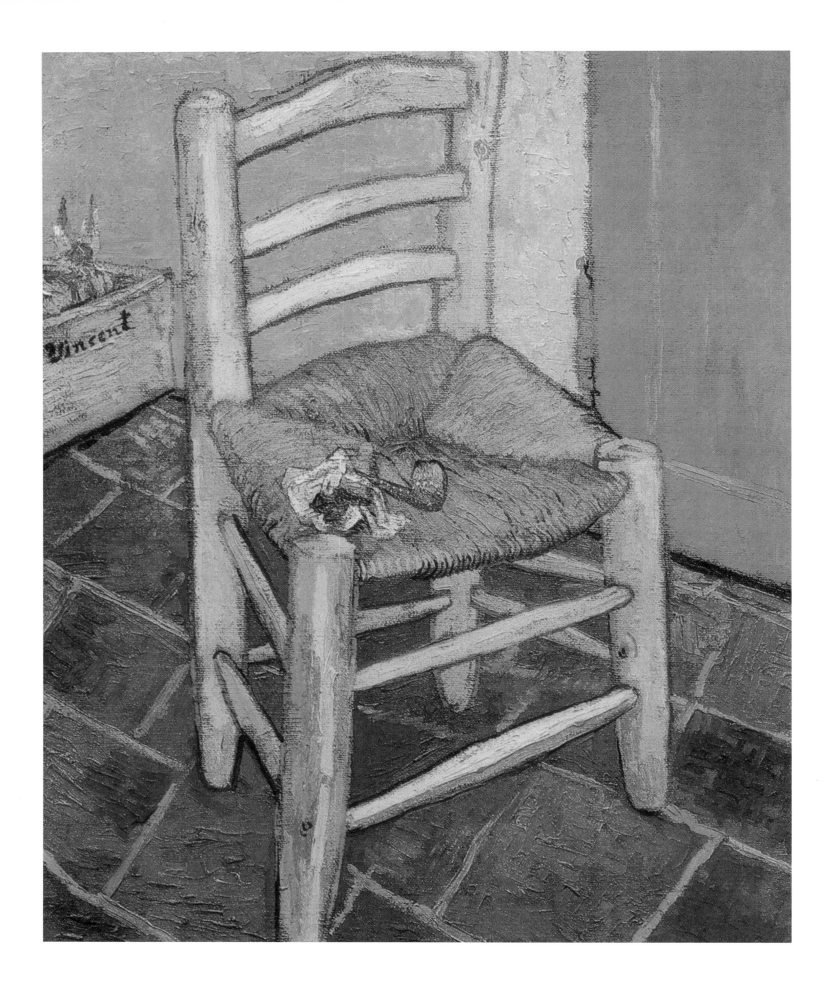

Van Gogh not only sought the love of women, but also that of his family and friends, although he never achieved it in the measure he would have wished. Several days before his suicide, he summed up his lifelong failure to find a satisfying intimacy in the following enigmatic remark: "As through a looking glass, by a dark reason – so it has remained."[9] The parson's son had taken his analogy from *The Excellencies of Love* in

4. *Vincent's Chair with His Pipe*
Arles: December 1888
Oil on canvas, 93 x 73.5 cm
London: National Gallery.

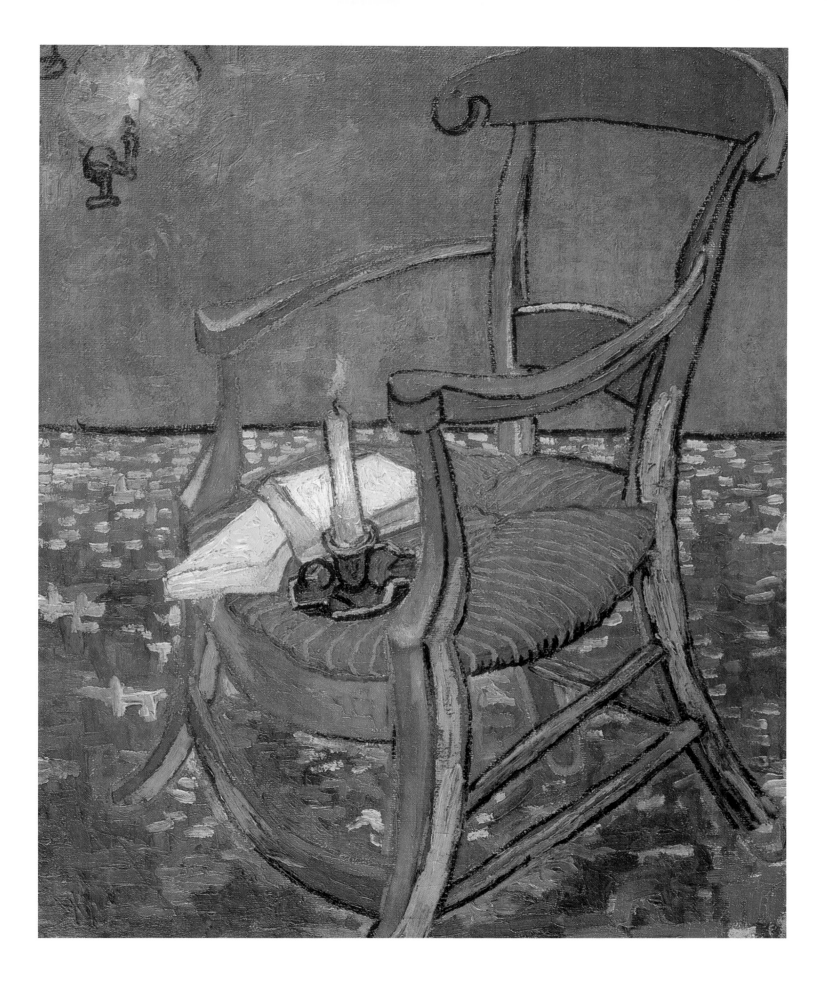

5. *Paul Gauguin's Armchair*
Arles: December 1888
Oil on canvas, 90.5 x 72.5 cm
Amsterdam: Rijksmuseum Vincent van Gogh, Foundation Vincent van Gogh.

the first epistle to the Corinthians: "For now we see through a glass, darkly: but then face to face: now I know in part; but then shall I know even as also I am known."

This longing for a place in the community and the struggle for renown are two themes which can be traced throughout van Gogh's life.

11

Holland, England and Belgium: 1853–1886

"Feeling nowhere so much myself a stranger

as in my family and country…"

On March 30th, 1852, a dead son was born at the vicarage of Zundert, but a year later, on the same date, Anna van Gogh gave birth to a healthy boy.[10] Pastor Theodorus van Gogh gave his second born son the same name as the first: Vincent. When the second Vincent walked to his father's church to attend services, he passed by the grave where 'his' name was written on a tombstone. In the last months of his life, van Gogh reminisced about the places of his childhood and often wistfully mentioned the graveyard of Zundert.

Very little is known about van Gogh as a child. A neighbour's daughter described him as "kind-hearted, friendly, good, pitiful,"[11] while a former servant girl of the family reported that "Vincent had 'oarige' (funny, meaning unpleasantly eccentric) manners, and that he was often punished accordingly."[12] Johanna van Gogh-Bonger, who met her brother-in-law only a few times near the end of his life, also described him as a difficult, naughty, and obstinate child who had been spoiled by over-indulgent parents.[13]

Similar inconsistencies appear in descriptions of van Gogh as an adult. Most of the descriptions were collected at the beginning of the 20th century by van Gogh-Bonger who took charge of van Gogh's assets after Theo's death in 1891. These accounts are somewhat dubious not only because of the distance of time, but also because the dead painter was by then already a figure of legend.

In general, van Gogh was kind and compassionate toward the poor or sick, and also to children. Another important trait that emerged early on, according to the artist's sister Elisabeth Huberta, was his close relation to nature: "He knew the places where the rarest flowers bloomed […] as regards birds, he knew exactly where each nested or lived, and if he saw a pair of larks descend in the rye field, he knew how

6. *Peasant Woman, Seated with White Cap*
Nuenen: December 1885
Oil on canvas, 36 x 26 cm
Private Collection.

to approach their nest without snapping the surrounding blades or harming the birds in the least."[14]

In his last years, van Gogh returned to the landscapes of his childhood through painting. "The whole south, everything became Holland for him,"[15] said Paul Gauguin of the paintings van Gogh made in Arles. In a letter to Emile Bernard, van Gogh compared the heath and flat landscape of the Carmargue with Holland. While

7. *Head of a Peasant*
 Nuenen: January 1885
 Oil on canvas, 47 x 85 cm
 Otterlo: Rijksmuseum Kröller-Müller.

staying in the mental hospital of Saint-Rémy he wrote to Theo: "During my illness I saw again every room in the house at Zundert, every path, every plant in the garden, the views of the fields outside, the neighbours, the graveyard, the church, our kitchen garden at the back – down to a magpie's nest in a tall acacia in the graveyard."[16] The references to nests made by both Elisabeth Huberta and by van Gogh himself suggests the extent of the importance of this image for the painter. The nest is a symbol of safety, which may explain why he called houses "human nests."[17]

Van Gogh had to leave his first nest – his parents' home – at the age of eleven. It is not clear why the elder van Gogh decided to send his son to a boarding school in Zevenbergen, some thirty kilometers from Zundert. Perhaps there was no Protestant school nearby; the neighbourhood of Zundert was almost entirely Catholic. Or perhaps the parents' nest had simply become too small with the arrival of four more children.

"It was an autumn day when I stood on the steps before Mr. Provily's school, watching the carriage in which Pa and Ma were driving home. One could see the little yellow carriage far down the road – wet with rain and with spare trees on either side – running through the meadows."[18] A few weeks before his death, van Gogh painted his memory of this farewell: a two-wheel carriage rolling through fields on a narrow path.

At the age of thirteen, Vincent went to a higher school in Tilburg, where the landscape painter Constantijn C Huysmans taught him drawing. Only one of van Gogh's schoolworks has been preserved: a page with two views of a back. In all, about a dozen of van Gogh's childhood drawings and paintings have survived. On one occasion, according to van Gogh-Bonger, the eight-year-old "had modeled a little clay elephant that drew his parents' attention, but he destroyed it at once when, according to his notion, such a fuss was made about it."[19]

During his stay in Tilburg the first of two known photographs of young van Gogh was taken. It shows a soft, boyish face with very light eyes. The second portrait shows van Gogh as an earnest 19-year-old. By then, he had already been at work for three years in The Hague, at the gallery of Goupil & Co, where one of van Gogh's uncles was a partner. Vincent reports that of the three and half years he spent in The Hague, "The first two were rather unpleasant, but the last one was much happier."[20] Van Gogh's master at Goupil's was the 24-year-old Hermanus Gijsbertus Tersteeg, of whom the artist wrote: "I knew him during a very peculiar period of his life, when he had just 'worked his way up,' as the saying goes, and was newly married besides. He made a very strong impression on me then – he was a practical man, extremely clever and cheerful, energetic in both small and big undertakings; besides, there was real poetry, of the true unsentimental kind, in him. I felt such respect for him then that I always kept at a distance, and considered him a being of a higher order than myself."[21] Later, when van Gogh had begun his career as a painter, he would continue struggling – always in vain – to win the respect of the highly regarded dealer.

During his apprenticeship, van Gogh came into contact with the paintings of the salons and of the school of Barbizon, whose most distinguished representative, Jean-François Millet (1814–1875), became one of the most influential figures for the painter. As Goupil & Co. also sold prints, the trainee saw reproductions of many

masterpieces. Here, van Gogh built his new nest: the gallery, and later the museums, became his "land of pictures."[22]

In August 1872, Theo came to see his elder brother in The Hague. During this meeting the two young men, then 19 and 15 years old, became closer in a way that changes relatives into friends. Thereafter, Vincent regarded Theo as his alter ego. Since the brothers lived most of the time in different cities – with the exception of the two years during which they shared a flat in Paris – they communicated through letters: they discussed art, argued about family problems, and gave one another advice about their illnesses and love affairs. Vincent wrote more than 600 letters in 18 years to his brother, who collected them faithfully. Most of these were published after van Gogh's death. Roughly 40 of Theo's letters survived. The others were the casualties of Vincent's frequent relocations, in which a large number of drawings and paintings were also lost.

"What pleasant days we spent together at The Hague; I think so often of that walk on the Rijswijk road, when we drank milk at the mill after the rain,"[23] van Gogh recalled wistfully in the summer of 1873. By then his training had come to an end, and the young man found himself working for Goupil's in London: "The business here is only a stockroom, and our work is quite different from that in The Hague; but I shall probably get used to it. At six o'clock my work is already done for the day, so that I have a nice bit of time for myself, which I spend pleasantly – taking walks, reading and letter-writing."[24] Van Gogh forgets to write about another activity in his spare time: drawing. Ten years later, just as he was about to become an artist, he remembered: "In London how often I stood drawing on the Thames Embankment, on my way home from Southampton Street in the evening, and it came to nothing."[25]

His favorite reading in London was *L'Amour* by Jules Michelet: "To me the book has been both a revelation and a Gospel at the same time [...] And that man and wife can be one, that is to say, one whole and not two halves, yes, I believe that too."[26] When van Gogh wrote these sentences at the end of July, 1874, he had every hope that his revelation would be fulfilled. But his love for Ursula Loyer, the daughter of his landlady, ended in disaster. Seven years later van Gogh summed up the events: "I gave up a girl and she married another, and I went away, far from her, but kept her in my thoughts always. Fatal."[27] This representation of the facts is dubious, at best: Eugénie was already engaged when van Gogh met her, and it was not his decision to leave London; in May, 1875, he was transferred to Paris – against his will.

By this time, van Gogh had already given up his Gospel of earthly love and turned instead to the love of God. His religious enthusiasm was perhaps one reason why he had to leave Goupil's in London. The business, moved into a bigger house, was no longer just a stockroom but a public gallery. And the solitary and eccentric van Gogh had difficulty pleasing the clientele. His family may also have wanted to bring an end to his "affair" with Ursula. Van Gogh himself suspected his father and uncle of being behind the transfer. He retaliated with silence – a weapon that he came to rely on quite often in conflicts. Theo, who had taken Vincent's place in Goupil's office in The Hague, thus became the only member of the family with whom van Gogh maintained contact. The brothers continued to exchange their opinions about art.

Vincent wrote often of his visits to the Louvre, and in particular, of his passion for the paintings of Ruysdael and Rembrandt. Above all else, van Gogh was an

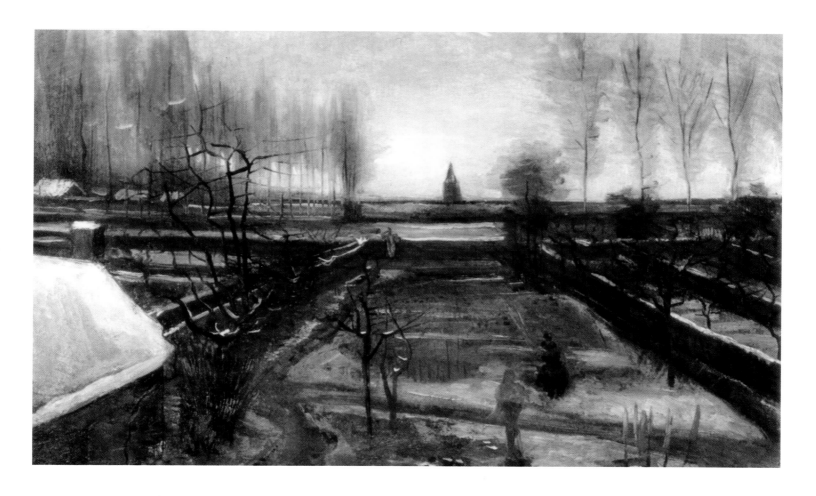

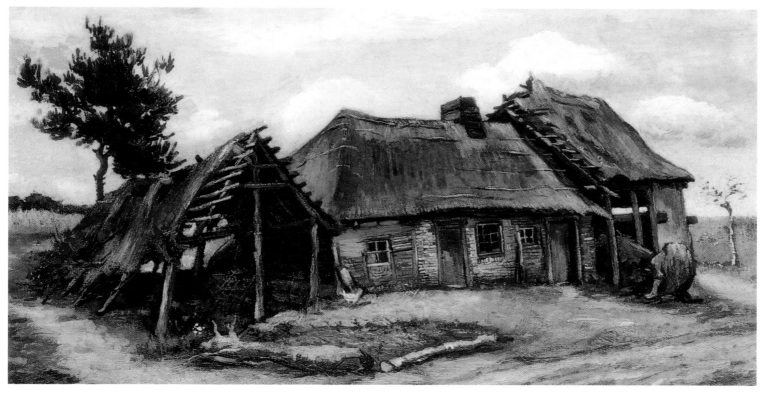

8. *The Parsonage Garden at Nuenen in the Snow*
Nuenen: January 1885
Oil on canvas, 53 x 78 cm
The Armand Hammer Museum of Art.

9. *Cottage with Decrepit Barn and Stooping Woman*
Nuenen: July 1885
Oil on canvas, 62 x 113 cm
Private Collection (sold, Sotheby's, London, 3. 12. 1985).

enthusiast, not a dealer, and he had little patience for the paintings he was supposed to sell at Goupil's. His parents were informed of his failure in the business. When Vincent came home for Christmas in 1875 – clearly without having obtained permission to leave the gallery during the busiest time of the year – his father suggested that he resign. But by then it was already too late, and the gallery manager dismissed van Gogh immediately after his return to Paris.

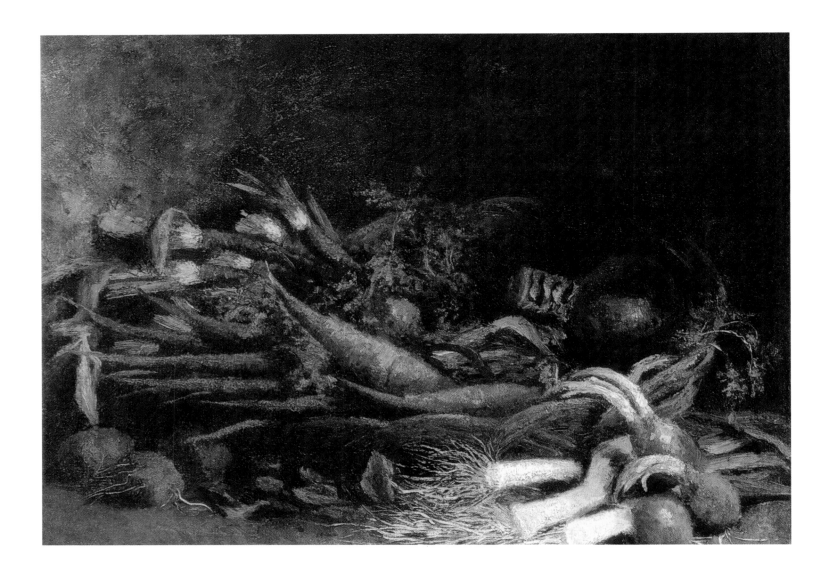

Van Gogh decided not to return to Holland, but to England. He found work as an assistant teacher in Ramsgate, and later as an assistant preacher in Isleworth. In October, 1876 he gave his first sermon, whose central thesis was: "We are pilgrims on the earth and strangers – we come from afar and we are going far."[28] When he returned to Holland to join his family for Christmas, his parents had already decided to change the direction of his journey through life, by steering him into the bookstore of Pieter Kornelius Braat in Dordrecht. Vincent accepted and took a position in the accounting department of the shop. But his Bible studies continued to be his main interest. On his first Sunday in Dordrecht, van Gogh went to church twice to listen to a sermon about this verse from the first epistle to the Corinthians: "Now we look through a mirror into a dark reason, now I only know in part, but then I shall know even as also I am known myself."[29] In his letters to Theo, van Gogh referred to this sentence obliquely: "When we meet again, we shall be as good friends as ever; sometimes I feel so delighted that we are again living on the same soil and speaking the same language."[30] Before leaving Dordrecht in April, 1877 – since he spent most of his nights engrossed in the Bible, he was too sleepy during the day to be of much use in the bookshop – he heard the same sermon again. In a letter to Theo, he wrote: "After church I walked along the path behind the station where we walked together; my thoughts were full of you, and I wished we might be together."[31]

Van Gogh's understanding of the biblical verse reveals his yearning to be known. This desire persisted through most of his life, manifesting itself in his friendship with Theo, in his love for Ursula Loyer or his cousin Kee, and in his attitudes about

10. *Still-Life with a Basket of Vegetables*
Nuenen: September 1885
Oil on canvas, 35.5 x 45 cm
Landsberg/Lech, Germany:
Collection Anneliese Brand.

11. *Peasant Women Digging*
Neunen: August 1885
Oil on canvas, 42 x 32 cm
Birmingham: Barber Institute of Fine Arts, University of Birmingham.

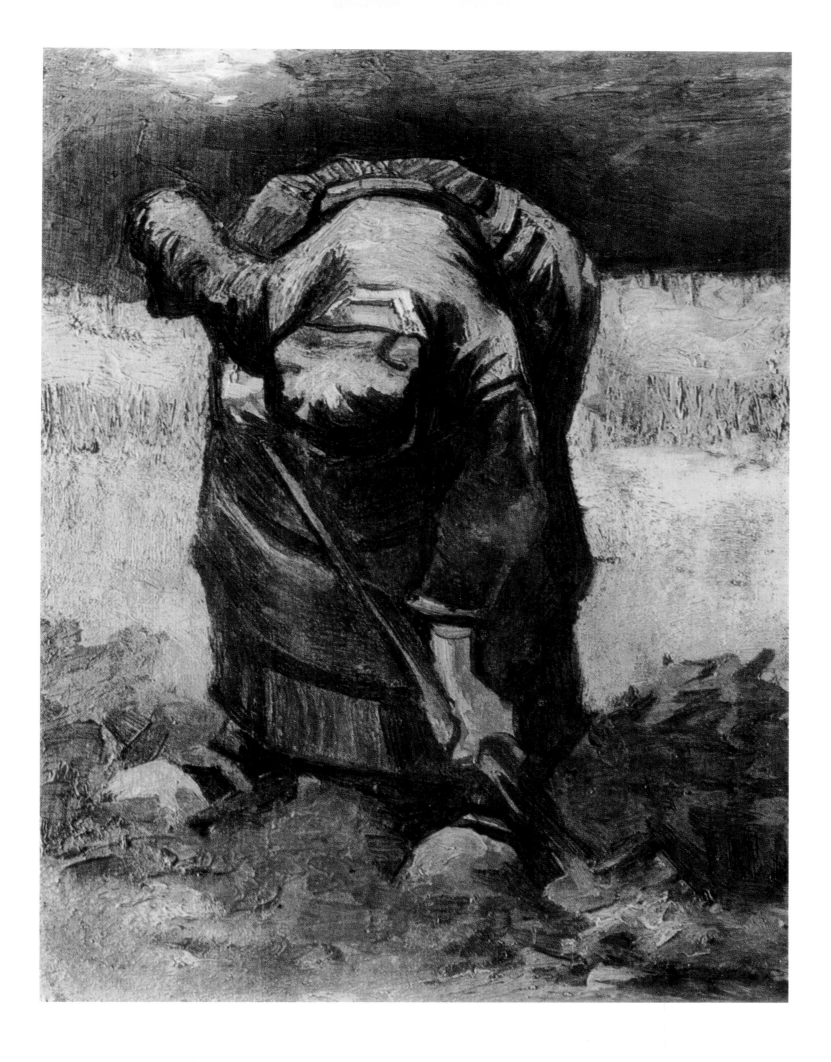

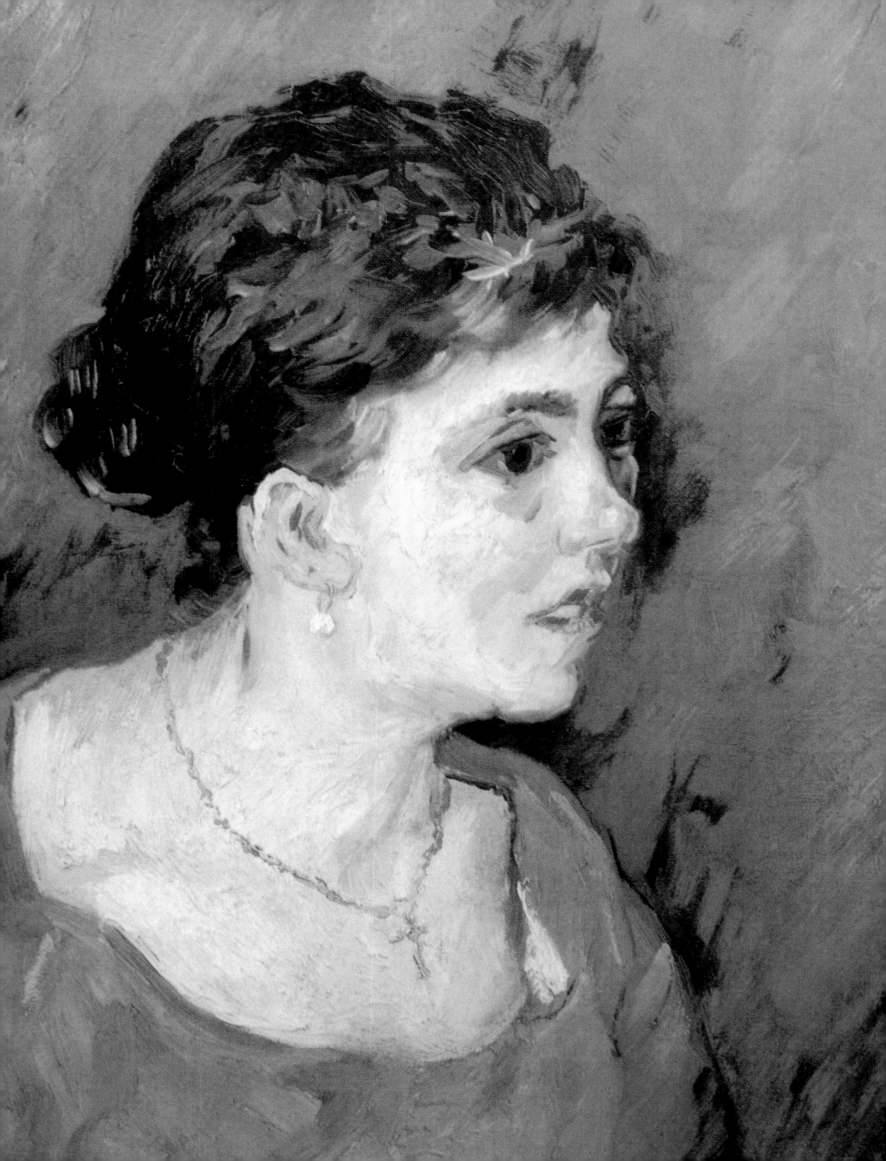

religion or art. The common thread in each of these is an intense longing to discover himself in a dialogue with others. The mercantile affairs of an art dealer or an accountant offered no such satisfaction. During his stay in Dordrecht, van Gogh finally arrived at a plan for his future: he set out to become a minister.

P C Görlitz, van Gogh's roommate in this time, wrote of him: "He was totally different from the usual type of man. His face was ugly, his mouth more or less awry, his face was densely covered with freckles, and he had hair of a reddish hue. As I said, his face was ugly, but as soon as he spoke about religion or art, and then became excited, which was sure to happen very soon, his eyes would sparkle, and his features would make a deep impression on me; it wasn't his own face any longer: it had become beautiful [...] When he came back from his office at nine o'clock in the evening, he would immediately light a little wooden pipe; he would take down a big Bible, and sit down to read assiduously, to copy texts and to learn them by heart; he would also write all kinds of religious compositions [...] When Sunday came, van Gogh would go to church three times, either to the Roman Catholic church, or to the Protestant or Old Episcopal church, which was commonly called the Jansenist church. When once we made the remark, "But, my dear van Gogh, how is it possible that you can go to three churches of such divergent creeds?" he said, "Well, in every church I see God, and it's all the same to me whether a Protestant pastor or a Roman Catholic priest preaches; it is not really a matter of dogma, but of the spirit of the Gospel, and I find this spirit in all churches."[32]

After his failure as a businessman, van Gogh hoped that his father would appreciate his decision to follow in his footsteps. But vicar van Gogh viewed his eldest son's enthusiasm for religion critically: Vincent's belief in the "spirit of the Gospel" deviated from the teachings of the Church. Nevertheless, he asked his brothers Cornelius and Jan, who lived in Amsterdam, to help the young man. Both uncles agreed to support their nephew: one promised to give him money, the other board and lodging.

In May, 1877 van Gogh began to prepare himself for the university. Since he had left school at the age of 15, he had to study mathematics and ancient languages before entering the academy. His language teacher, Mendes da Costa, described his student: "I succeeded in winning his confidence and friendship very soon, which was so essential in this case: and as his studies were prompted by the best of intentions, we made comparatively good progress at the beginning [...]; but after a short time the Greek verbs became too much for him. However I might set about it, whatever trick I might invent to enliven the lessons, it was no use. – "Mendes", he would say [...] "do you seriously believe that such horrors are indispensable to a man who wants to do what I want to do: give peace to poor creatures and reconcile them to their existence on earth?"[33]

Van Gogh stayed less then one year in Amsterdam, and then he abandoned his studies. He did not lack talent – van Gogh spoke a couple of languages, read German books, and wrote his letters in English and French. But he was impatient; he didn't want to meditate on the Gospel; he wanted to live it.

He travelled to Brussels to begin training at a mission school. Three months later, he left the school and applied for a job as a preacher in the Borinage, a Belgian mining

12. *Portrait of Woman in Blue*
Antwerp: December 1885
Oil on canvas, 46 x 38.5 cm
Amsterdam: Rijksmuseum Vincent van Gogh, Foundation Vincent van Gogh.

area. In January, 1879, he found a temporary post that might have been renewed if an inspector of the Comité d'Évangélisation had not discovered that the new preacher took the Bible more literally than the authorities of the church.

Vicar Bonte, who also worked in the neighbourhood, reported: "He felt obliged to imitate the early Christians, to sacrifice all he could live without, and he wanted to be even more destitute than the majority of the miners to whom he preached the Gospel. I must add that also his Dutch cleanliness was singularly abandoned; soap was banished as a wicked luxury; and when our evangelist was not wholly covered with a layer of coal dust, his face was usually dirtier than that of the miners. [...] He no longer felt any inducement to care for his own well-being – his heart had been aroused by the sight of others' want. He preferred to go to the unfortunate, the wounded, the sick, and always stayed with them a long time; he was willing to make any sacrifice to relieve their sufferings."[34]

After he 'failed' as a preacher, van Gogh broke with the church, which was, in his opinion, dominated by Christian conventions instead of a Christ-like love for mankind. This rupture also sent ripples through his relationship with his father, who threatened to have his son committed to the mental hospital in Gheel.[35]

After his father's death in 1885, van Gogh expressed his resentment against father and church in two still lifes: one shows his father's pipe and tobacco pouch lying next to a vase with a bouquet of flowers, known in Holland as silver of Judas. The second composition depicts a large, open Bible next to a small, well-thumbed copy of Zola's *Joie de Vivre* – "*The joy of Life*". Vicar van Gogh disapproved of his son's preference for contemporary French literature, which was – in his opinion – depraved. The Bible in the painting is opened to the book of Isaiah, chapter 53: "He is despised and rejected of men; a man of sorrows, and acquainted with grief: and we hid as it were our faces from him; he was despised, and we esteemed him not."

The correspondence between autumn 1879 and spring 1880 is full of gaps. Van Gogh remained in the Borinage, where he spent most of his time drawing. He had already started to make sketches in Brussels and during his time as a preacher: "Often I draw far into the night, to keep some souvenir and to strengthen the thoughts raised involuntarily by the aspect of things here."[36]

For his parents' sake, van Gogh tried to cloak his artistic aspirations in the more sensible garb of a bourgeois professional, like a printer or a technical draughtsman. He told his mother that he wanted to draw costumes and machines. In his letters to Theo, he was more candid: "On the other hand, you would also be mistaken if you thought that I would do well to follow your advice literally to become an engraver of bill headings and visiting cards, [...] But, you say, I do not expect you take that advice literally; I was just afraid you were too fond of spending your days in idleness, and I thought you had to put an end to it. May I observe that this is a rather strange sort of 'idleness'. It is somewhat difficult for me to defend myself, but I should be very sorry if, sooner or later, you could not see it differently."[37]

Van Gogh compared his unproductive period with a bird's change of feathers: "As the moulting time [...] is for birds, so adversity or misfortune is the difficult time for us human beings. One can stay in it – in that time of moulting – one can also emerge renewed; but anyhow it must not be done in public and it is not at all amusing,

13. *The Potato Eaters*
Nuenen: April 1885
Oil on canvas, 81.5 x 114.5 cm
Amsterdam: Rijksmuseum Vincent van Gogh.

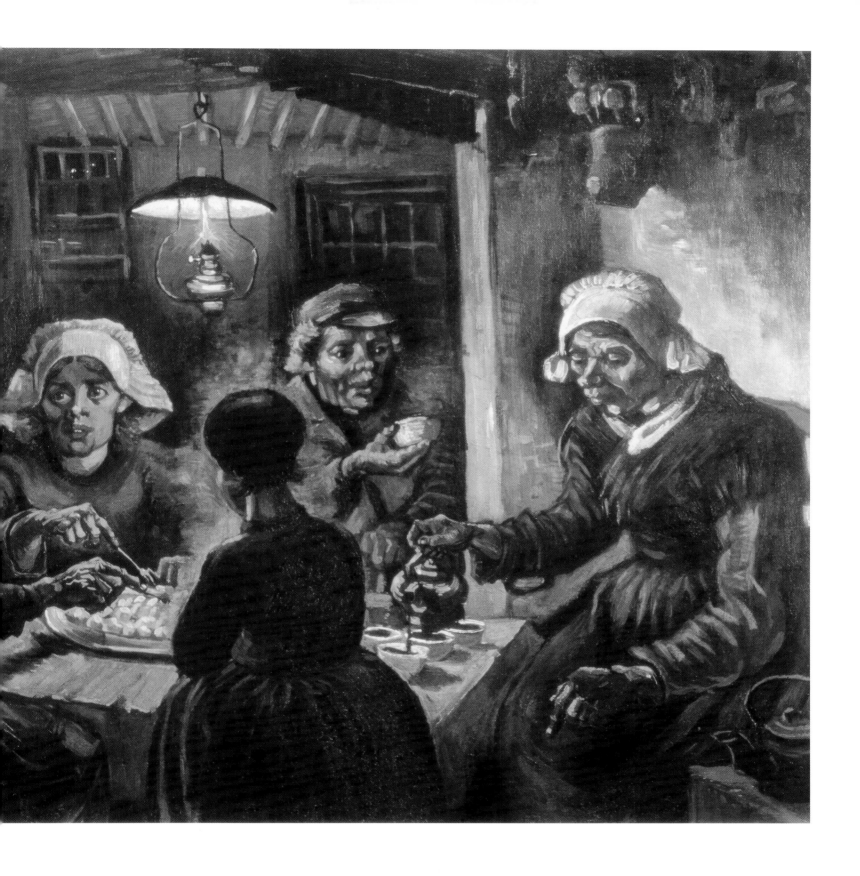

therefore the only thing to do is to hide oneself. Well, so be it."[38] The 'renewed' van Gogh made two important decisions: First, he resolved to determine the course of his life entirely on his own and not to seek his family's advice; second, he set out to put his passions to good use: "When I was in other surroundings, in the surroundings of pictures and works of art, you know how violent a passion I had for them, reaching the highest pitch of enthusiasm. And I am not sorry about it, for even now, far from that land, I am often homesick for the land of pictures."[39]

Homesick for the world of art, van Gogh moved to Brussels in October, 1880. He began to study with reproductions and models: "There are laws of proportions, of

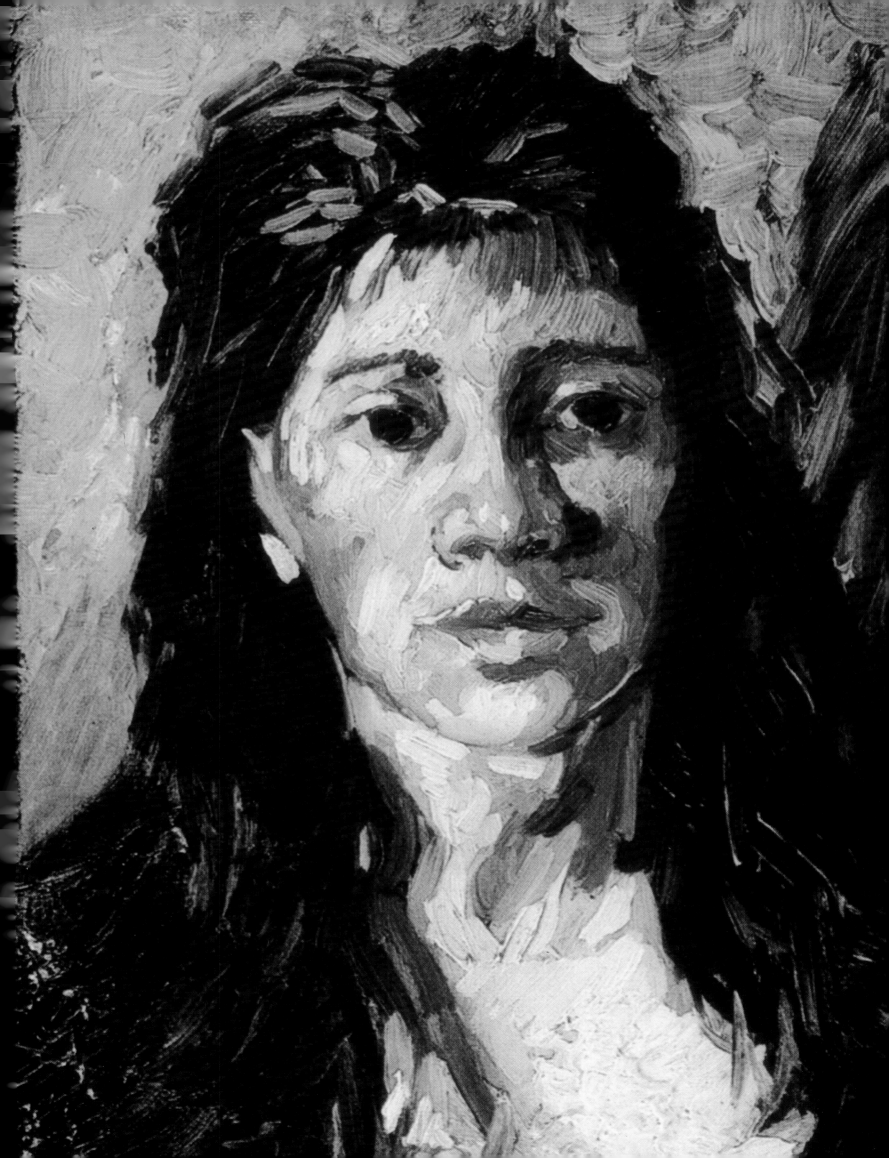

light and shadow, of perspective, which one must know in order to be able to draw well; without that knowledge, it always remains a fruitless struggle, and one never creates anything."[40] Though his father disapproved of his decision, he supported his son financially. Theo, who by that time had begun working in Goupil's branch in Paris, also sent him money.

In the spring of 1881, to reduce his expenses, van Gogh moved to the vicarage in Etten, where his father had been working for some time. The young painter did not suffer from material wants, but his family neither understood nor supported his ideas: "Father and Mother are very good to me in that they do everything to feed me well, etc. Of course I appreciate it very much, but it cannot be denied that food and drink and sleep are not enough for a man, that he longs for something nobler and higher – aye, he positively cannot do without it."[41] At this time, "something nobler and higher" meant, first of all, not the artistic work, but his love for his cousin Kee. Although she had resisted his advances, he continued trying to win her heart. His family was ashamed by his persistence, and openly criticized his passion. After a particularly heated argument during the Christmas holidays in 1881, the pastor ordered his wayward son to leave.

Two years later Vincent returned to the family nest for the last time. With this final break, he abandoned the family name, and began signing his canvases simply 'Vincent.' The event which precipitated the rupture was van Gogh's decision to take up residence in The Hague with the prostitute Christina Hoornik, called Sien. In May, 1882 he wrote to Theo: "Last winter I met a pregnant woman, deserted by a man whose child she carried. A pregnant woman who had to walk the streets in winter, had to earn her bread, you understand how. I took this woman for a model, and I have worked with her all the winter. I could not pay her the full wages of a model, but that did not prevent my paying her rent, and thank God, so far I have been able to protect her and her child from hunger and cold by sharing my own bread with her."[42] The compassion he felt for the pregnant woman was coupled with his longing to have a nest: "I have a feeling of being at home when I am with her, as though she gives me my own hearth, a feeling that our lives are interwoven."[43]

The family reacted with reproaches, exhortations, and threats. Once again, the familiar pattern recurs: van Gogh's parents could not understand the behavior of their son, but they cared about his well being. In the winter of 1883 they sent him a package of clothes which included a woman's coat. For some time van Gogh had been dependent on people who did not accept him, a paradox which prompted him to think at length about the relationship between art and money. He wrote to Theo: "I will succeed in earning money to keep myself, not in luxury, but as one who eats his bread in the sweat of his brow."[44] In the years to come, van Gogh would defend the artist as a productive – and therefore respectable – member of society. He began sending Theo some of his pictures in exchange for the money he sent; in this way Theo became his employer rather than his patron.

In The Hague, van Gogh focused on figurative drawing. Sien was his most important model: "I find in her exactly what I want: her life has been rough, and sorrow and adversity have put their marks upon her – now I can do something with her."[45] Van Gogh's conception of women was quite far removed from the classical ideal of beauty. On one occasion, he expressed his opinion in these terms: "Uncle Cor asked me today if I didn't like *Phryne* by Gérôme. I told him that I would rather see a

14. *Head of a Woman with her Hair Down*
Anvers: December 1885
Oil on canvas, 35 x 24 cm
Amsterdam: Rijksmuseum Vincent van Gogh, Foundation Vincent van Gogh.

homely woman by Israëls or Millet, or an old woman by Edouard Frère: for what's the use of a beautiful body such as Phryne's? Animals have it too, perhaps even more than men; but the soul, as it lives in the people painted by Israëls or Millet or Frère, that is what animals never have. Is not life given to us to become richer in spirit, even though the outward appearance may suffer?"[46]

For some time van Gogh served as an apprentice to the painter Anton Mauve. There, he started to paint with oil colours. His major motifs involved people: "I am decidedly not a landscape painter; when I make landscapes, there will always be something of the figure in them."[47] The comparison between the drawings *Sorrow*, a crouched nude, and *Les racines*, roots of a tree, tells us something of what he has in mind: "I tried to put the same sentiment into the landscape as into the figure: the convulsive, passionate clinging to the earth, and yet being half torn up by a storm. I wanted to express something of the struggle for life in that pale, slender woman's figure, as well as in the black, gnarled and knotty roots."[48] When Mauve discovered that van Gogh was living together with Sien, he canceled the contact. Tersteeg, van Gogh's former master, sought to pressure him by asking Theo to stop the financial support. The painter was largely isolated in The Hague, and his relations with Sien became increasingly strained as money grew tight. During a visit, Theo convinced Vincent to abandon the relationship.

At the end of 1883, van Gogh joined his parents, who had moved to Etten, near Eindhoven. The return of the prodigal son was not a success: "I am sick at heart about the fact that, coming back after two years' absence, the welcome home was kind and cordial in every respect, but basically there has been no change whatever, not the slightest, in what I must call the most extreme blindness and ignorance as to the insight into our mutual position."[49]

Because his family was unable to understand him – to know him – van Gogh severed the connection. "They have the same dread of taking me in the house as they would about taking a big rough dog. He would run into the room with wet paws – and he is so rough. He will be in everybody's way. And he barks so loud. In short, he is a foul beast. [...] And I, admitting that I am a kind of dog, leave them alone."[50] Van Gogh has often been criticized because of his appearance and his manners. He confesses that, in some periods of his life, he had neglected his clothes in order to ensure his solitude. He left the vicarage and rented rooms in the home of a Catholic sexton. When he visited his father's house for a meal, he sat away from the family table: "I consciously choose the dog's path through life; I will remain the dog, I shall be poor, I shall be a painter, I want to remain human – going into nature."[51]

In the summer of 1884, van Gogh met Margot Begemann, a neighbour's daughter. The 43-year-old-woman fell in love with the 31-year-old, who, as he stressed to Theo, had feelings of friendship for her and respected her "on a certain point that would have dishonoured her socially."[52] He noticed "certain symptoms" in her behavior, and so wrote to his brother "that I was afraid that she would get brain fever, and that I was sorry to state that, in my eyes, the Begemann family acted extremely imprudently in speaking to her the way they did. This had no effect, at least no other than that they told me to wait two years, which I decidedly refused to do, saying that if there was a question of marriage, it had to be soon or not at all."[53] At the beginning of September, Margot attempted suicide. Van Gogh rescued her by making her vomit the poison she had taken. He reported this incident "which hardly anybody here

15. *Weaver, Seen from the Front,*
Neunen: May 1884
Oil on canvas, 70 x 85 cm
Otterlo: Rijksmuseum Kröller-Müller.

16. *The Bois de Boulogne with the People Walking*
Paris: Summer 1886
Oil on canvas, 37.5 x 45.5 cm
United States: Private Collection
(sold, Sotheby's, New York,
12. 05. 1980).

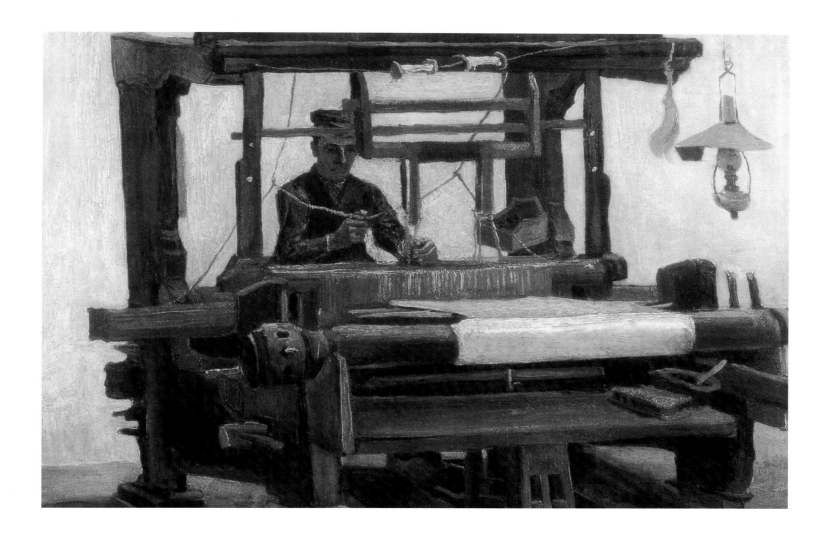

knows, or suspects, or may ever know"[54] to Theo. Defamation and the family's pressure were, in van Gogh's view, the reasons behind the suicide attempt: "But for heaven's sake, what is the meaning of that standing and of that religion which the respectable people maintain? – oh, they are perfectly absurd, making society a kind of lunatic asylum, a perfectly topsy-turvy world – oh, that mysticism."[55] Four years later, van Gogh was to suffer his own crisis, a despair which would drive him to attempt suicide. Unlike Margot, however, he would not be rescued.

Van Gogh's artistic work in Nuenen is dominated by one central motif: the working man. The painter went into the fields and drew women digging out potatoes. He also sketched the weavers. In April 1885, he worked on the oil painting *The Potato Eaters*, that today is considered to be his first masterpiece. He described the picture to Theo: "I have tried to emphasize that those people, eating their potatoes in the lamplight, have dug the earth with those very hands they put in the dish, and so it speaks of manual labor, and how honestly they earned their food. I wanted to give the impression of a way of life quite different from that of us civilized people. Therefore I am not at all anxious for everyone to like it or to admire it at once."[56]

In his letters, van Gogh stressed again and again his appreciation for the life of peasants and workers. However, as in the Borinage, he longed for the land of pictures. In November, 1885, he moved to Antwerp to join the Academy of Art. But he stayed there for only a short time. Four months later he left for Paris; he never returned to Holland. He declared later that he hadn't become an adventurer by choice "but by fate, and feeling nowhere so much myself a stranger as in my family and country."[57]

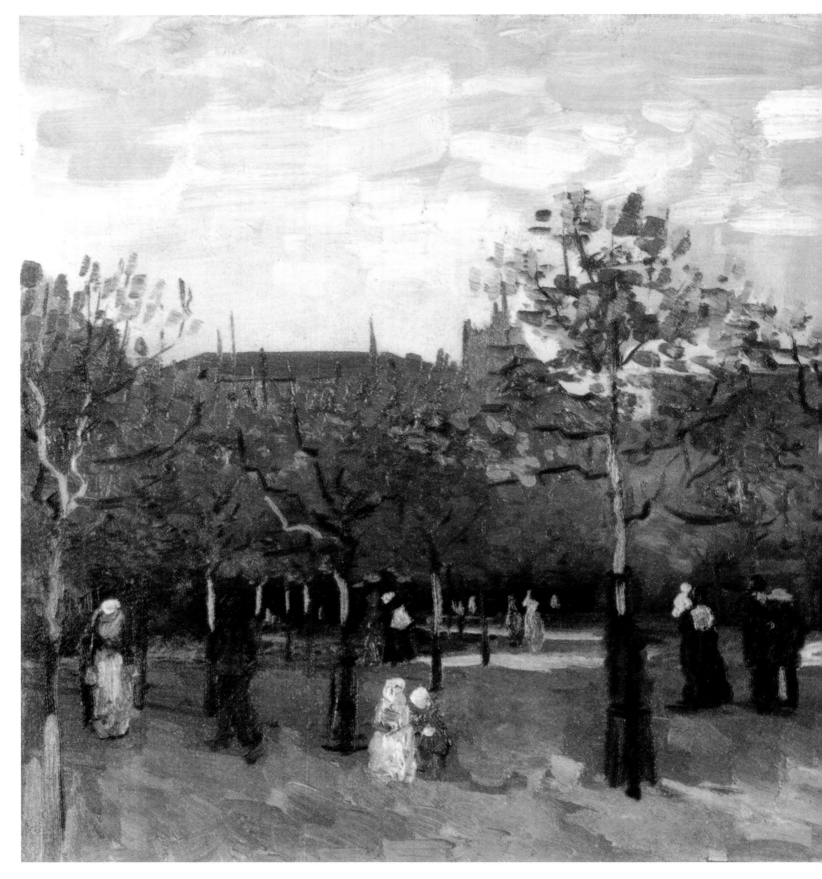

"The spreading of ideas"

Van Gogh had been living in the French capital for nearly half a year when he wrote to Horace M. Levens, an English painter he had met in Antwerp: "And mind my dear fellow, Paris is Paris. There is but one Paris and however hard living may be here, and if it became worse and harder even – the French air clears up the brain and does you good – a world of good."[58]

He had arrived unexpectedly in March, 1886. He immediately sent a note to his brother at the gallery: "My dear Theo, Do not be cross with me for having come all at once like this: I have thought about it so much, and I believe that in this way we shall save time. Shall be at the Louvre from midday on or sooner if you like."[59]

Van Gogh stayed in the capital of the 19th century for two years. Because he was living with his most significant correspondent, this chapter of his life is poorly documented. The cohabitation of the two brothers was not without its conflicts. "There was a time, where I thought much of Vincent and where he was my best friend, but this is over now," complains Theo to his sister Willemien. "From his point of view it seems to be even worse, because he doesn't miss an occasion to let me know that he despises and detests me. For that reason, my home has become intolerable. No one comes to see me anymore because of his reproaches, and also because the house is so dirty that it is not very inviting."[60]

The brothers eventually overcame this crisis, and drew closer than ever before. After Vincent's departure, Theo again wrote to his sister: "It is unbelievable, how much he knows and what a bright view he has upon the world […] Through him I got in contact with many painters who worship him a lot […] Anyway, he has got such a big heart that he is always longing to do something for other people."[61]

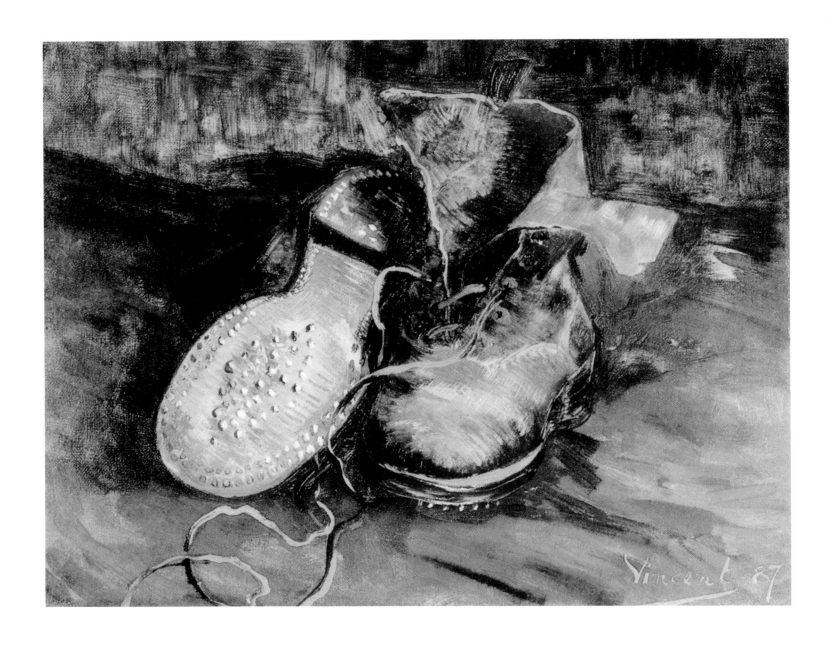

Vincent opened his brother's eyes not only to new painters and paintings, but also to the world of music: "Though I don't know much about it, I like to listen to music, but here one can seldom hear something good without going to concerts. But before Vincent left, I sometimes went with him to a Wagner concert, and we both liked it a lot. It is disconcerting for me, that he is gone; at the end he was so much to me."[62] Van Gogh continued to study the French literature that had excited him for such a long time: "The work of the French naturalists, Zola, Flaubert, Guy de Maupassant, de Goncourt, Richepin, Daudet, Huysmans, is magnificent, and one can hardly be said to belong to one's time if one has paid no attention to it."[63]

To van Gogh, Paris offered a time for reflection and a time for painting. It was there that he first saw the Impressionist canvases of which Theo had written so often. He found work in the studio of Fernand Cormon, whose liberal way of teaching and disdain for the beaten track of the salons attracted many young painters. Henri de Toulouse-Lautrec and Emile Bernard also worked in Cormon's studio, and both befriended van Gogh. Another student, François Gauzi, recalled that "When van Gogh entered the Cormon atelier, he wanted to be called only by his first name, and for a long time we didn't know his real last name.

17. *A Pair of Shoes*
Paris: early 1887
Oil on canvas, 34 x 41.5 cm
Baltimore: The Baltimore Museum of Art, The Cone Collection.

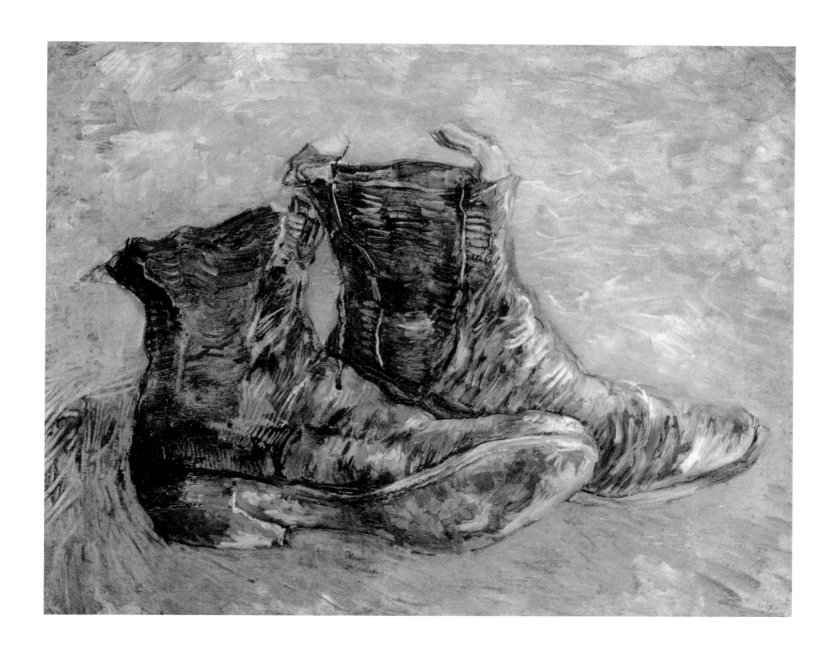

He was an excellent companion who had to be left in peace […] When discussing 'art', if one disagreed with him and pushed him to the limit, he would flare up in a disturbing way […] He worked with a disorderly fury, throwing colours on the canvas with feverish speed. He gathered up the colour as though with a shovel, and the gobs of paint, covering the length of the paintbrush, stuck to his fingers. When the model rested, he didn't stop painting. The violence of his study surprised the atelier; the classically-oriented remained bewildered by it."[64]

Even more than the studio, the colour store of Julien Tanguy fascinated the young painter. Over his wife's protests, the proprietor occasionally let his customers pay for their supplies with paintings. Tanguy's store thus became something of a gallery, where the painters met to see the work of their colleagues. It was here that van Gogh came to know Paul Gauguin, whose paintings he greatly admired.

18. *A Pair of Shoes*
 Paris: Spring 1887
 Oil on cardboard, 33 x 41 cm
 Amsterdam: Rijksmuseum Vincent
 van Gogh, Foundation Vincent van
 Gogh.

The Scottish painter Archibald Standish Hartrick offers this impression of the conversations in Père Tanguy's store: van Gogh "was particularly pleased with a theory that the eye carried a portion of the last sensation it had enjoyed into the next, so that something of both must be included in every picture made. The difficulty was

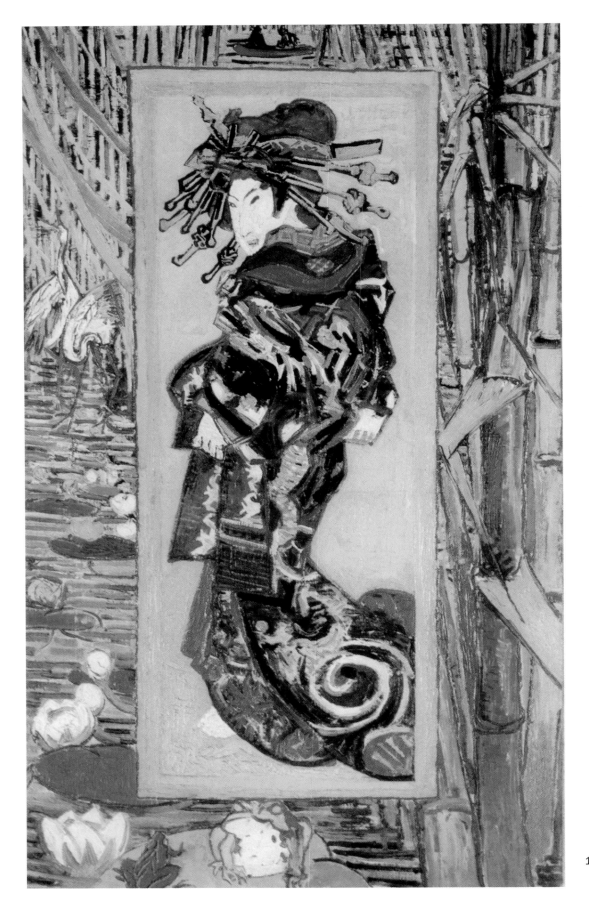

19. *Japoniaiserie: Oiran*
(after Kesaï Eisen)
Paris: September–October 1887
Oil on canvas, 105.5 x 60.5 cm
Amsterdam: Rijksmuseum Vincent
van Gogh, Foundation Vincent
van Gogh.

20. *Japonaiserie : Bridge in the Rain*
(after Hiroshige)
Paris: September–October 1887
Oil on canvas, 73 x 54 cm
Amsterdam: Rijksmuseum Vincent
van Gogh, Foundation Vincent van
Gogh.

to decide what were the proper sensations so coloured to combine together. An obvious instance of this sort of idea will be found in the fact that the entering of a lamplit room out of the night increases the orange effect of the light, and in the contrary case, the blue. Hence to depict it properly, according to the theory, it was necessary in the former case to include some blue into the picture and in the latter

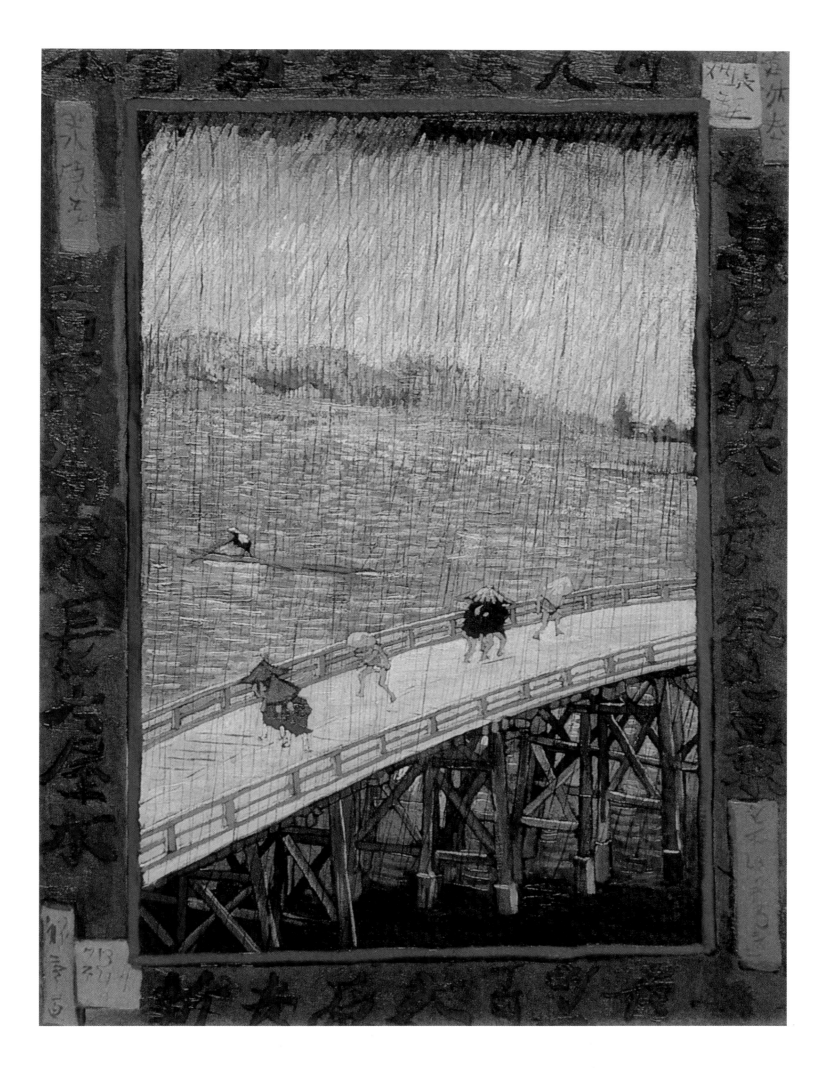

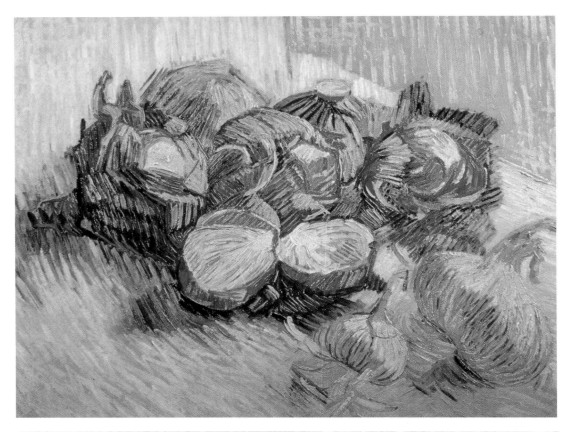

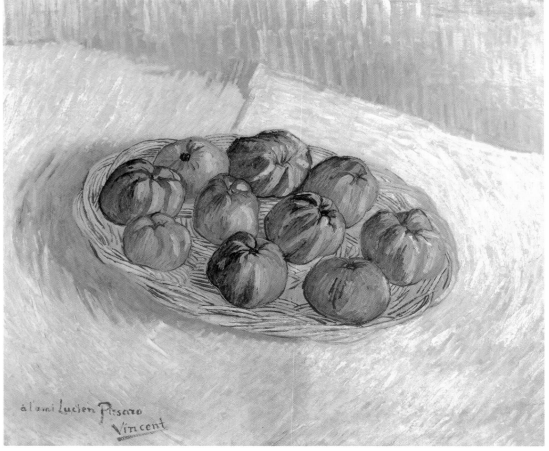

21. *Still Life with Red Cabbages and Onions*
 Paris: Autumn 1887
 Oil on canvas, 50 x 64.5 cm
 Amsterdam: Rijksmuseum Vincent van Gogh, Foundation Vincent van Gogh.

22. Still Life with Basket of Apples (to Lucien Pissarro)
 Paris: Autumn 1887
 Oil on canvas, 50 x 61 cm
 Otterlo: Rijksmuseum Kröller-Müller.

23. *Portrait of Père Tanguy*
 Paris: Autumn 1887
 Oil on canvas, 92 x 75 cm
 Paris: Musée Rodin.

some orange. Van Gogh would roll his eyes and hiss through his teeth with gusto, as he brought out the words 'blue', 'orange' – complementary colours of course."[65]

The effects of colour also prompted van Gogh's interest in the Japanese woodcuts he had first encountered in Antwerp. He had a sizable collection of these prints in Paris,

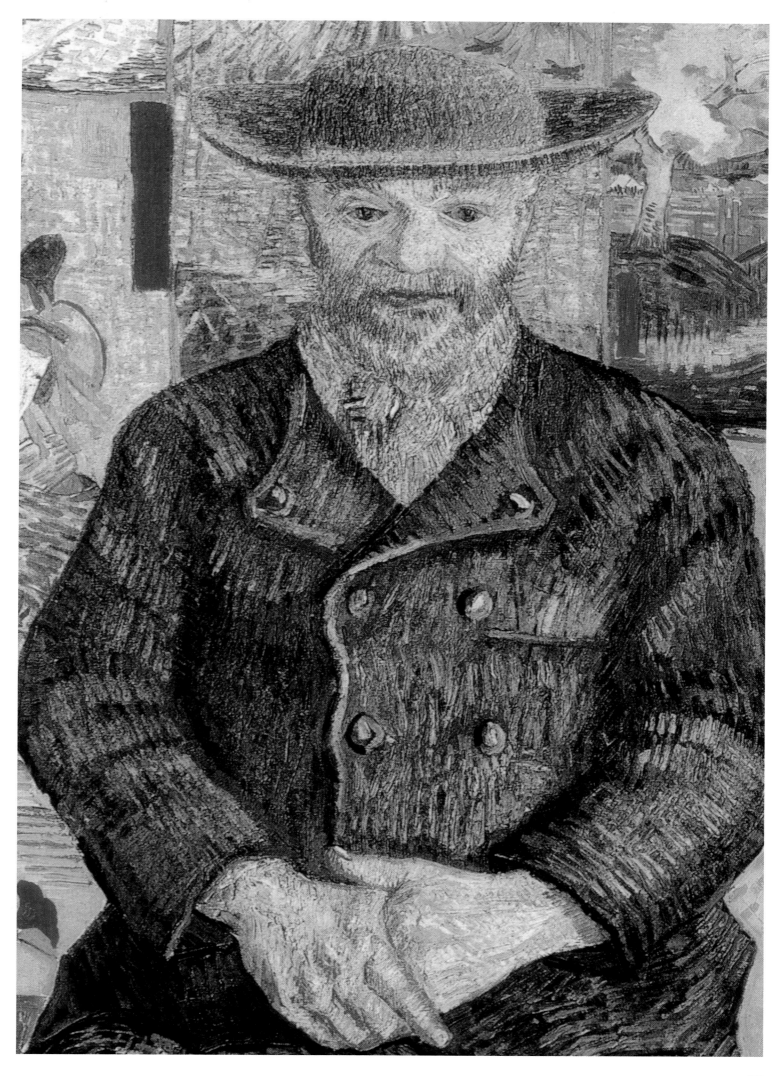

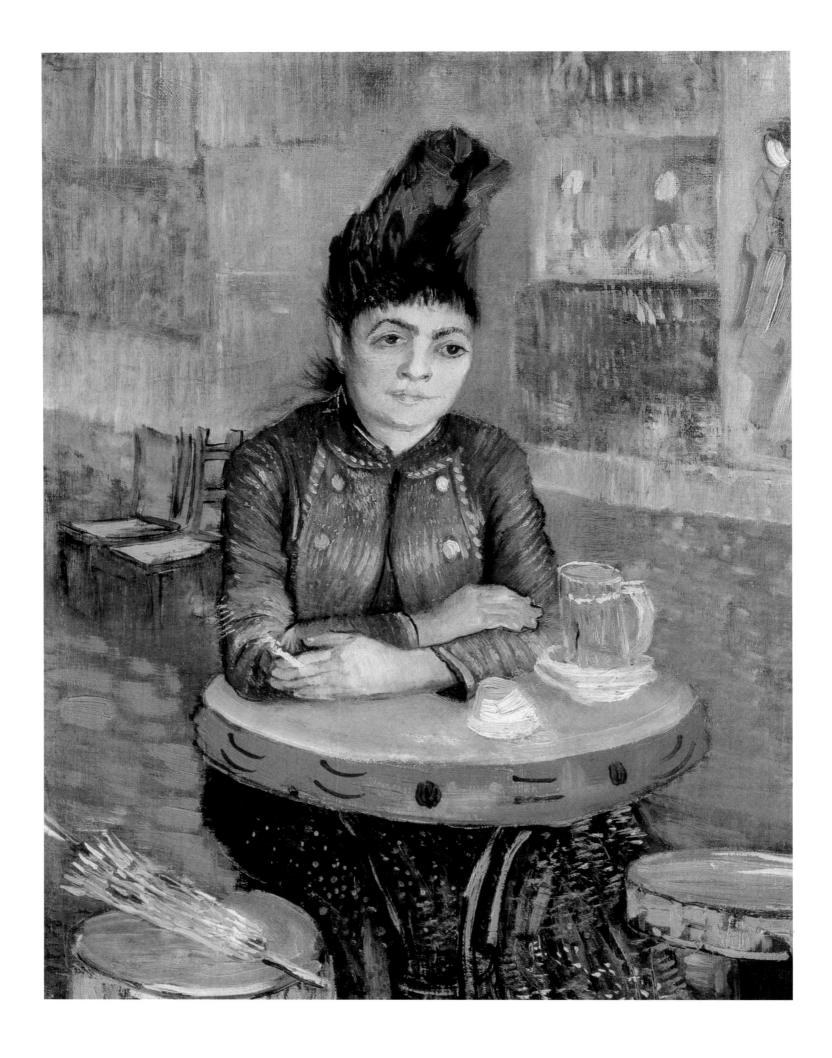

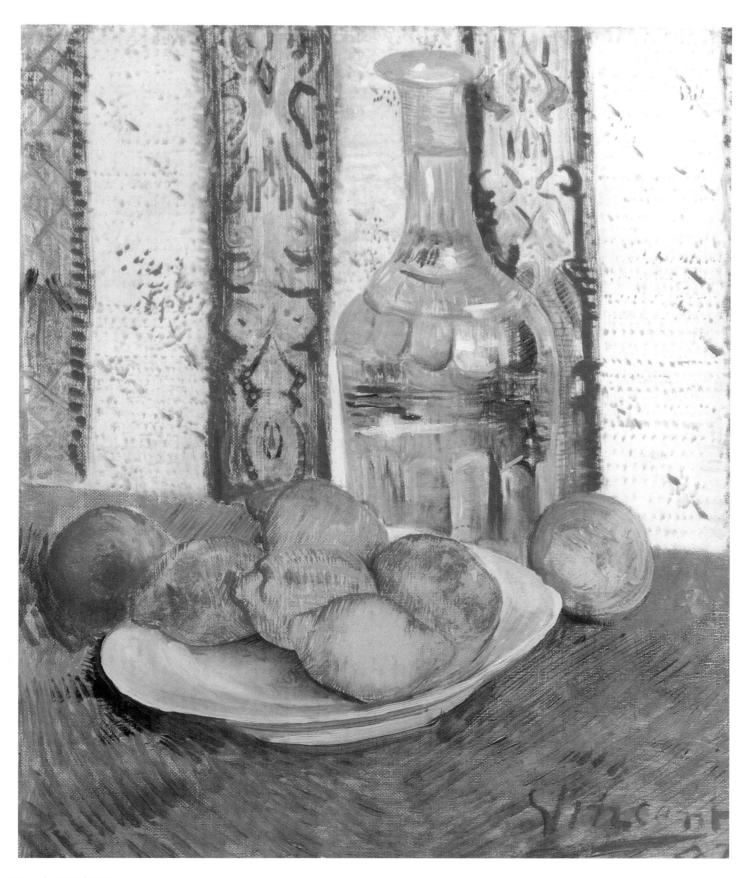

24. *Agostina Segatori Sitting
in the Cafe Tambourin*
Paris: February–March 1887
Oil on canvas, 55.5 x 46.5 cm
Amsterdam: Rijksmuseum
Vincent van Gogh,
Foundation Vincent van Gogh.

25. *Still Life with Decanter
and Lemons on a Plate*
Paris: Spring 1887
Oil on canvas, 46.5 x 38.5 cm
Amsterdam: Rijksmuseum
Vincent van Gogh,
Foundation Vincent van Gogh.

and organized an exhibition of them in the café "Tambourin" that aroused considerable interest among his contemporaries. A show of his own works ended, however, with trouble: the landlady of the "Tambourin" refused to return the paintings because van Gogh had not paid his bills in the café. The self-portrait was the main subject of van Gogh's work from 1886 to 1888. In one canvas, he represents himself as a painter, with brush and palette.

26. *Le Moulin de la Galette*
Paris: March 1887
Oil on canvas, 46 x 38 cm
Pittsburgh: Museum of Art, Carnegie
Institute.

27. *Flowerpot with Chives*
Paris: March–April 1887
Oil on canvas, 31.5 x 22 cm
Amsterdam: Rijksmuseum
Vincent van Gogh,
Foundation Vincent van Gogh.

28. *Portrait of the Art Dealer Alexandre Reid*
Paris: Spring 1887
Oil on canvas, 41.5 x 33.5 cm
Glasgow: Glasgow Art Gallery and Museum.

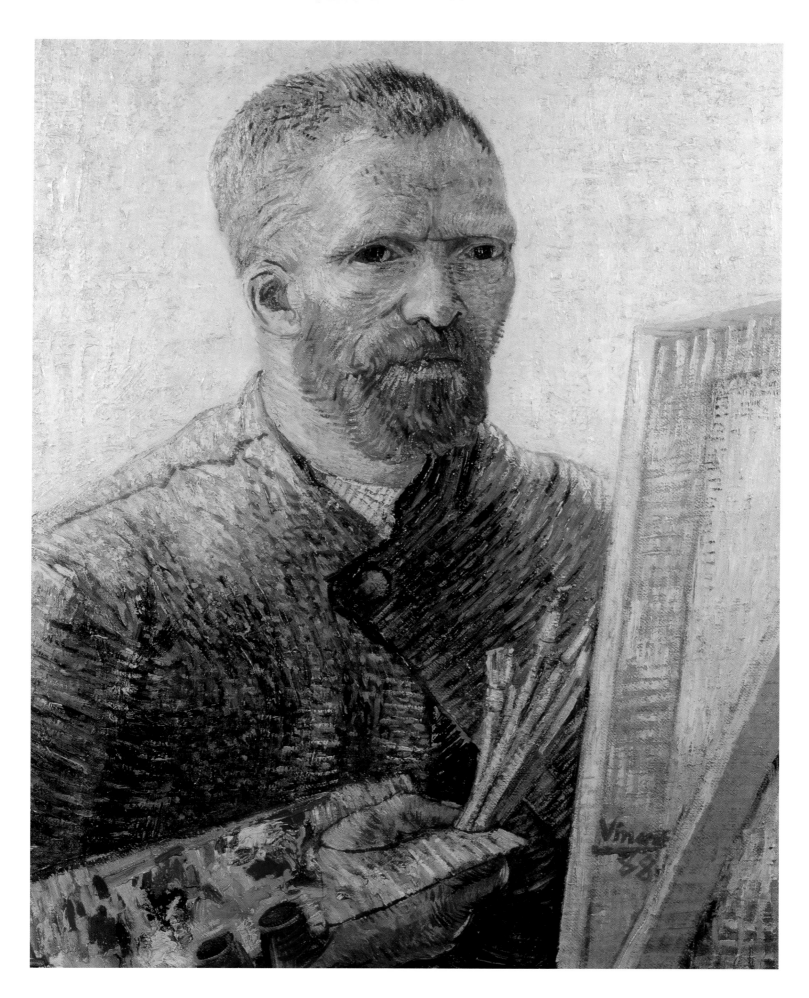

29. *Self-Portrait in Front of the Easel*
 Paris: January–February 1888
 Oil on canvas, 65 x 50.5 cm
 Amsterdam: Rijksmuseum
 Vincent van Gogh,
 Foundation Vincent van Gogh.

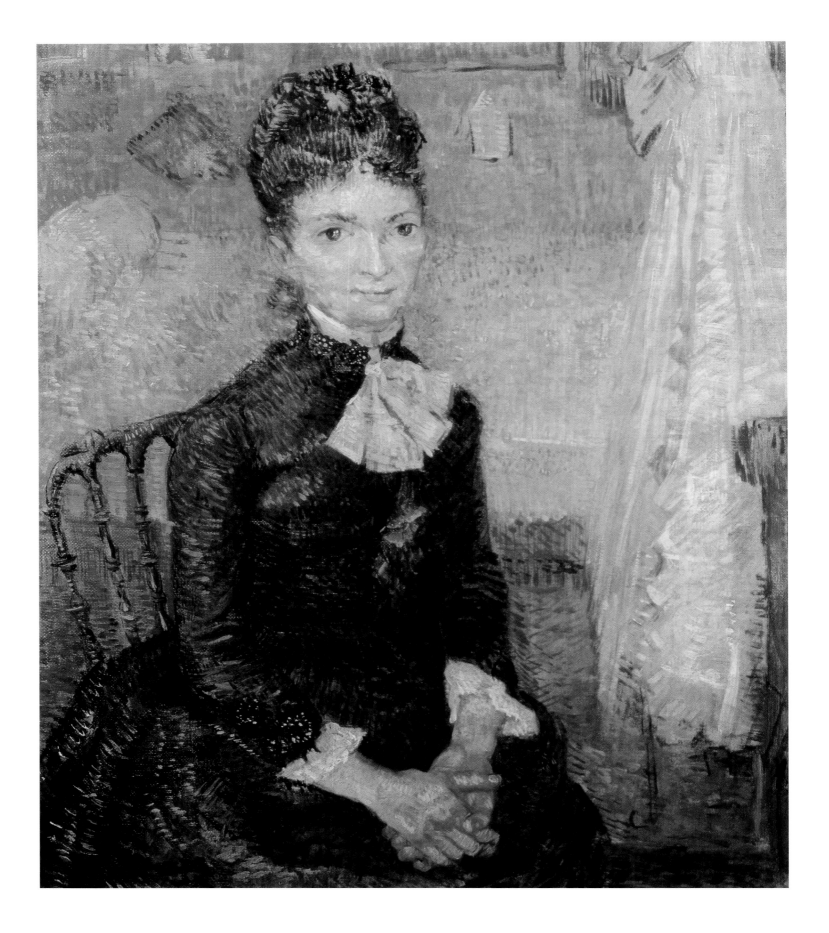

In the Paris that he once called a "spreading of ideas,"[66] he found his way. In the summer of 1887, he wrote to his sister Willemien: "In every man who is healthy and natural there is a germinating force as in a grain of wheat. And so natural life is germination.

What the germinating force is in the grain of wheat, love is in us [...] My own adventures are restricted chiefly to making swift progress toward growing into a

30. *Woman Sitting by a Cradle*
 Paris: Spring 1887
 Oil on canvas, 61 x 46 cm
 Amsterdam: Rijksmuseum
 Vincent van Gogh,
 Foundation Vincent van Gogh.

31. *Portrait of Eugène Boch*
 Arles: September 1888
 Oil on canvas, 60 x 45 cm
 Paris: Musée d'Orsay.

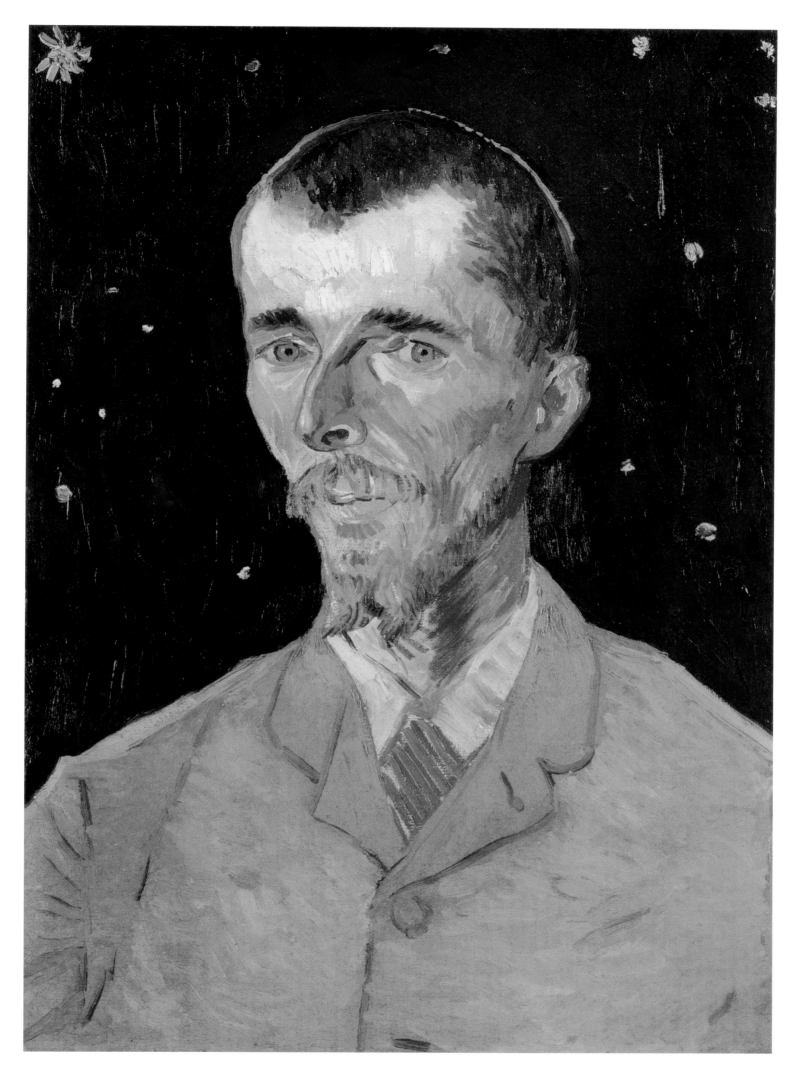

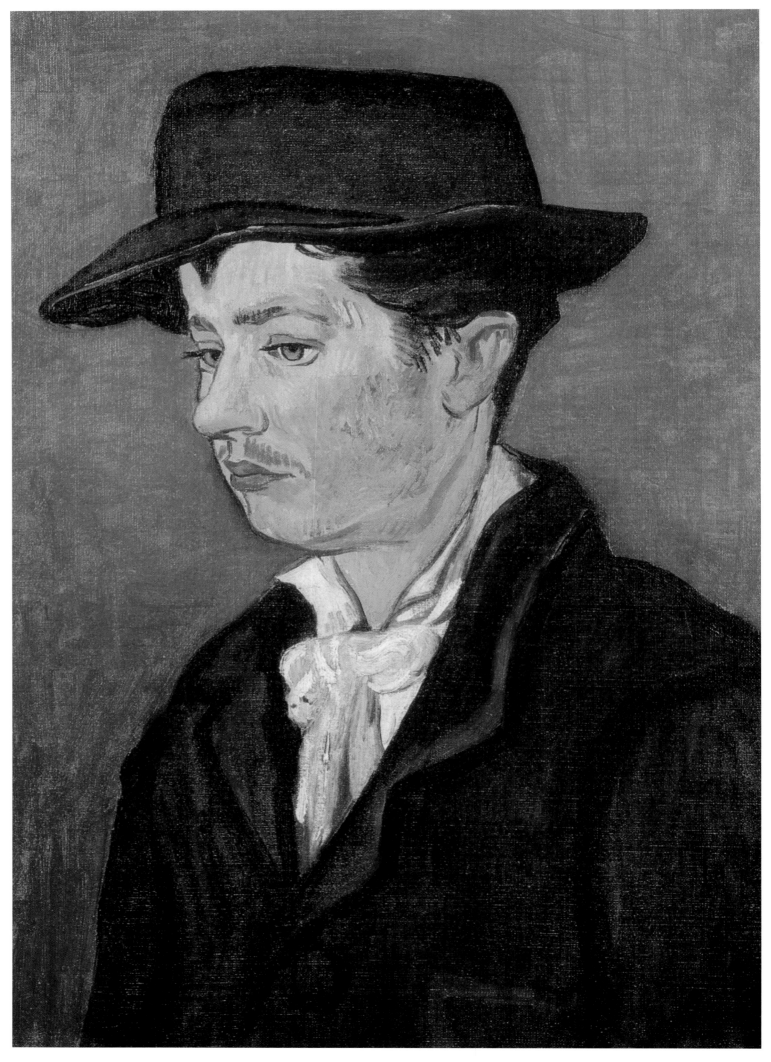

44

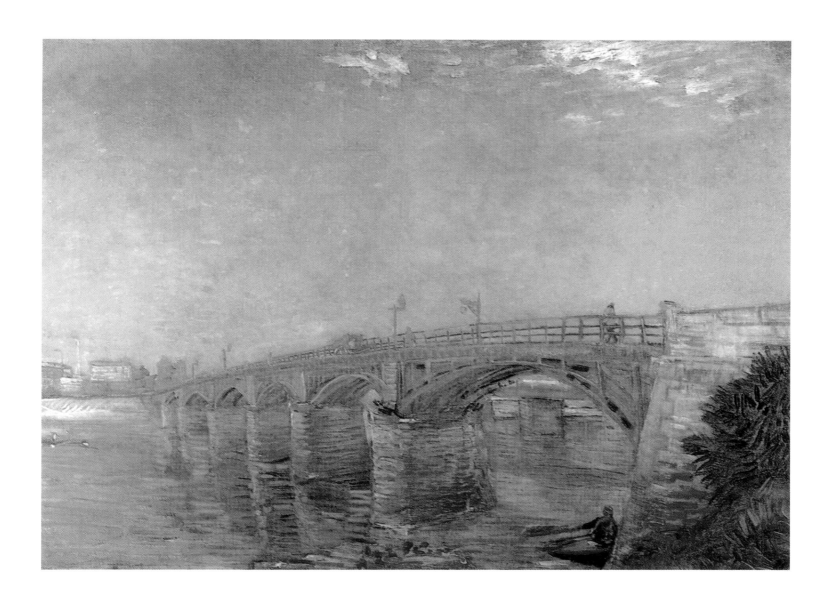

32. *Portrait of Armand Roulin*
 Arles: November–December 1888,
 Oil on canvas, 65 x 54 cm
 Rotterdam: Musée Boymans-van
 Beuningen.

33. *Asnières Bridge*
 Paris: Summer 1897
 Oil on canvas, 53 x 73 cm
 Houston: Dominique de Menil
 Collection.

little old man, you know, with wrinkles, and a tough beard and a number of false teeth, and so on. But what does it matter? I have a dirty and hard profession – painting – and if I were not what I am, I should not paint; but being what I am, I often work with pleasure, and in the hazy distance I see the possibility of making pictures in which there will be some youth and freshness, even though my own youth is one of the things I have lost […] It is my intention as soon as possible to go temporarily to the South, where there is even more colour, even more sun. But the thing I hope to achieve is to paint a good portrait. But never mind."[67]

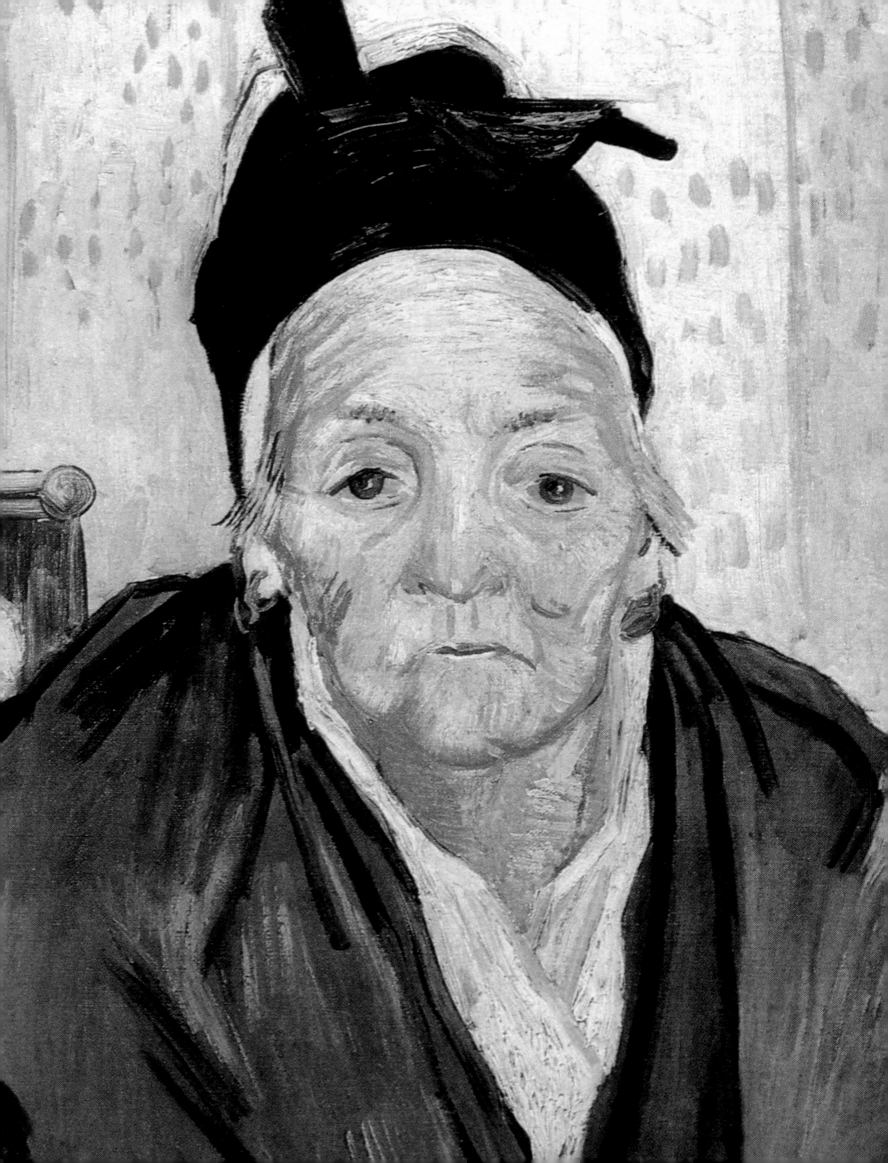

"An artists' house"

On February 19th, 1888 van Gogh left Paris for Arles. Two days later he wrote to Theo: "It seems to me almost impossible to work in Paris unless one has some place of retreat where one can recuperate and get one's tranquillity and poise back."[68] The region of Arles reminded him not only of the Dutch landscape, but also of the Japan shown in the woodcuts. He rented a room in the Carrel Inn and set to work immediately. In the morning, he went out into the fields and gardens, where he stayed until late afternoon. He spent his evenings in the Café de la Gare, where he wrote letters and read newspapers or novels like Pierre Loti's *Madame Chrysanthème*. It was there that he befriended the Zouave second lieutenant Paul-Eugène Milliet, the postman Joseph Roulin, and the couple Ginoux, who owned the café. In a letter to Theo, he explained that "I would rather fool myself than feel alone."[69] Van Gogh held his new friends in high esteem – later, in the time of crisis, they would become his most faithful and empathic companions – but he missed being near people with whom he could discuss art and painting.

In May of the same year, he rented two rooms in an empty house on the Place Lamartine. Since the rooms were unfurnished, he slept in the Café de la Gare, having abandoned the Carrel Inn after a quarrel with the landlords. The task of decorating the house – which he called both the *Yellow House* and *The Artists' House* – delighted him to no end. In his mind, it was to form the nucleus of an artists' colony, a studio of the South. "You know that I have always thought it idiotic the way painters live alone," he wrote to Theo. "You always lose by being isolated."[70]

Dependent on his family for financial support, van Gogh began to reflect on the position of the artist in society: "It is hard, terribly hard, to keep on working when one does not sell, and when one literally has to pay for one's colour out of what would not be too much for eating, drinking and lodgings, however strictly calculated [...] All the same they are building state museums, and the like, for hundreds of thousands of

34. *An Old Woman from Arles*
 Arles: February 1888
 Oil on canvas, 58 x 42.5 cm
 Amsterdam: Rijksmuseum
 Vincent van Gogh,
 Foundation Vincent van Gogh.

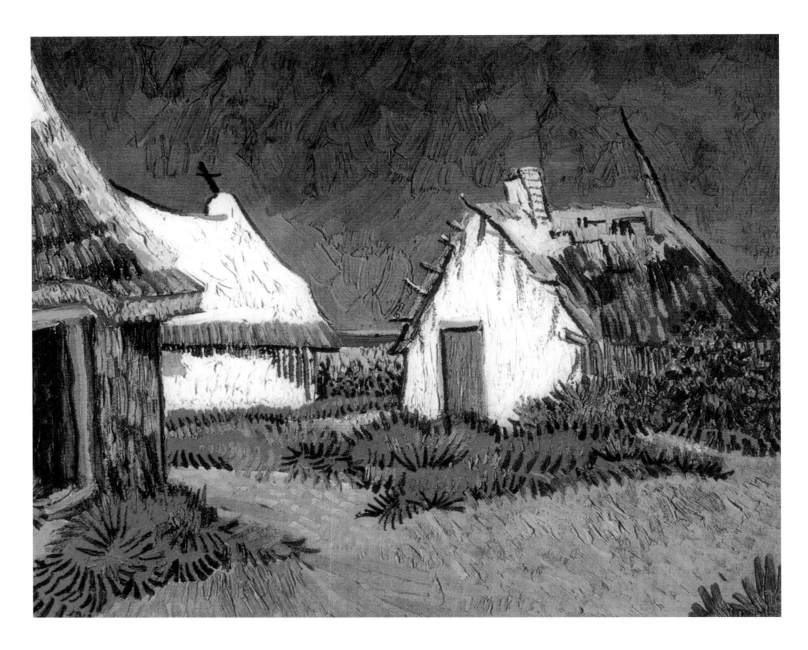

guilders, but meanwhile the artists very often starve."[71] For van Gogh, museums were cemeteries. He was similarly contemptuous of the art trade: "Given ten years as necessary to learn the profession and somebody who has struggled through six years and paid for them and then has to stop, just think how miserable that is, and how many there are like that! And those high prices one hears about, paid for work of painters who are dead and who were never paid so much while they were alive, it is a kind of tulip trade, under which the living painters suffer rather than gain any benefit. And it will also disappear like the tulip trade."[72] Van Gogh's alternative to this unhappy state of affairs was a community of artists: The painters should work together, support each other and give their works to one, faithful dealer – Theo – who would pay a monthly sum to the artists, regardless of whether the works sold or not.

Van Gogh tried to persuade Gauguin to join the studio of the South. For over half a year, from March to October 1888, he courted his admired colleague with letters. He asked Theo to increase his monthly allowance to 250 francs, so that Gauguin could live with him in Arles. In return, Theo would receive one painting from Gauguin. Gauguin, who was living in Brittany, stalled in his replies: sometimes he claimed to be too ill to travel, and on other occasions to be short of funds.

The months of waiting for Gauguin were the most productive time in van Gogh's life. He wanted to show his friend as many new pictures as possible. At the same

35. *Three White Cottages in Saintes-Maries*
Arles: early June 1888
Oil on canvas, 33.5 x 41.5 cm
Zurich: Kunsthaus Zurich (loan).

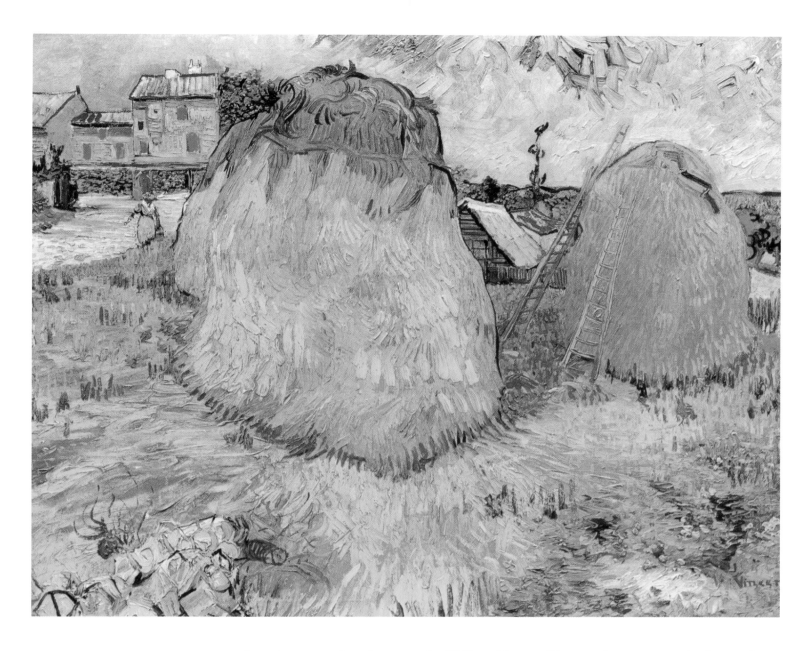

time, he wanted to decorate the Yellow House: "I wanted to arrange the house from the start not for myself only, but so as to be able to put someone else up too […] For a visitor there will be the prettier room upstairs, which I shall try to make as much as possible like the boudoir of a really artistic woman. Then there will be my own bedroom, which I want to be extremely simple, but with large, solid furniture, the bed, chairs and table all in white deal. Downstairs will be the studio, and another room, a studio too, but at the same time a kitchen […] The room you will have then, or Gauguin if he comes, will have white walls with a decoration of great yellow sunflowers […] I want to make it a real artists' house – not precious, on the contrary nothing precious, but everything from the chair to the pictures having character […] I cannot tell you how much pleasure it gives me to find a big serious job like this."[73]

In the middle of August, he started the cycle of the sunflowers for the guest room: "I am hard at it, painting with the same enthusiasm of a Marseillais eating bouillabaisse, which won't surprise you when you know that what I'm at is the painting of some big sunflowers. I have three canvases going – 1st, three huge flowers in a green vase, with a light background […]; 2nd, three flowers. one gone to seed, having lost its petals, and one a bud against a royal-blue background […]; 3rd, twelve flowers and buds in a yellow vase […] The last one is therefore light on light, and I hope it will be the best […] If I carry out this idea there will be a dozen panels. So the whole thing will be a symphony in blue and yellow."[74]

36. *Haystacks in Provence*
 Arles: June 1888
 Oil on canvas, 73 x 92.5 cm
 Otterlo: Rijksmuseum Kröller-Müller.

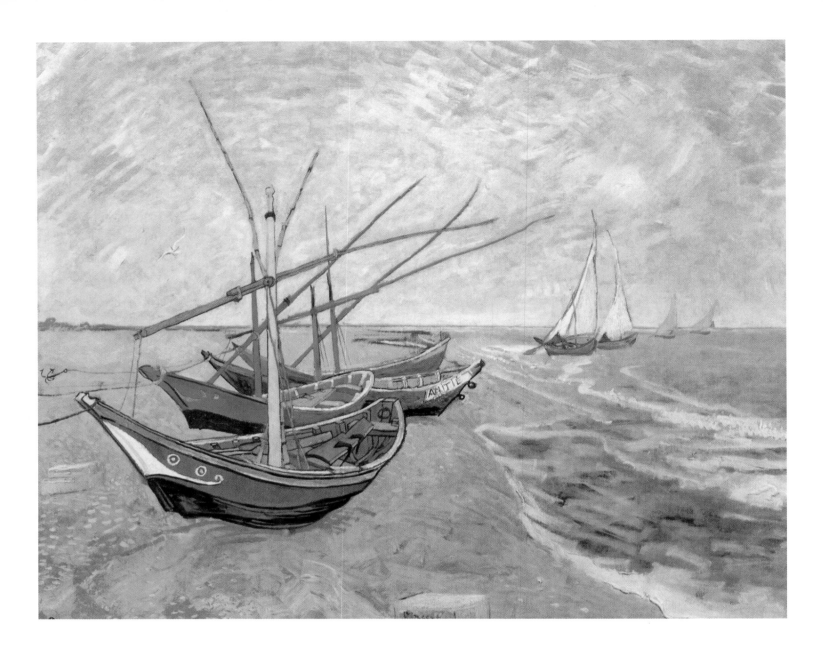

Of the projected twelve sunflower pictures, he completed only two, because the 'models' disappeared too quickly. He therefore turned to a new subject: the garden of the poet. Three variations on this theme, together with the two sunflower paintings became the decoration for the guest room, which was waiting for Gauguin's arrival. The nest had been built, but it remained empty. Van Gogh tried to remain optimistic: "If I am alone – I can't help it, but honestly I have less need of company than of furiously hard work, […] It's the only time I feel I am alive, when I am drudging away at my work. If I had company, I should feel it less of a necessity; or rather I'd work at more complicated things. But alone, I only count on the exaltation that comes to me in certain moments, and then I let myself run to extravagances."[75] At the same time, he resolved to control his exaltation: "Don't think that I would maintain a feverish condition artificially, but understand that I am in the midst of a complicated calculation which results in a quick succession of canvases quickly executed but calculated long beforehand. So now, when anyone says that such and such is done too quickly, you can reply that they have looked at it too quickly. Apart from that I am now busy going over all my canvases a bit before sending them to you."[76]

On October 23rd, Paul Gauguin finally arrived in Arles. "He is very interesting as a man," Vincent writes to Theo, "and I have every confidence that we shall do loads of things with him. He will probably produce a great deal here, and I hope perhaps I shall too."[77] The first thing Gauguin produced was order. Fifteen years later he wrote

37. *Fishing Boats on the Beach at Saintes-Maries*
Arles: End of June 1888
Oil on canvas, 65 x 81.5 cm
Amsterdam: Rijksmuseum
Vincent van Gogh,
Foundation Vincent van Gogh.

38. *Still Life: Vase with Fifteen Sunflowers*
Arles: August 1888
Oil on canvas, 93 x 73 cm
London: National Gallery.

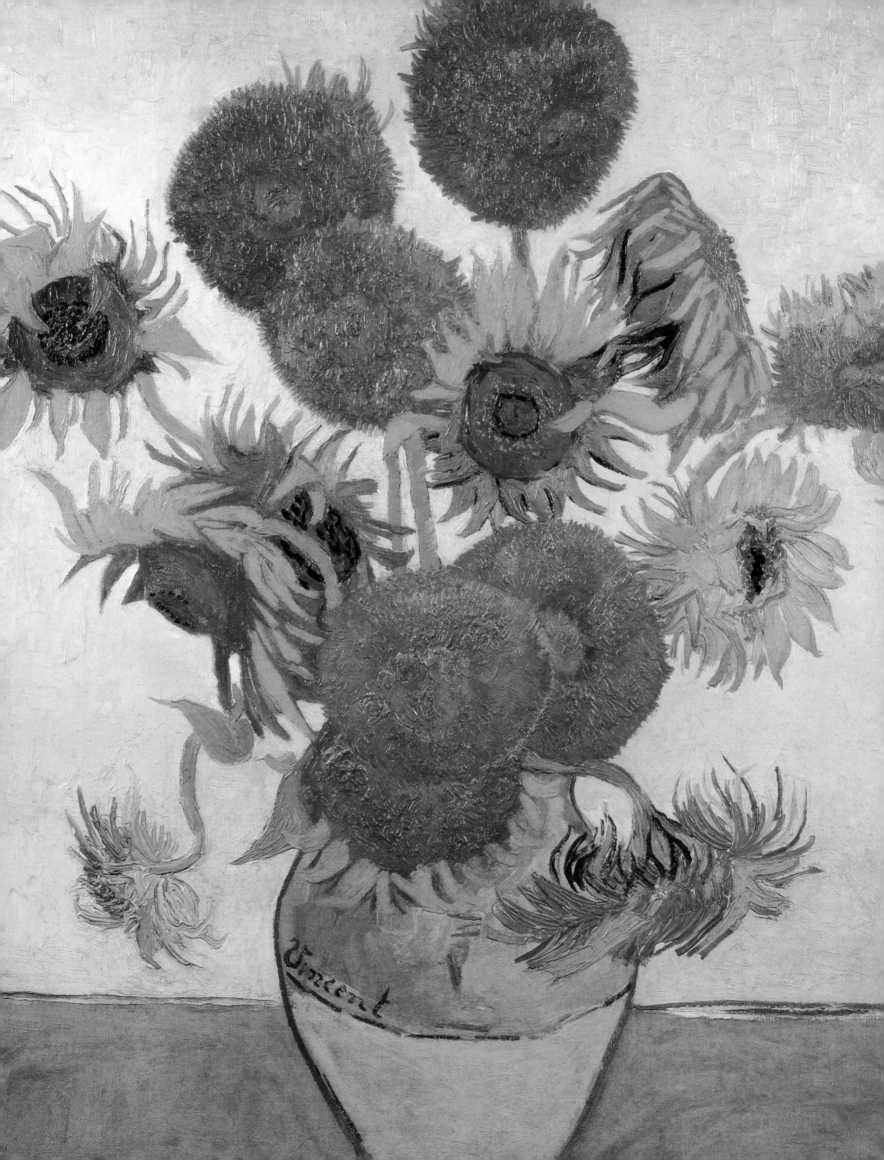

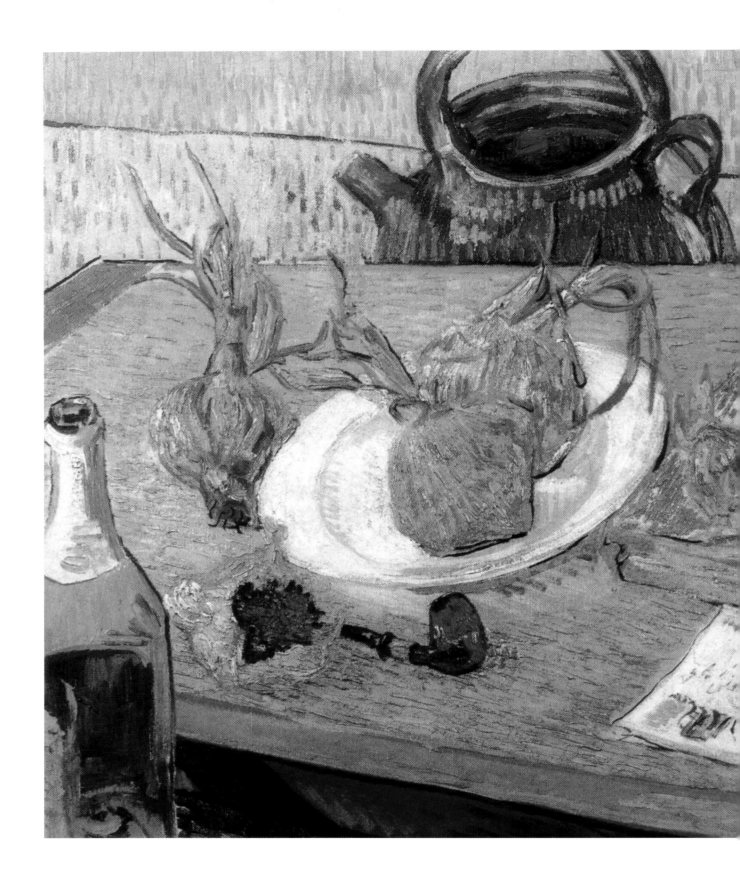

in his memoirs of the time in Arles: "First of all, I was shocked to find disorder everywhere and in every respect. His box of colours barely sufficed to contain all those squeezed tubes, which were never closed up, and despite all this disorder, all this mess, everything glowed on the canvas – and in his words as well."[78]

In the middle of November, Gauguin reported to his dealer and financial backer Theo: "The good Vincent and *le grièche* Gauguin continue to make a happy couple and eat at home the little meals they prepare themselves."[79] Before, Vincent had eaten in restaurants, quickly exhausting the sums Theo sent him: between 150 and 250 francs each month. By way of comparison, the postman Roulin, who was married and had three children, earned only 135 francs. Plainly, van Gogh's chronic lack of money was a result of his somewhat impromptu way of living. He took rooms in hotels and inns while traveling around – and didn't like it at all. He was not extravagant: he always looked for the cheapest accommodation, and forbade himself to eat large meals. But his acts of self-denial often bordered on the ritualistic: even when invited as a guest, he would refuse meals out of a belief that, like a monk, he should eat no more than was necessary for him to live. Even during his studies in Amsterdam he had exhibited a tendency towards self-abnegation. He confessed to his teacher Mendes da Costa that he was beating himself with a stick as punishment for not having worked enough.

A stomach disorder and dental problems were the consequence of his unbalanced diet, which consisted mostly of bread and cheese. It is doubtful, however, that these health problems were the exclusive result of poor nutrition; they might also have been symptoms of syphilis, a disease from which Theo suffered. His course of treatment – balanced nutrition, repose, abstinence from sex – was often discussed between the brothers, and Vincent came to believe that the same way of living would cure his ills as well.

Another factor that contributed to van Gogh's financial difficulties is that he would spend large sums on colours and canvases or prints as soon as the money arrived. Here too, Gauguin was able to counterbalance the impulsiveness of his host: instead of ordering prepared canvases from Paris he sought out cheap burlap in Arles, and fashioned frames by hand. Van Gogh was impressed by his friend's technical and practical skills. But he refused when Gauguin tried "to disentangle from that disordered brain a logical reasoning behind his critical options."[80]

Paul Gauguin saw himself in the position of sage, and relegated van Gogh to the role of his student: "Vincent, at the moment when I arrived in Arles, was fully immersed in the Neo-Impressionist school, and he was floundering considerably, which caused him to suffer [...] With all these yellows on violets, all this work in complementary colours – disordered work on his part – he only arrived at subdued, incomplete, and monotonous harmonies; the sound of the clarion was missing. I undertook the task of enlightening him, which was easy for me, for I found a rich and fertile soil. Like all natures that are original and marked with the stamp of personality, Vincent had no fear of his neighbour and was not stubborn. From that day on, my van Gogh made astonishing progress."[81]

Regarding the pictures van Gogh painted before and after Gauguin undertook him, however, there is little evidence of this progress. In March, 1888 van Gogh painted the *The Bridge at Langlois*, in July *The Mousmé* and the *Portrait of Joseph Roulin*, in August the *Sunflowers*, in September *The Poet's Garden*, *The Starry Night*, *The Yellow*

39. *Still-Life: Drawing Board with Onions*
Arles: January 1889
Oil on canvas, 50 x 54 cm
Otterlo: Rijksmuseum Kröller-Müller.

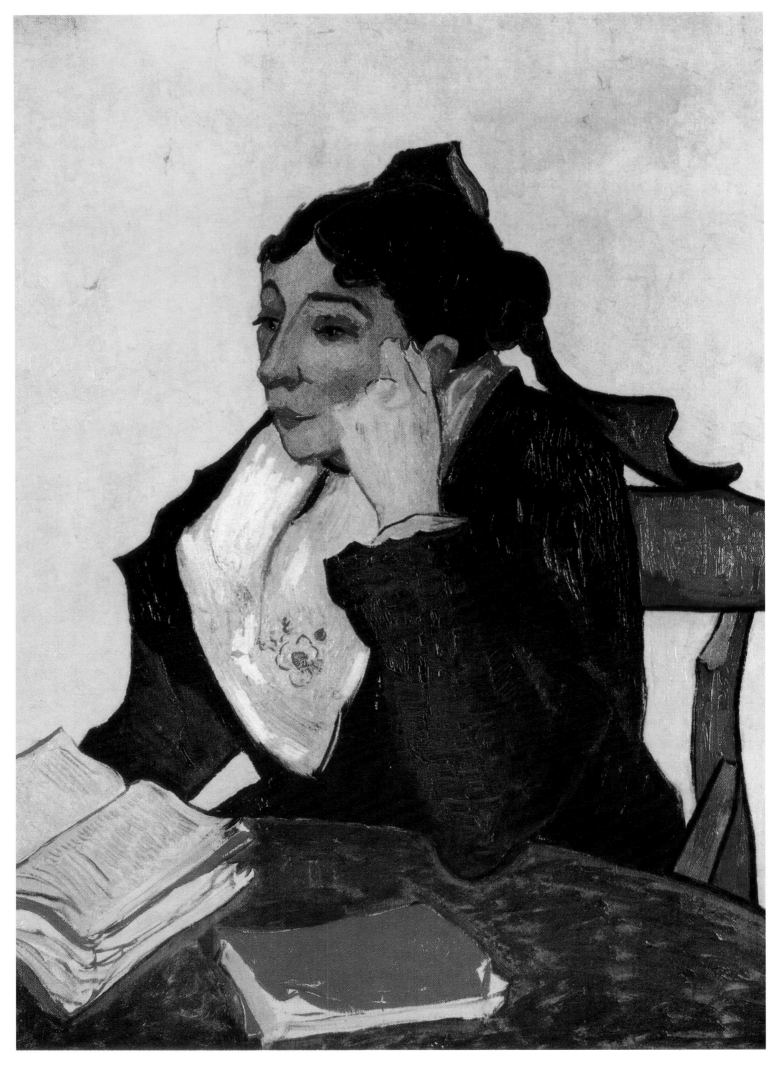

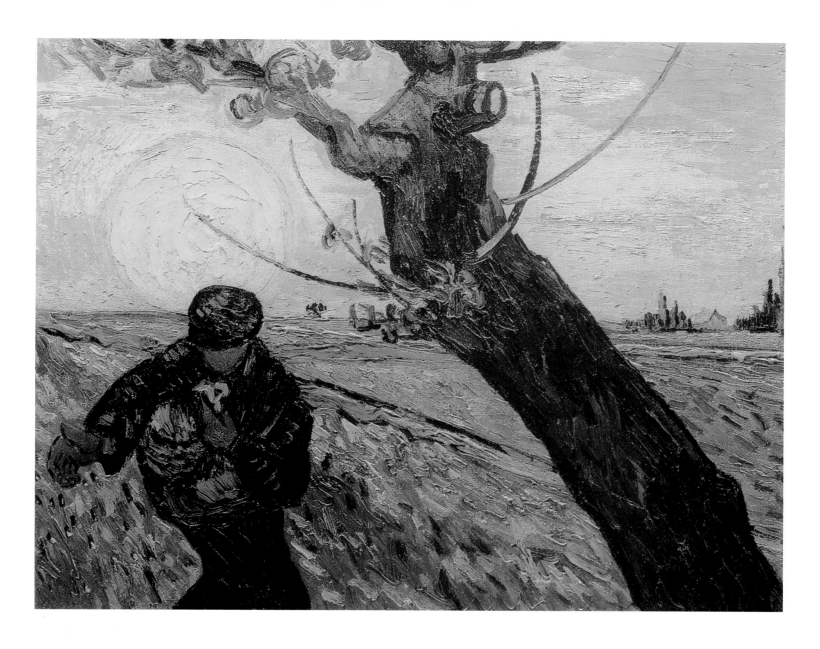

House, the *Self-portrait for my Friend Paul Gauguin*, *The Café by Night* and in October *Vincent's Room at Arles*. The very paintings that Gauguin dismissed as 'subdued, incomplete and monotonous' are today regarded as his greatest masterpieces.

With Gauguin at his side, van Gogh painted less and without the force he had discovered earlier that year. Discussions with his more confident colleague might have shaken his nerve. But as the year drew to a close, poor weather conditions had also made it impossible to work outside. Unlike Gauguin, van Gogh needed reality as a model. He was not able to separate his thoughts from his subjects. He strove for a synthesis of reflection and the immediate feeling he had about the things and people he painted. In his letters, he explains the meaning of certain motifs: The sunflower, which he called 'his flower', signifies gratitude. The sowing man, a subject he had borrowed from Millet, stands for the longing for the infinite. Van Gogh's aim was "to express the love of two lovers by a wedding of two complementary colours, their mingling and their opposition, the mysterious vibrations of kindred tones. To express the thought of a brow by the radiance of a light tone against a somber background. To express hope by some star, the eagerness of a soul by a sunset radiance. Certainly there is no delusive realism in that, but isn't it something that actually exists?"[82]

The love and hope he had introduced into his canvases while waiting for Gauguin were ultimately frustrated. Gauguin didn't share his views on art. That was painful

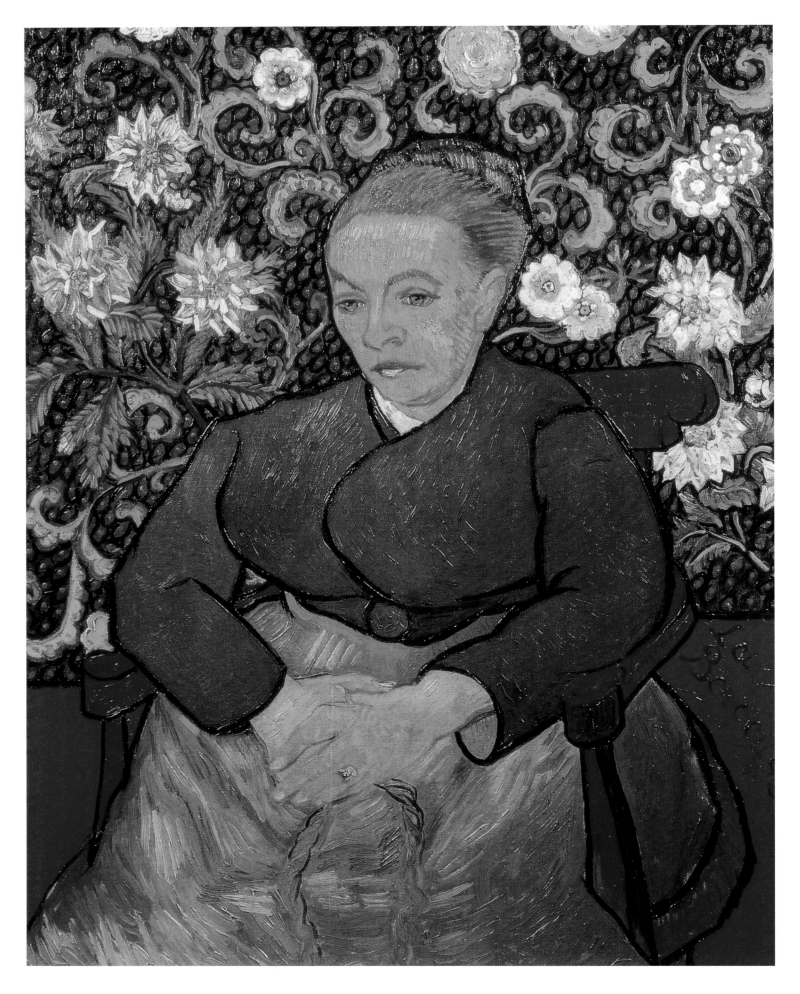

42. *Madam Roulin Rocking the Cradle*
(La Berceuse)
Arles: January 1889
Oil on canvas, 92 x 73 cm
Otterlo: Rijksmuseum Kröller-Müller.

enough, but van Gogh was even more hurt by the way his friend disparaged him. He had already had a similar experience with Anton van Rappard, whom he had met in Brussels. Both artists exchanged letters during the years 1881 and 1885. When Rappard criticized his *Potato Eaters*, van Gogh was not wounded by the remarks themselves – he admitted that Rappard was right in some details – but by their tone: "Now you are speaking to me and behaving to me exactly as a certain abominably arrogant Rappard studying at a certain academy did at one time."[83]

In December, 1888, Gauguin wrote to Emile Bernard: "I'm in Arles, completely out of my element because I find everything, the landscape and the people, so petty and shabby. In general, Vincent and I rarely agree on anything, especially on painting. He admires Daumier, Daubigny, Ziem, and the great Rousseau, none of whom I can stand. And, on the other hand, he detests Ingres, Raphaël, Degas, all of whom I admire […] He loves my paintings, but when I'm doing them, he always finds that I've done this or that wrong. He is a romantic and I am more inclined to a primitive state. Regarding colour, he sees the possibilities of impasto as in Monticelli, whereas I hate the mess of execution, etc…"[84] At about the same time, Gauguin announced to Theo that he wanted to return to Paris: "Vincent and I absolutely cannot live side-by-side any longer without friction because of the incompatibility of our temperaments and because he and I both need tranquillity for our work."[85]

Nobody knows, finally, what happened in the last days before Christmas. In his biography of van Gogh, Matthias Arnold points out that many letters of this period are missing. He doubts that these documents – which might contain information about van Gogh's first crisis and, later, about his suicide – could have been lost while all the other letters were collected by Theo with such care. Whatever the circumstances of their disappearance, however, the bulk of the available information about the events of December 23rd, 1888 comes from a less than objective witness, Paul Gauguin: "During the latter part of my stay, Vincent became excessively brusque and noisy, then silent. Several nights I surprised Vincent who, having risen, was standing over my bed. To what can I attribute my awakening just at that moment? Invariably it sufficed for me to say to him very gravely: 'What's the matter, Vincent?' for him to go back to bed without a word and to fall into a deep sleep.

I came upon the idea of doing his portrait while he painted the still life that he so loved – some sunflowers. And, the portrait finished, he said to me: "That's me all right, but me gone mad." The same evening we went to the café: he took a light absinthe. Suddenly he threw the glass and its contents at my head. I avoided the blow and, taking him bodily in my arms, left the café and crossed the Place Victor-Hugo; some minutes later, Vincent found himself in bed, where he fell asleep in a few seconds, not to awaken again until morning. When he awoke, he said to me very calmly: "My dear Gauguin, I have a very vague memory of having "offended you last evening." – I answered: "I gladly forgive you with all my heart, but yesterday's scene could happen again, and if I were struck I might lose control of myself and strangle you. So permit me to write to your brother and announce my return." My God, what a day!

When evening had arrived and I had quickly eaten my dinner, I felt the need to go out alone and take in the air, scented with flowering laurels. I had already almost crossed the Place Victor Hugo, when I heard behind me a familiar short footstep,

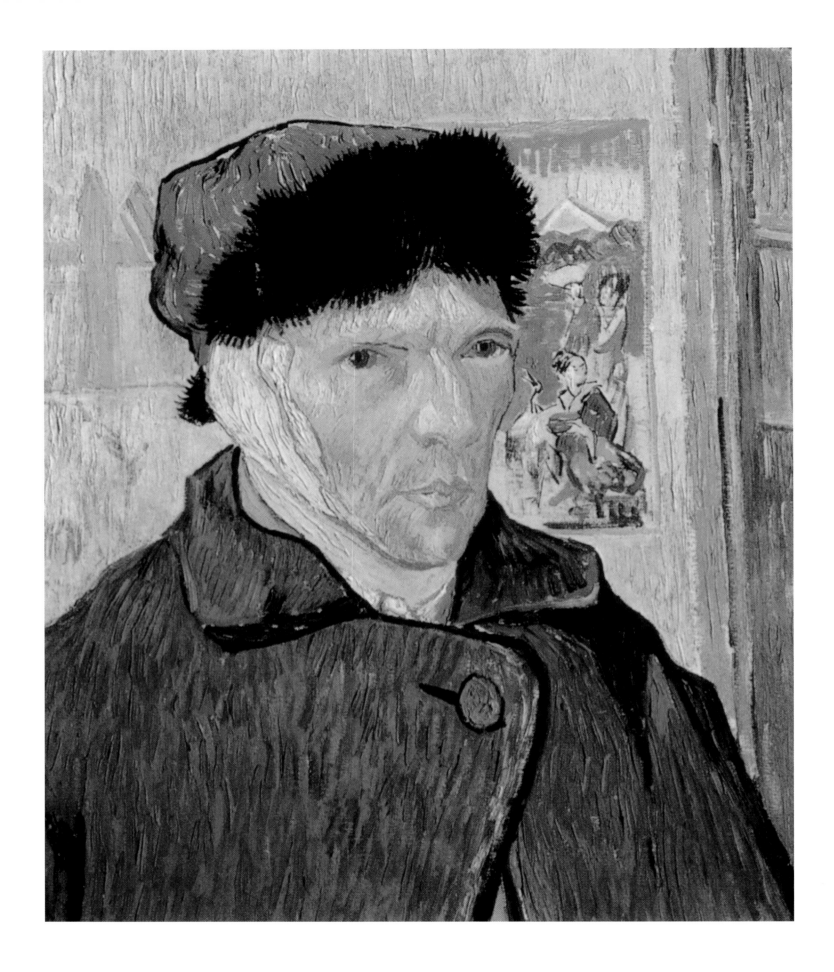

rapid and irregular. I turned just at the moment when Vincent rushed towards me, an open razor in his hand. My look at that moment must have been powerful indeed, for he stopped, and lowering his head, took off running in the direction of the house. Was I lax in that moment, and oughtn't I to have disarmed him and sought to calm him down? Often I have questioned my conscience, but I do not reproach myself at all. Let him who will cast the stone at me.

43. *Self-portrait with Bandaged Ear*
Arles: January 1889
Oil on canvas, 60 x 49 cm
London: Courtauld Institute.

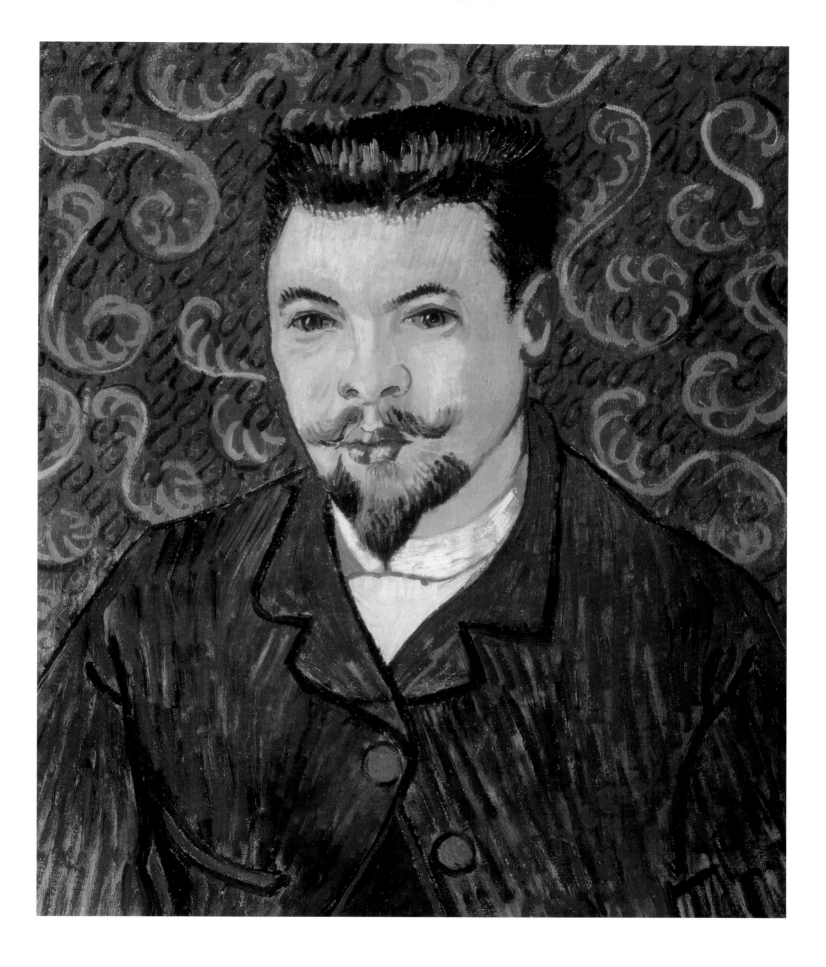

44. *Portrait of Doctor Félix Rey*
Arles: January 1889
Oil on canvas, 64 x 53 cm
Moscow: Pouchkin Museum.

Only a short stretch, and I was in a good hotel in Arles, where, after asking the time, I took a room and went to bed. Very agitated I could not fall asleep until about three in the morning, and I awoke rather late, about seven-thirty. Upon arriving at the square, I saw a large crowd assembled. Near our house, there were some gendarmes and a little gentleman in a bowler hat, who was the police commissioner. Here is what had happened. Van Gogh returned to the house and, immediately, cut off his

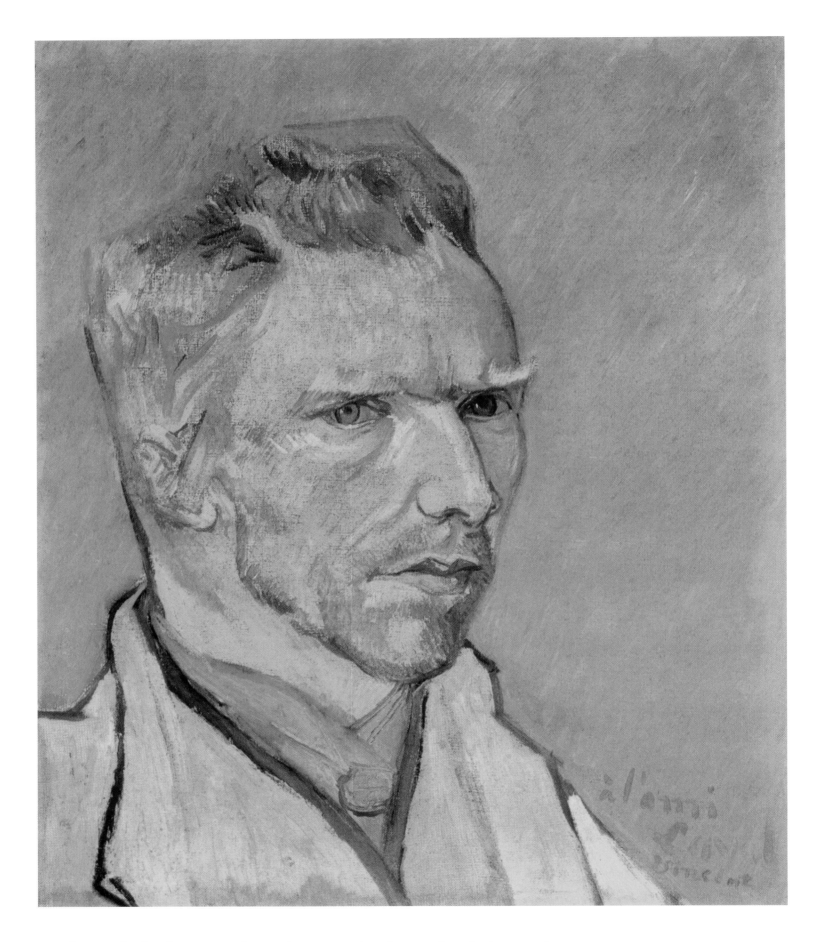

ear close to the head. He must have taken some time in stopping the heamorrhage, for the next day there were many wet towels scattered about on the floor tiles of two rooms downstairs. When he was in good enough condition to go out, his head covered up by a Basque beret pulled all the way down, he went straight to a house where, for want of a fellow-countrywoman, one can find a chance acquaintance, and gave the 'sentry' his ear, carefully washed and enclosed in an envelope. "Here," he said, "a remembrance of me." Then he fled and returned home, where he went to

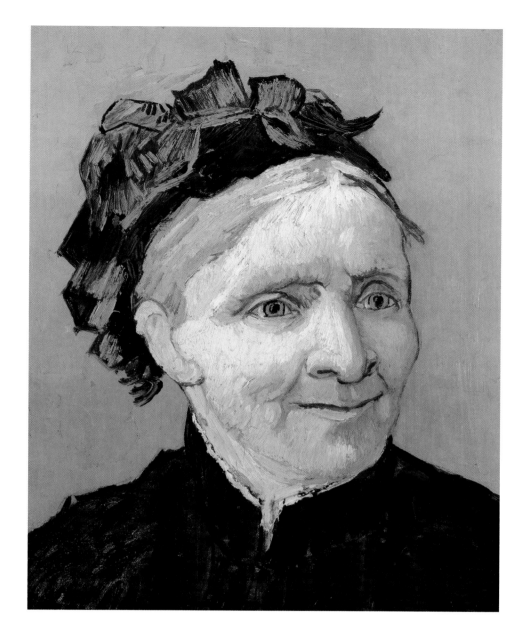

bed and slept. He took the trouble, however, to close the shutters and to set a lighted lamp on a table near the window. Ten minutes later, the whole street given over to the *filles de joie* was in commotion and chattering about the event.

I had not the slightest inkling of all this when I appeared on the threshold of our house and the gentleman with the bowler hat said to me point-blank, in a more than severe tone: "What have you done, sir, to your comrade?" – "I don't know." – "Oh, yes, …you know very well, …he is dead." I would not wish anyone such a moment, and it took me a few long minutes to be able to think clearly and to repress the beating of my heart.

Anger, indignation, and grief as well, and the shame of all those gazes that were tearing my entire being to pieces suffocated me, and I stuttered when I said, "Alright, sir, let us go upstairs, and we can explain ourselves up there." In the bed, Vincent lay completely enveloped in the sheets, curled up like a gun hammer; he appeared lifeless. Gently, very gently, I touched the body, whose warmth surely announced life. For me it was as if I had regained all my powers of thought and energy. Almost in a whisper, I said to the commissioner of police: "Be so kind, sir, as to awaken this man with great care and, if he asks for me, tell him that I have left for Paris. The sight of me could be fatal to him."[86] Compared with the reports of other witnesses, such as that of the policeman Alphonse Robert, Gauguin's story is incorrect on some minor points. Van Gogh did not cut off his whole ear, but only a piece above the lobe. He gave this 'present' to the prostitute Rachel, and not to the 'sentry.'

Gauguin's account offers little insight into the motives behind his host's act of self-mutilation. Perhaps van Gogh feared that his friend would make good his threat to leave him. Gauguin's departure would have been doubly traumatizing, for it also meant the end of the artists' house. Another reason for his distress might have been Theo's engagement with Johanna Bonger. Arnold tells us that van Gogh was informed of his brother's plans to marry on December 23rd. This change would surely have had an impact on his life. Perhaps Theo, faced with the expense of setting up his new household, would no longer be able to offer the support – financial or intellectual – on which his brother had come to depend. Gauguin informed Theo about Vincent's crisis, and the younger van Gogh arrived in Arles on December 25th, but stayed for only a very short time. In all likelihood, he returned to Paris the same day, accompanied by Gauguin.

45. *Self-Portrait*
 Arles: November–December 1888
 Oil on canvas, 46 x 38 cm
 New York: The Metropolitan Museum of Art.

46. *Portrait of the Artist's Mother*
 Arles: October 1888
 Oil on canvas, 40.5 x 32.5 cm
 Pasadena, California: Norton Simon Museum of Art.

47. *Langlois Bridge at Arles*
 Arles: April 1888
 Oil on canvas, 60 x 65 cm
 Paris: Private collection.

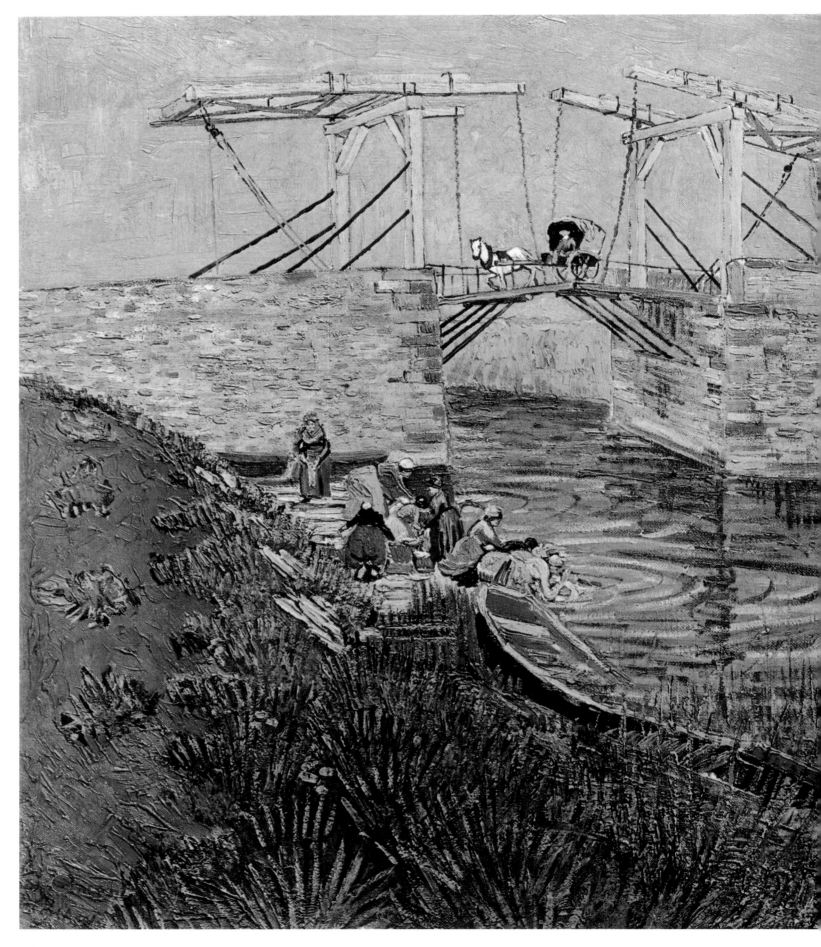

"I was a fool and everything I did was wrong"

On January 7th, fourteen days after his self-mutilation, van Gogh left the hospital. Joseph Roulin and his wife began to look after him. He wrote to Theo: "I am going to set to work again tomorrow. I shall begin by doing one or two still lifes so as to get back into the habit of painting."[87] In the first letters after his return into the Yellow House, van Gogh makes no mention of his madness: "I hope I have just had simply an artist's fit, and then a lot of fever after very considerable loss of blood, as an artery was severed; but my appetite came back at once, my digestion is all right and my blood recovers from day to day, and in the same way serenity returns to my brain day by day. So please quite deliberately forget your unhappy journey and my illness."[88]

Writing and painting, van Gogh hoped to recover and to forget. He painted a portrait of his physician, Dr. Rey. Still, he clung to his belief in the future of the artists' house. He wrote to Gauguin, who answered immediately. The first page of this letter is missing; in the second part, Gauguin advises his friend how to restore a painting: "The 'vintage' is totally flaked, because the White peeled off. I have glued everything with a method recommended. I tell you about it, because I think that it is easy to do and will help you to retouch your pictures."[89] As if nothing had happened, Gauguin resumed his habitual role as the teacher.

The letter van Gogh sent one week later to Theo can be read like an indirect answer to Gauguin: "Look here, I won't say more about the absurdity of this measure. Suppose that I was as wild as anything, then why wasn't our illustrious partner more collected? [...] How can Gauguin pretend that he was afraid of upsetting me by his presence when he can hardly deny that he knew I kept asking for him continually, [...] One good quality he has is the marvelous way he can apportion expenses from day to day. While I am often absent-minded, preoccupied with aiming at the goal,

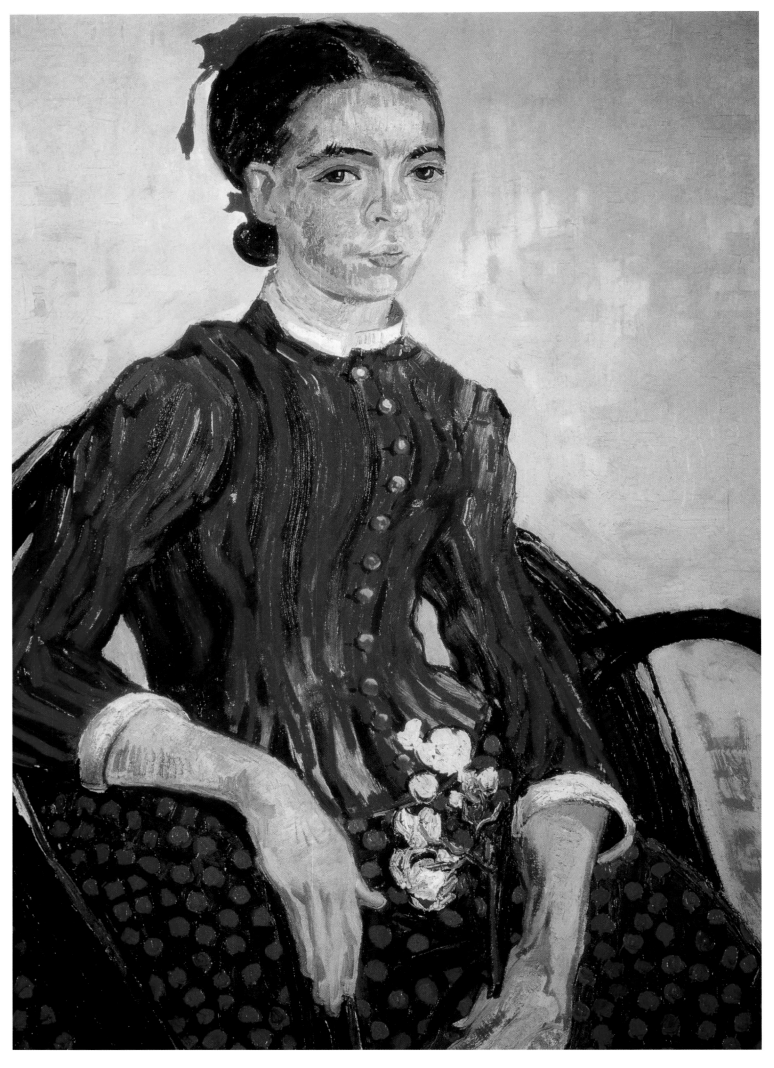

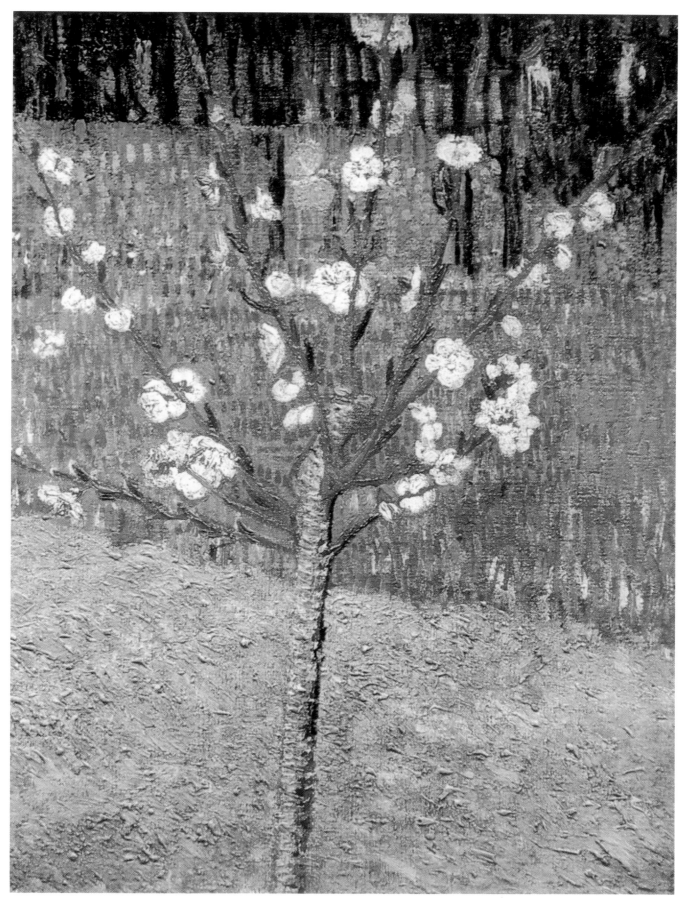

48. *La Mousmé*
 Arles: July 1888
 Oil on canvas, 74 x 60 cm
 Washington: National Gallery of Art.

49. *Almond Tree in Blossom*
 Arles: April 1888
 Oil on canvas, 48.5 x 36 cm
 Amsterdam: Rijksmuseum Vincent
 van Gogh, Vincent van Gogh
 Foundation.

he has far more money sense for each separate day than I have. But his weakness is that by a sudden freak or animal impulse he upsets everything he has arranged. Now do you stay at your post once you have taken it, or do you desert it? I do not judge anyone in this, hoping not to be condemned myself in cases when my strength

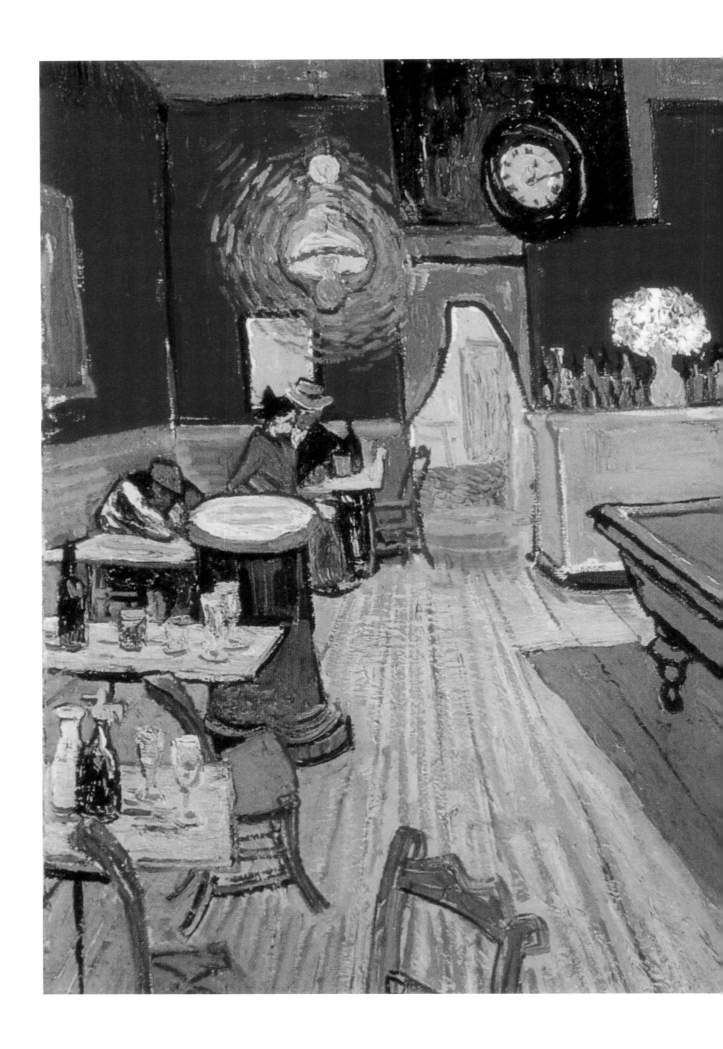

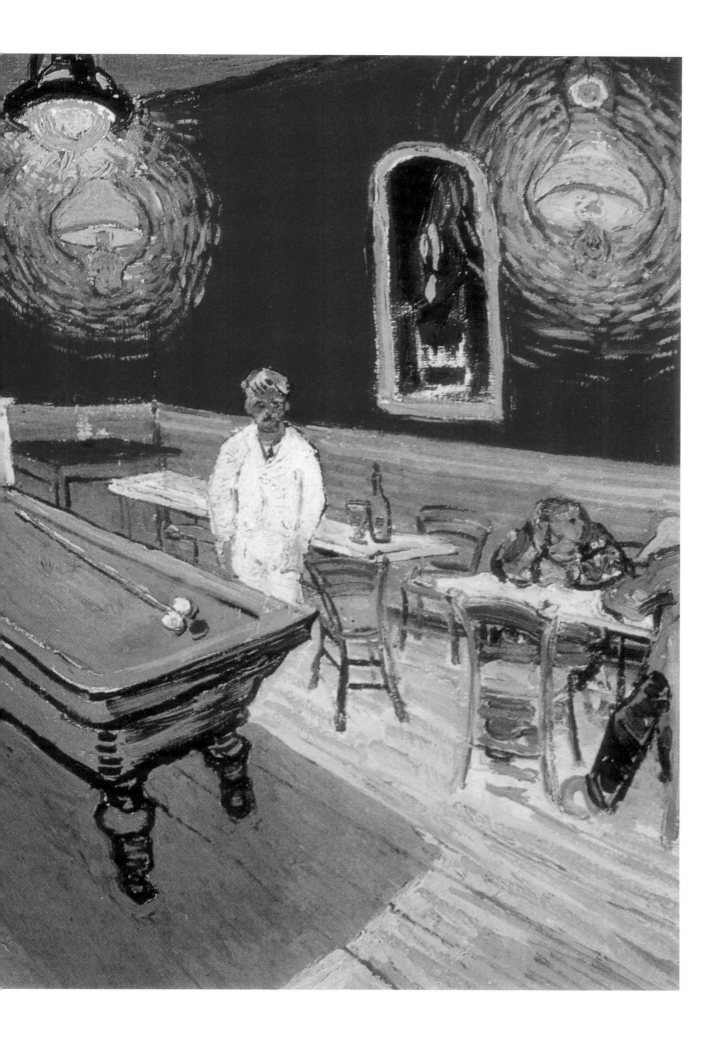

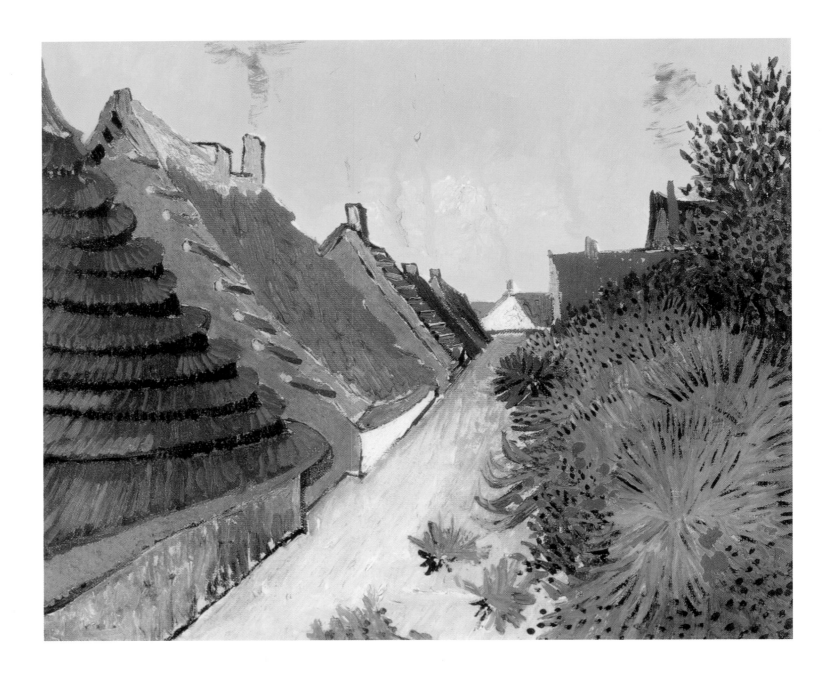

might fail me, but if Gauguin has so much real virtue, and such capacity, how is he going to employ himself?"[90]

In spite of his deep disappointment over Gauguin's flight from Arles, van Gogh wrote to him to propose that they again try to establish an artists' community, this time in Brittany. In his reply, Gauguin evaded the suggestion. Van Gogh sought to maintain a positive outlook, but the hopefulness he felt when he was waiting for Gauguin in Arles continued to elude him. His world was in turmoil; nothing was clear.

During this period, van Gogh worked on a painting he had already begun in December: a portrait of Augustine Roulin, the wife of the postman, that he calls *La Berceuse*. He describes the picture to Theo: "I think I have already told you that [...] I have a canvas of *La Berceuse* the very one I was working on when my illness interrupted me [...] I have just said to Gauguin about this picture that when he and I were talking about the fishermen of Iceland and of their mournful isolation [...] the idea came to me to paint a picture in such a way that sailors, who are at once children and martyrs, seeing it in the cabin of their Icelandic fishing boat, would feel the old

50. *Café at Night*
 Arles: September 1888
 Watercolour, 44 x 63 cm
 Berne: Private Collection.

51. *Street in Saintes-Maries*
 Arles: early June 1888
 Oil on canvas, 38 x 46.1 cm
 Private Collection (sold, Christie's, New York, 19. 05. 1981)

52. *Portrait of Patience Escalier*
 Arles: August 1888
 Oil on canvas, 69 x 56 cm
 Collection Stavros S. Niarchos.

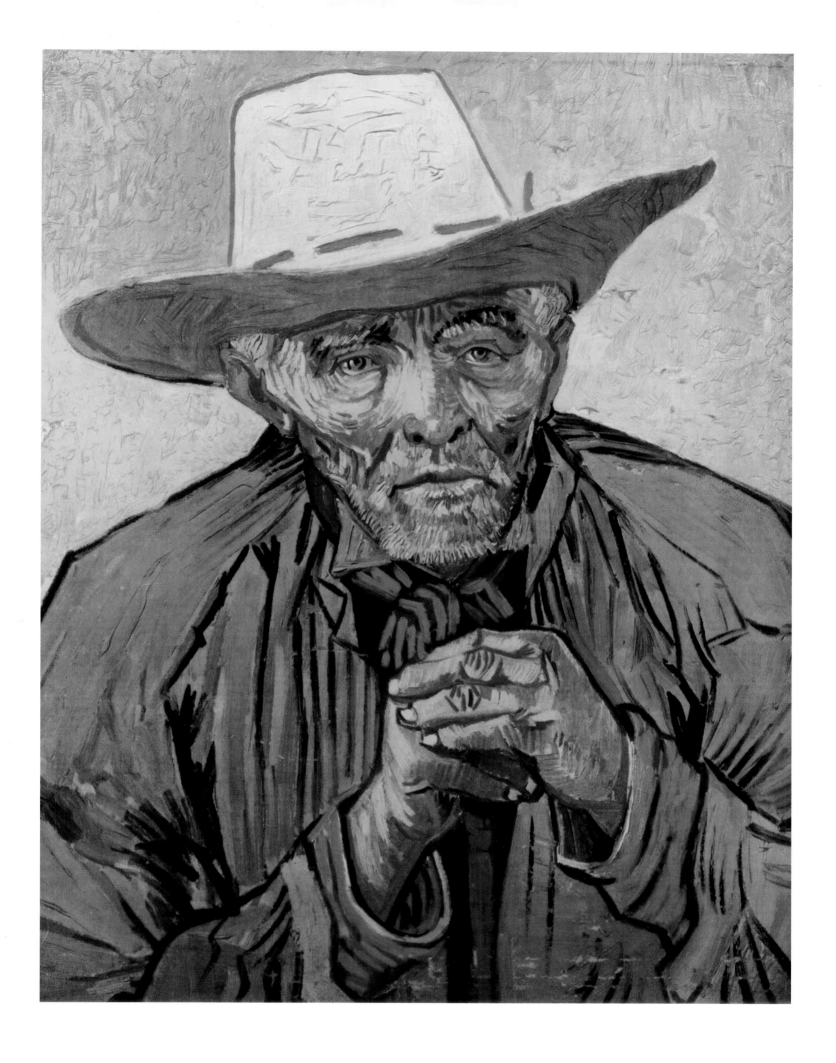

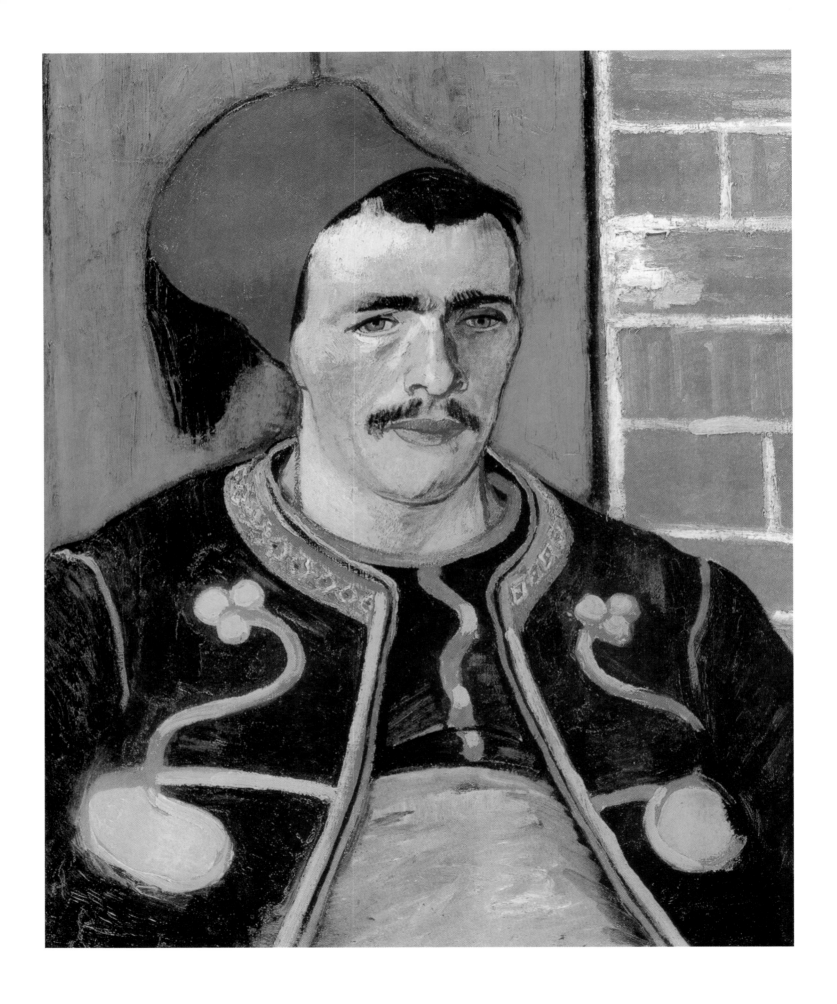

sense of being rocked come over them and remember their own lullabies."[91] The picture painted to comfort others became a consolation for himself. He wrote to Gauguin: "My dear friend, to achieve in painting what the music of Berlioz and Wagner has already done […] an art that offers consolation for the broken-hearted!"[92]

53. *The Zouave* (half-length)
Arles: June 1888
Oil on canvas, 65 x 54 cm
Amsterdam: Rijksmuseum
Vincent van Gogh,
Foundation Vincent van Gogh.

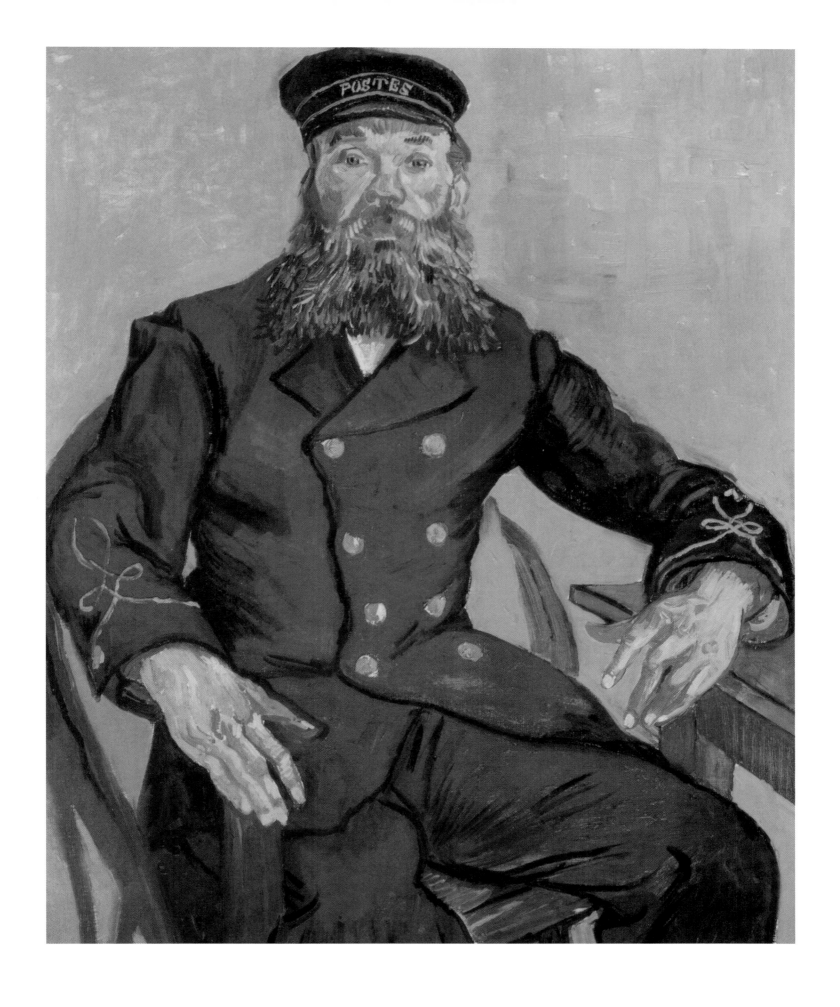

At the end of January, Joseph Roulin had to move to Marseille. On February 3rd, van Gogh informed his brother: "I am feeling very well, and I shall do everything the doctor says, but [...] When I came out of the hospital with kind old Roulin, who had come to get me, I thought that there had been nothing wrong with me,

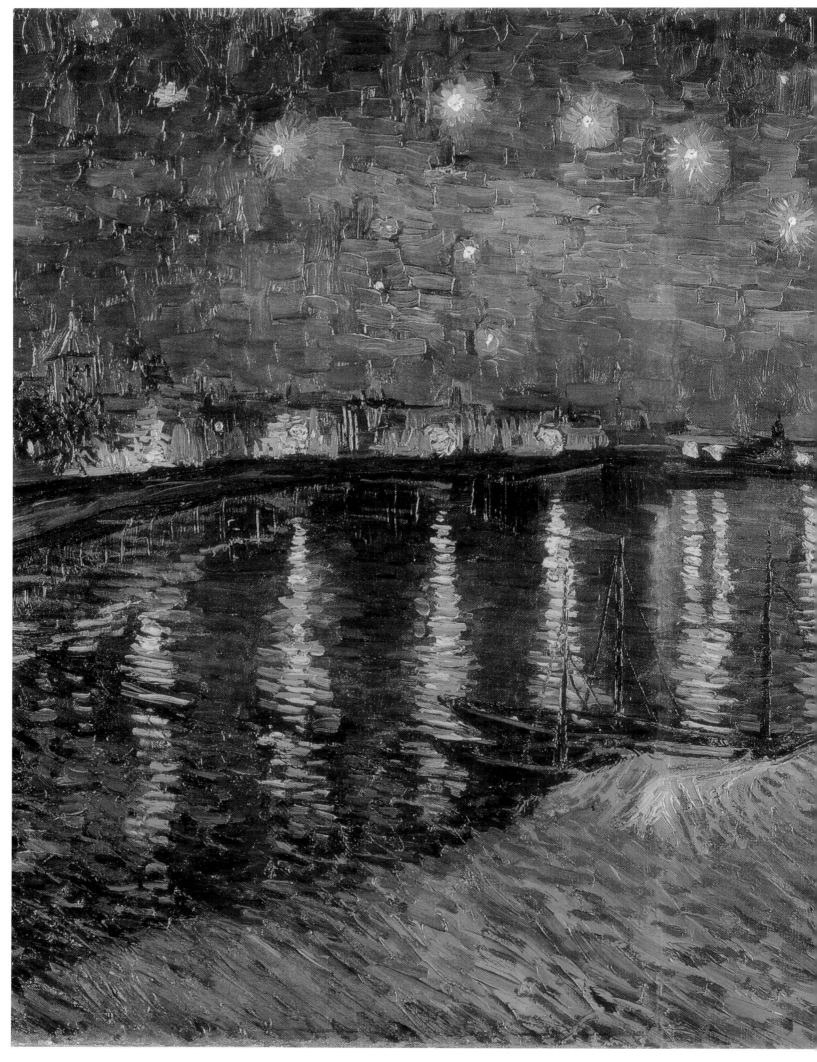

55. *Starry Night over the Rhone*
Arles: September 1888
Oil on canvas, 72.5 x 92 cm
Paris: Musée d'Orsay.

but afterward I felt that I had been ill."[93] For the first time van Gogh spoke about the possibility that he could again have an attack and he promised his doctor in Arles, Dr. Rey, "that at the slightest grave symptom I would come back and put myself under the treatment of the mental specialists in Aix, or under his."[94] A few days later, van Gogh was back in the hospital, but not of his own free will. On February 7th, Reverend Salles, the Protestant clergyman, informed Theo: "Your brother […] had again shown symptoms of mental derangement. For three days, he believes he sees everywhere people who poison and people who are poisoned. The charwoman […] in view of his abnormal state, took it for her duty to report the affair; the neighbours informed the superintendent. He gave the order to watch your brother and admit him into the hospital […] What shall be done now?"[95]

In the following weeks, Salles would pose this question several times – but Theo's instructions remained vague. Van Gogh returned to the Yellow House, but only for a short while – "the neighbours, who had grown afraid of him, petitioned the mayor, complaining that it was dangerous to leave him at liberty."[96]

56. *The Green Vineyard*
Arles: September 1888
Oil on canvas, 72 x 92 cm
Otterlo: Rijksmuseum Kröller-Müller.

57. *Portrait of a Patient in Saint-Paul Hospital*
Saint-Rémy: October 1889
Oil on canvas, 32.5 x 23.5 cm
Amsterdam: Rijksmuseum Vincent van Gogh, Vincent van Gogh Foundation.

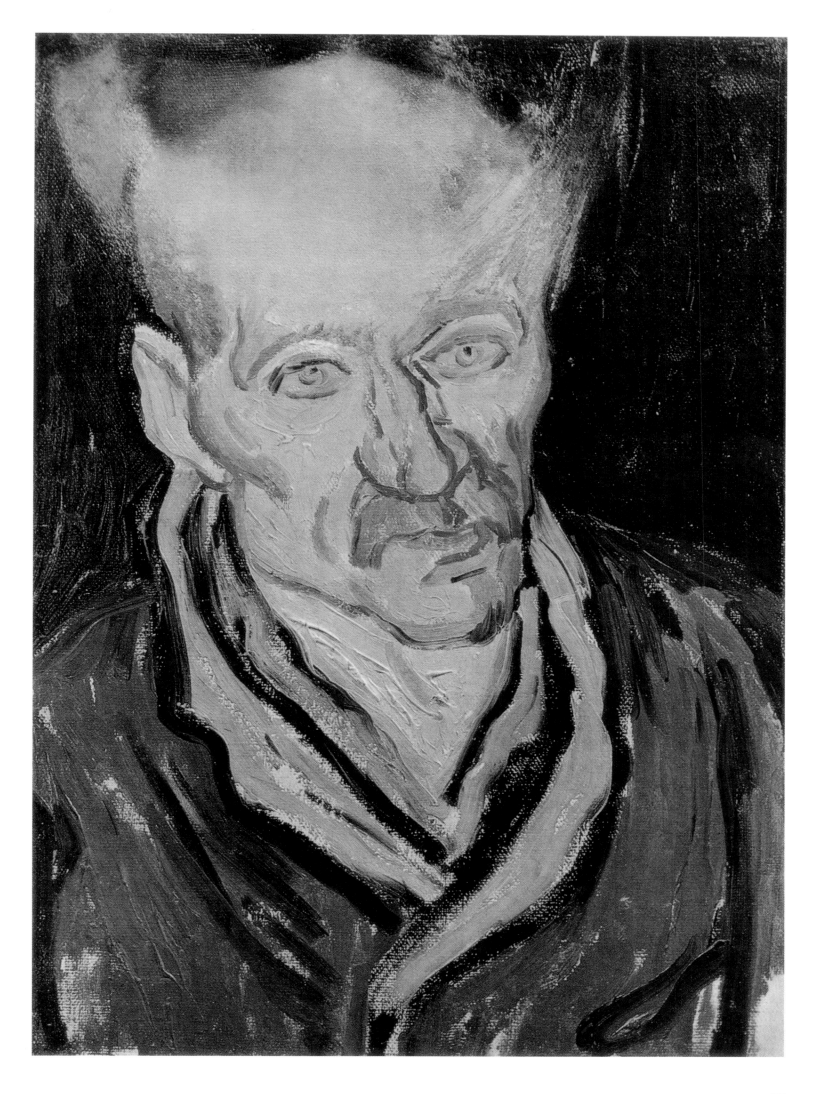

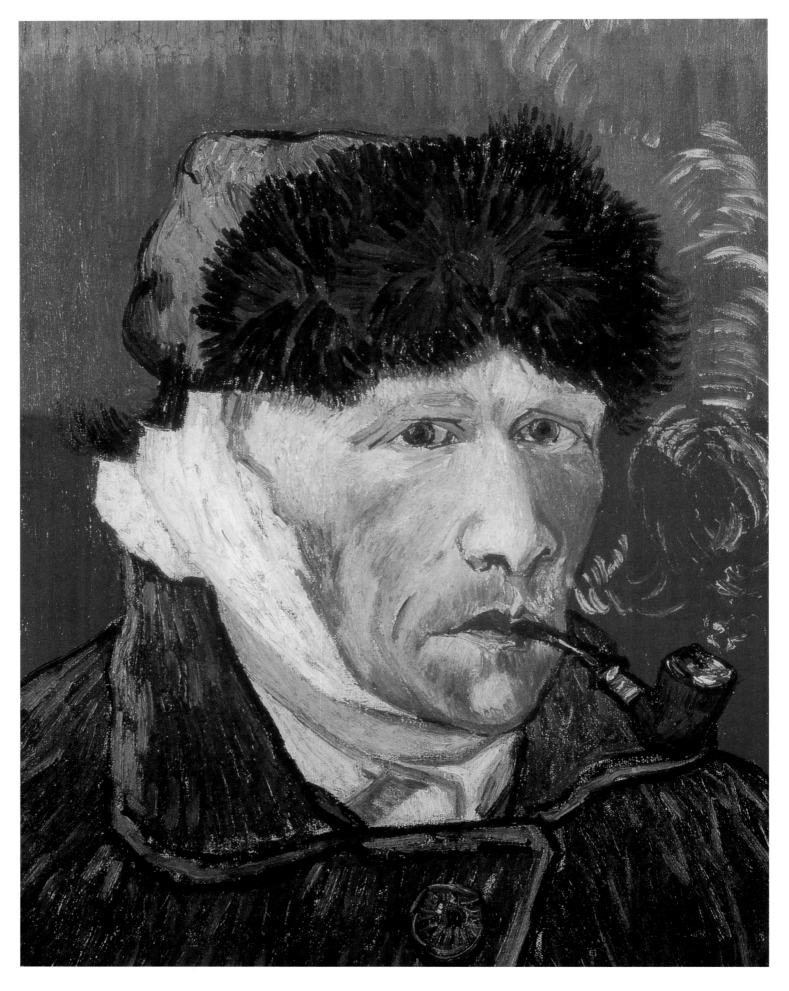

58. *Self Portrait with Bandaged
Ear and Pipe*
Arles: January 1889
Oil on canvas, 90 x 49 cm
London: Courtauld Institute.

59. *Les Alyscamps*
 Arles: late October 1888
 Oil on canvas, 93 x 72 cm
 Lausanne: Collection
 Basil P. and Elise Goulandris.

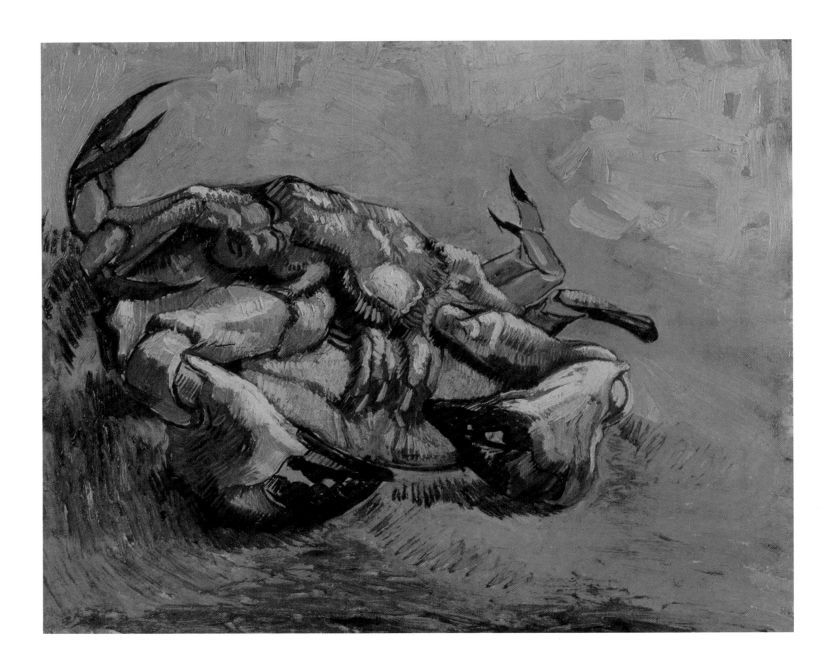

On March 19th, van Gogh described the events: "I write to you in full possession of my faculties and not as a madman, but as the brother you know. This is the truth. A certain number of people here (there were more than 80 signatures) addressed a petition to the Mayor [...], describing me as a man not fit to be at liberty, or something like that [...] Anyhow, here I am, shut up in a cell all the livelong day, under lock and key and with keepers, without my guilt being or even open to proof."[97]

Van Gogh saw himself as wrongly convicted, not ill. On several previous occasions he had learned that deviation from social conventions is often punished with exclusion. After van Gogh's failure as a preacher, his father had threatened to admit him to the mental hospital in Gheel.[98] Tersteel, the manager of Goupil's gallery in The Hague considered him to be of "unsound mind and temperament"[99] when he learned that the painter was living with a prostitute. During one visit he gave van Gogh a homily: "He was hasty in everything; he was sure of just one thing: I was a fool and everything I did was wrong."[100]

In his letters, van Gogh uses madness and illness quite often as a metaphor for the state of society: "Then the doctors will tell us that not only Moses, Mahomet, Christ,

60. *Crab on its Back*
Arles: January 1889
Oil on canvas, 38 x 46.5 cm
Amsterdam: Rijksmuseum
Vincent van Gogh,
Foundation Vincent van Gogh.

61. *Poppies and Butterflies*
Saint-Rémy: April–May 1890
Oil on canvas, 34.5 x 25.5 cm
Amsterdam: Rijksmuseum
Vincent van Gogh,
Foundation Vincent van Gogh.

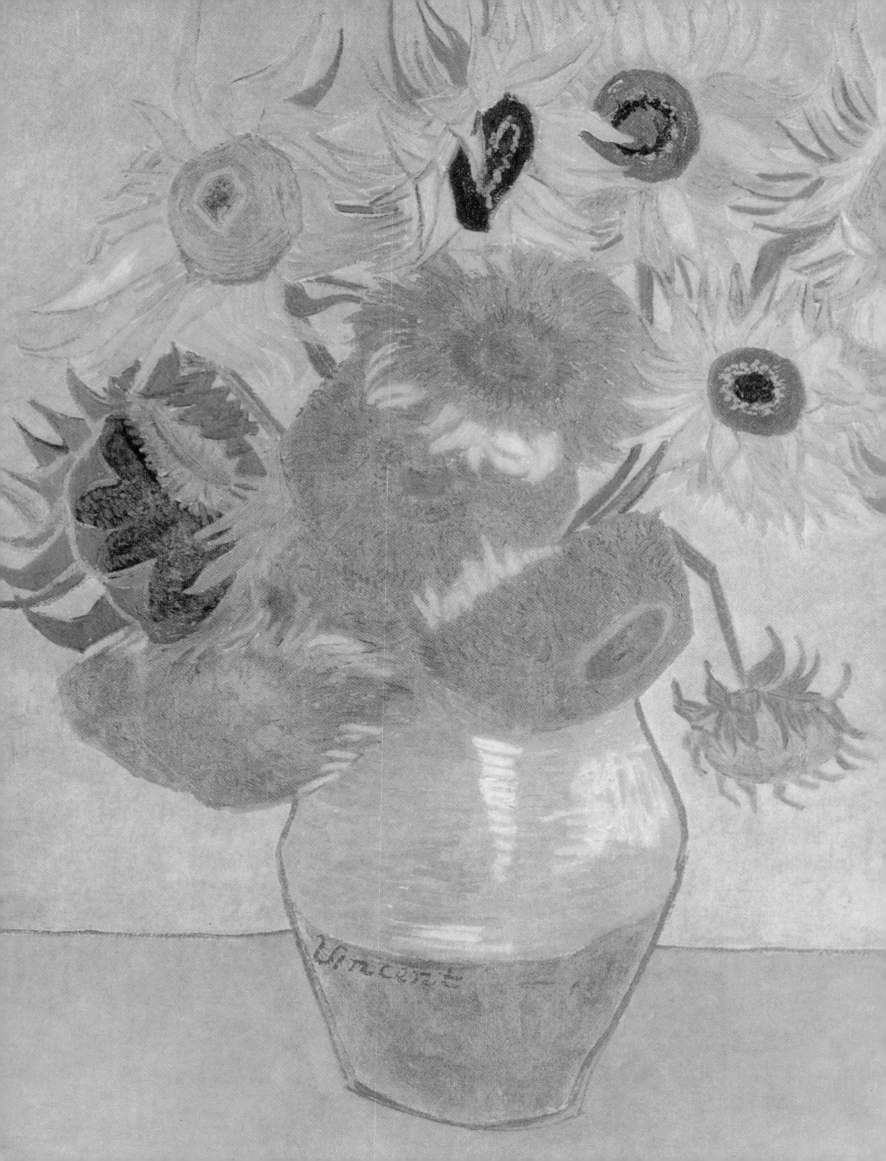

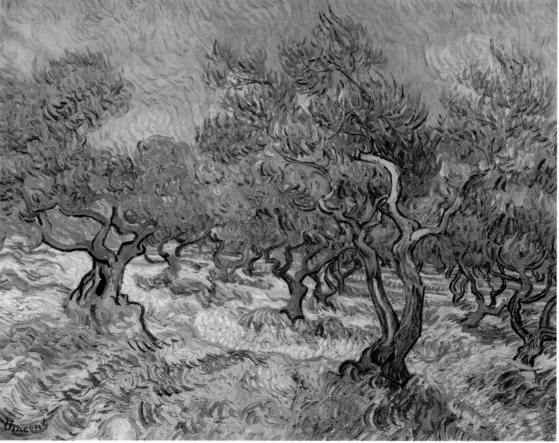

62. *Still-Life: Vase with Twelve Sunflowers*
Arles: January 1889
Oil on canvas, 92 x 72.5 cm
Philadelphia: The Philadelphia Museum of Art.

63. *The Poet's Garden*
Arles: September 1888
Oil on canvas, 73 x 92 cm
Chicago: The Art Institute of Chicago.

64. *Olive Grove*
Saint-Rémy: mid-June 1889
Oil on canvas, 72 x 92 cm
Otterlo: Rijksmuseum Kröller-Müller.

Luther, Bunyan and others were mad, but Frans Hals, Rembrandt, Delacroix, too, and also all the dear narrow-minded old women like our mother. Ah – that's a serious matter – one might ask these doctors: Where then are the sane people? Are they the brothel bouncers who are always right? Probably. Then what to choose? Fortunately there is no choice."[101]

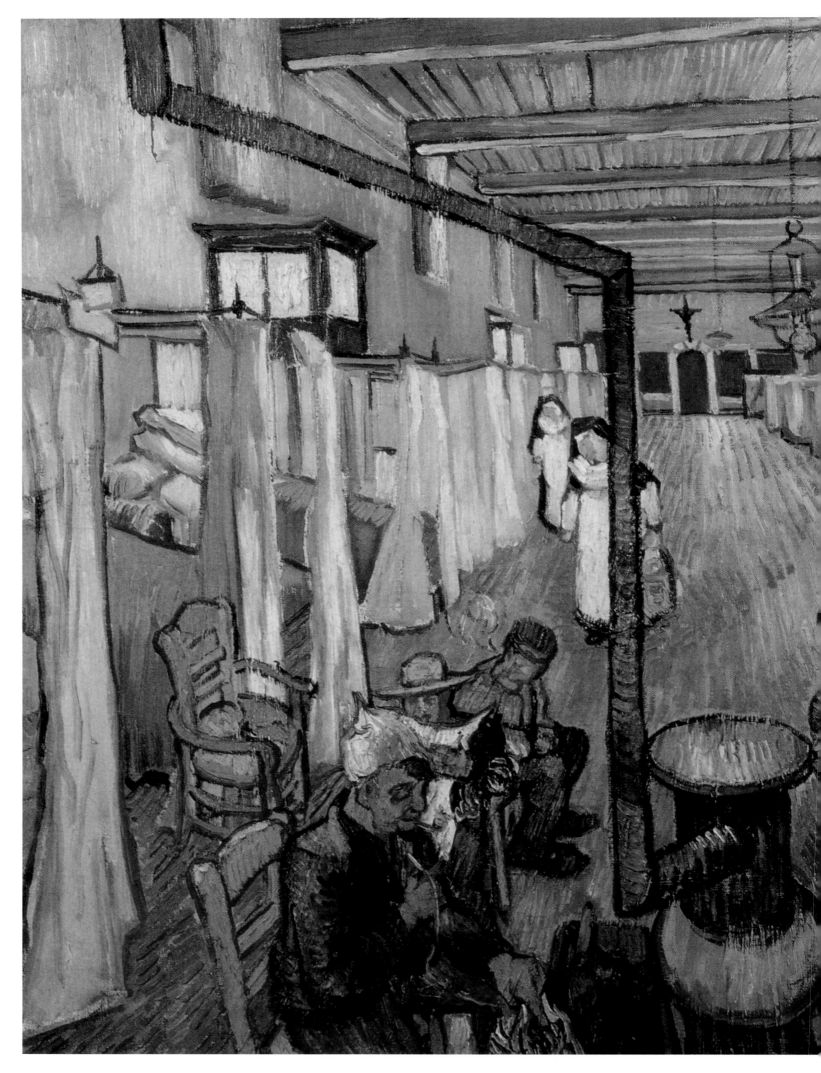

65. *Ward in the Hospital in Arles*
April 1889
Oil on canvas, 74 x 92 cm
Winterthur, Collection Oskar
Reinhart.

Since he had no choice, van Gogh took the place assigned to him by the citizens of Arles: "Am I to suffer imprisonment or the madhouse? Why not? Didn't Rochefort and Hugo, Quinet and others give an eternal example by submitting to exile, and the first even to a convict prison? But all I want to say is that this is a thing above the mere question of illness and health. [...] And that is what the first and last cause of my aberration was. Do you know those words of a Dutch poet – 'Ik ben aan d'aard gehecht met meer dan aardse banden' [I am attached to the earth by more than earthly ties]. That is what I have experienced in the midst of much suffering – above all – in my so-called mental illness."[102]

Van Gogh understood, from the beginning, the social side of his 'madness.' In time, he learned to accept that he was ill and that he needed help. But he didn't want to be punished: "If – say – I should become definitely insane – I certainly say that this is impossible – in any case I must be treated differently, and given fresh air, and my work, etc."[103]

66. *Pollard Willows*
Arles: April 1889
Oil on canvas, 55 x 65 cm
Collection Stavros S. Niarchos.

The mental hospital in Saint-Rémy, suggested by Pastor Salles, seemed to offer this treatment. Van Gogh also had other reasons to consent to going there: he had

67. *Chestnut Tree in Blossom*
Auvers-sur-Oise: May 1890
Oil on canvas, 70 x 58 cm
South America: Pivate Collection.

nowhere else to go. The owner of the Yellow House had cut off their contract; Gauguin refused to join him in Brittany; and his place in Theo's flat was now occupied by the bride. He was afraid that he would again have to live in hotels: "I must have my own fixed niche."[104] The mental hospital became a shelter, a substitute for a home, a nest.

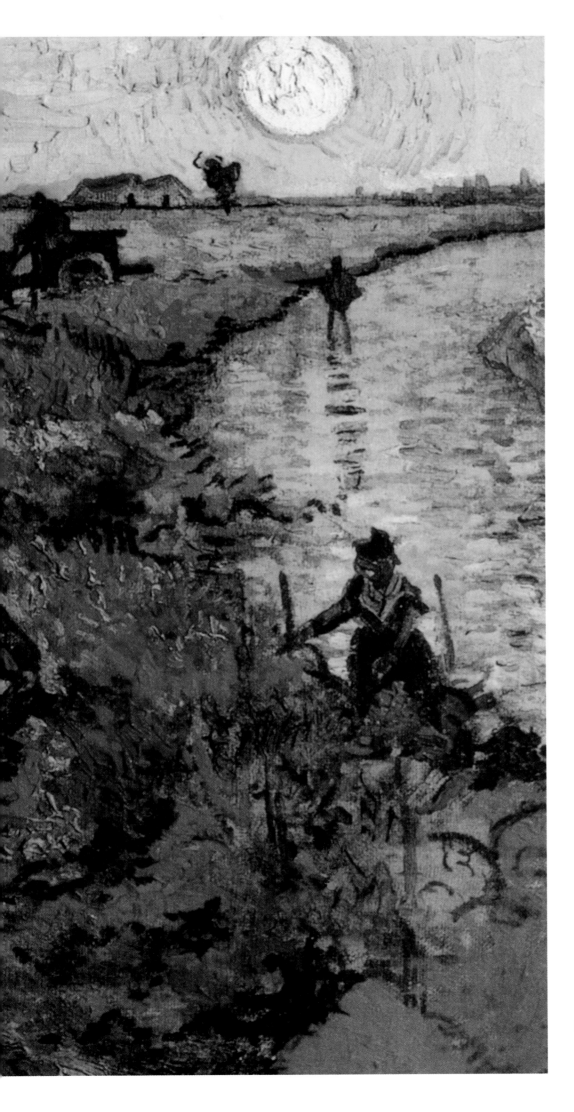

68. *The Red Vineyard*
Arles: November 1888
Oil on canvas, 75 x 93 cm
Moscow: Pouchkin Museum.

Saint-Rémy: 1889-1890

"What is the good of getting better?"

On May 8th, 1889, Pastor Salles took van Gogh to the mental hospital in Saint-Rémy, thirty kilometers from Arles. One week later, van Gogh wrote to Theo: "I wanted to tell you that I think I have done well to come here; first of all, by seeing the reality of the life of the various madmen and lunatics in this menagerie, I am losing the vague dread, the fear of the thing. And little by little I can come to look upon madness as a disease like any other. Then the change of surroundings does me good, I think. As far as I can make out, the doctor here is inclined to consider that I have had some sort of epileptic attack."[105]

The vague dread, or 'nameless fear' – an expression used by van Gogh – disappeared as soon as the illness had a name: "I really think that once you know what it is, once you are conscious of your condition and of being subject to attacks, then you can do something yourself to prevent your being taken unawares by the suffering or the terror."[106]

Van Gogh himself led Dr. Rey to believe that there was a history of epileptic attacks in his family. The doctor in Saint-Rémy accepted this diagnosis of his new patient without question. More recently, however, scholars have found no indication that any of van Gogh's relatives were, in fact, epileptic.

That the diagnosis was false finally did not matter very much: the treatment at Saint-Rémy was the same for all patients. They were bathed regularly; otherwise they were left on their own: "As these poor souls do absolutely nothing (not a book, nothing to distract them but a game of bowls and a game of checkers) they have no other daily distraction than to stuff themselves with chickpeas, beans, lentils, and other groceries and merchandise from the colonies in fixed quantities and at regular hours."[107]

69. *Cypresses with Two Female Figures*
Saint-Rémy: June 1889
Oil on canvas, 92 x 73 cm
Otterlo: Rijksmuseum Kröller-Müller.

70. *Landscape of Auvers in the Rain*
Auvers-sur-Oise: July 1890
Oil on canvas, 50 x 100 cm
Cardiff: National Museum of Wales.

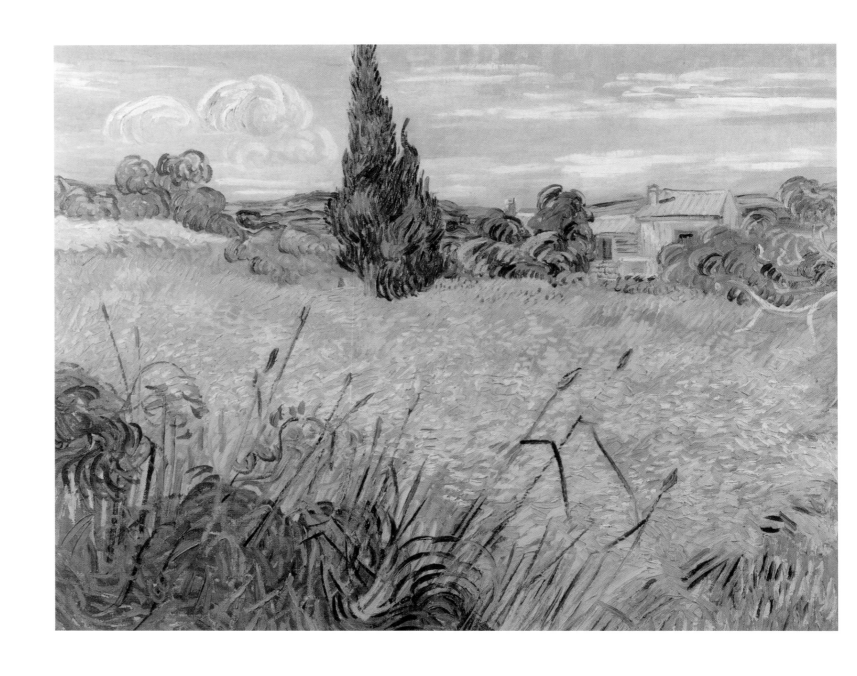

71. *Green Wheat Field with Cypress*
Saint-Rémy: mid-June 1889
Oil on canvas, 73.5 x 92.5 cm
Prague: Narodni Gallery.

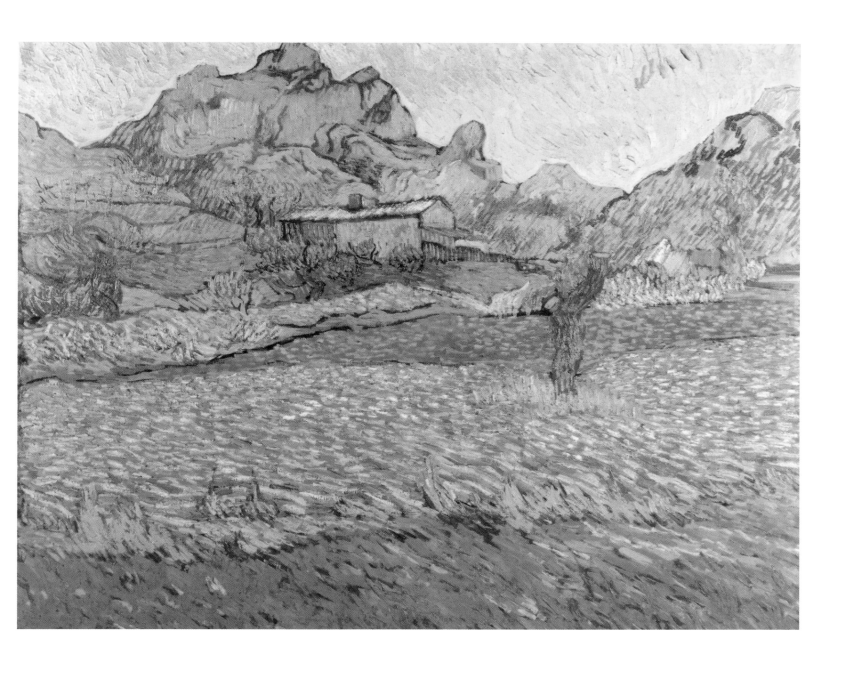

72. *A Meadow in the Mountains:*
 Le Mas de Saint-Paul
 Saint-Rémy: mid-June 1889
 Oil on canvas, 73 x 91.5 cm
 Otterlo: Rijksmuseum Kröller-Müller.

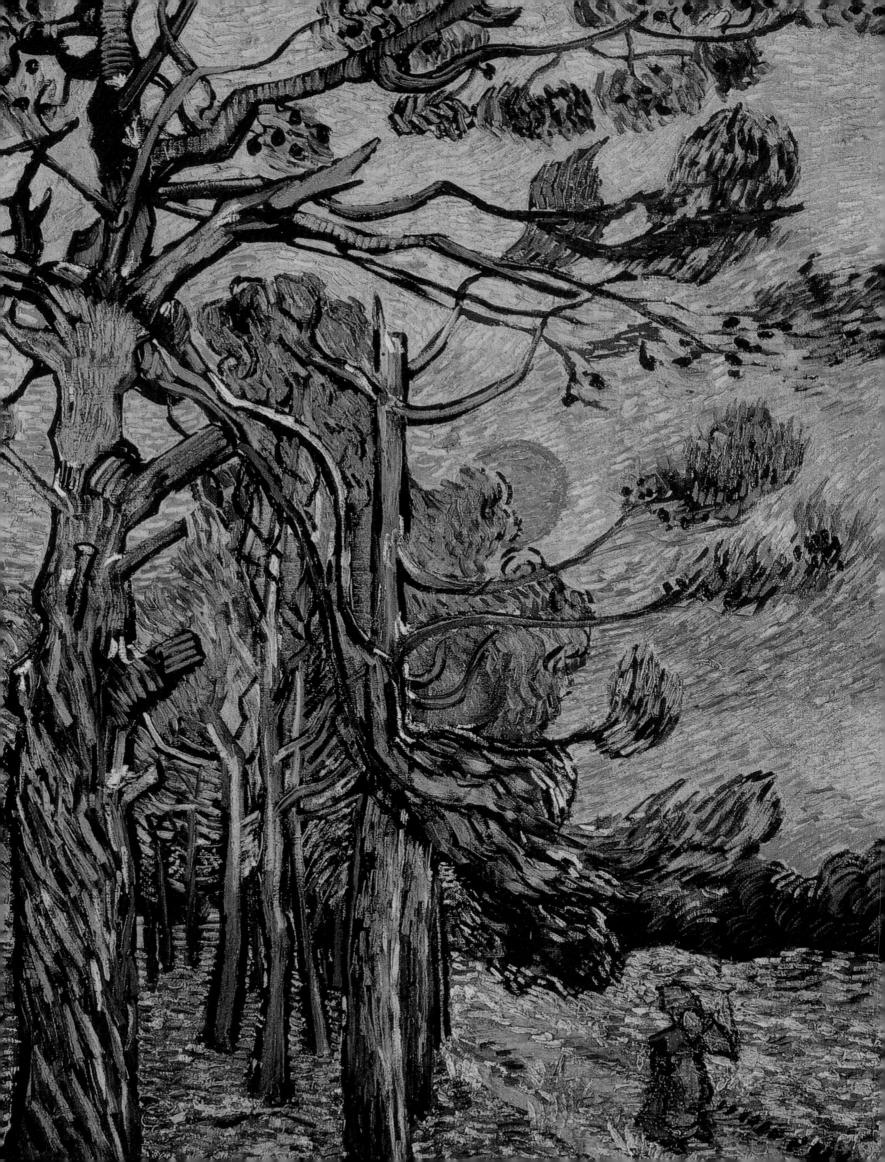

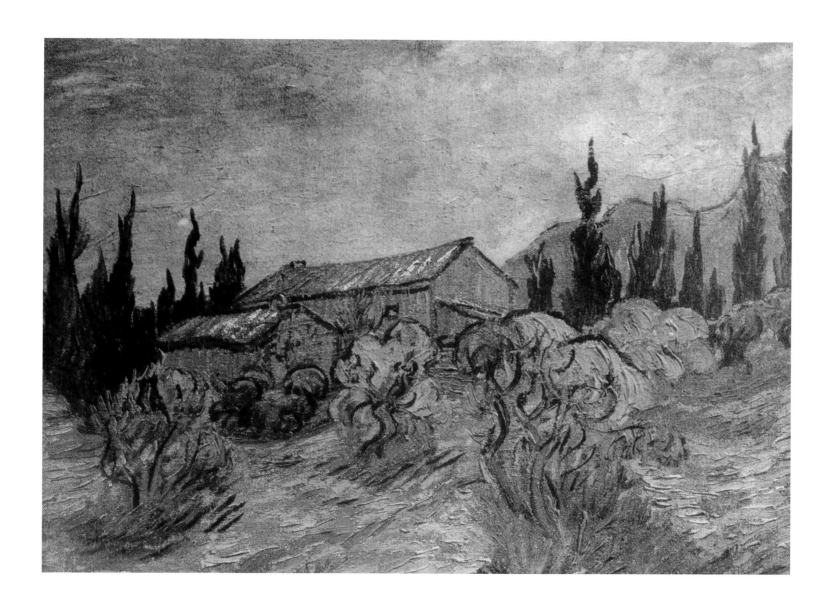

At the beginning, van Gogh was impressed by the community of the sick, which seemed to him, in some parts, more human than the community of the healthy: "For though there are some who howl or rave continually, there is much real friendship here among them; they say we must put up with others so that others will put up with us, and other very sound arguments, which they really put into practice. And among ourselves we understand each other very well. For instance I can sometimes chat with one of them who can only answer in incoherent sounds, because he is not afraid of me."[108]

73. *Pine Tree against a Red Sky with Setting Sun*
Saint-Rémy: November 1889
Oil on canvas, 92 x 73 cm
Otterlo: Rijksmuseum Kröller-Müller.

74. *Wooden Sheds*
Saint-Rémy: December 1889
Oil on canvas, 45.5 x 60 cm
Brussels: Private Collection.

For the first time, van Gogh felt that he was a part of the hospital community, but, in contrast with the other patients, he did not succumb to lethargy. Since he felt a duty to work, he started painting as soon as he arrived. He asked Theo to send him canvases and colours, along with a statement indicating how much he would have to produce in order to 'pay' for his stay. For the art dealer, this must have been a naïve delusion – Theo hadn't sold one of his brother's pictures. Nevertheless he bought all of the necessary materials and sent them to Saint-Rémy.

During his stay in the hospital, van Gogh painted landscapes, in which he recreated the world of his childhood anew. At the same time, he continued to study the effects of colours: "Only I have no news to tell you, for the days are all the same, I have no ideas, except to think that a field of wheat or a cypress is well worth the trouble of looking at close up, and so on. I have a wheat field, very yellow and very light, perhaps the lightest canvas I have done. The cypresses are always occupying my thoughts, I should like to make something of them like the canvases of the sunflowers, because it astonishes me that they have not yet been done as I see them. It is as beautiful of line and proportion as an Egyptian obelisk. And the green has a quality of such distinction. It is a splash of black in a sunny landscape, but it is one of

75. *Les Peiroulets Ravine*
Saint-Rémy: December 1889
Oil on canvas, 72 x 92 cm
Otterlo: Rijksmuseum Kröller-Müller.

76. *The Garden of Saint-Paul's Hospital*
Saint-Rémy: May 1889
Oil on canvas, 95 x 75.5 cm
Otterlo: Rijksmuseum Kröller-Müller.

77. *Morning: Peasant Couple Going to Work*
 (after Millet)
 Saint-Rémy: January 1890
 Oil on canvas, 73 x 92 cm
 St. Petersburg: The Hermitage Museum.

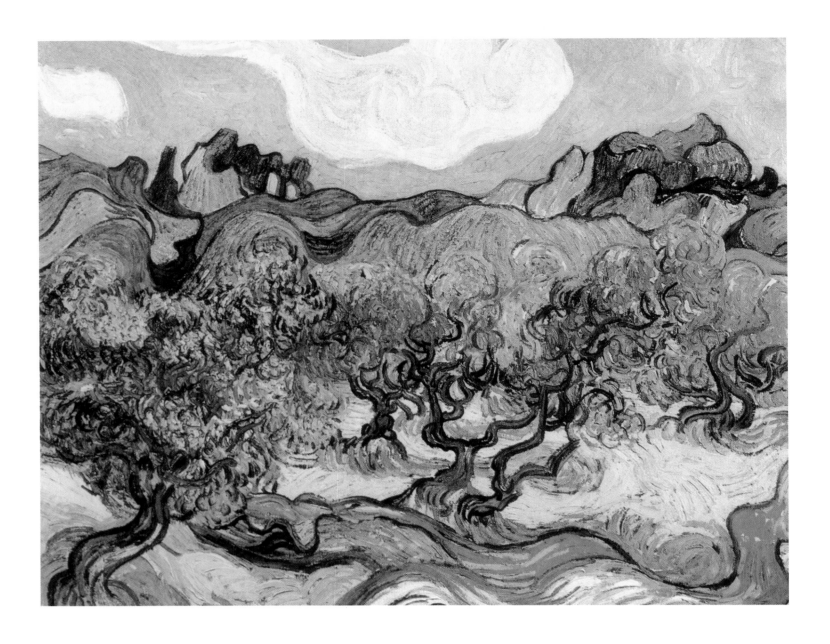

the most interesting black notes, and the most difficult to hit off exactly what I can imagine. But then you must see them against the blue, in the blue rather. To paint nature here, as everywhere, you must be in it for a long time."[109]

During the first months, the orderly life at the hospital seemed to have a positive effect on the painter. In his letters, he stressed that he only wished to work, and that he was not missing his friends. But then, one day in July, he was working in an open field when he suffered another attack, and for many days afterwards his "mind [was] absolutely wandering."[110]

During this state of confusion he might have tried to commit suicide by drinking paint or turpentine. After the crisis had subsided, Dr. Peyron informed Theo that his brother's brain was clear again and that all thoughts of suicide had disappeared.

Van Gogh again returned to his work, but his view of the hospital life had changed. The other patients, who had previously appeared to form an ideal community, now frightened him. Worse, the nuns who worked in Saint-Rémy terrified him. He realized that his attacks tended "to take an absurd religious turn," and he was

78. *Olive Trees with the Alpilles in the Background*
Saint-Rémy: June 1889
Oil on canvas, 72.5 x 92 cm
New York: Collection Mrs. John Hay Whitney.

79. *Cypress and Two Women*
Saint-Rémy: February 1890
Oil on canvas, 43.5 x 27 cm
Amsterdam: Rijksmuseum Vincent van Gogh, Foundation Vincent van Gogh.

100

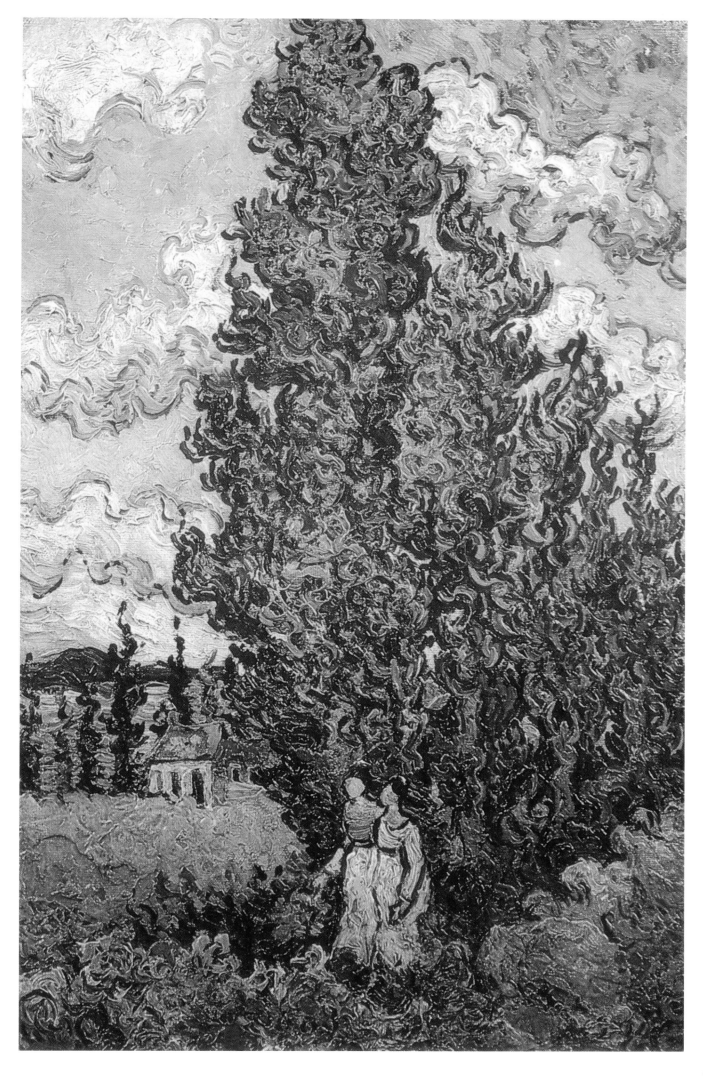

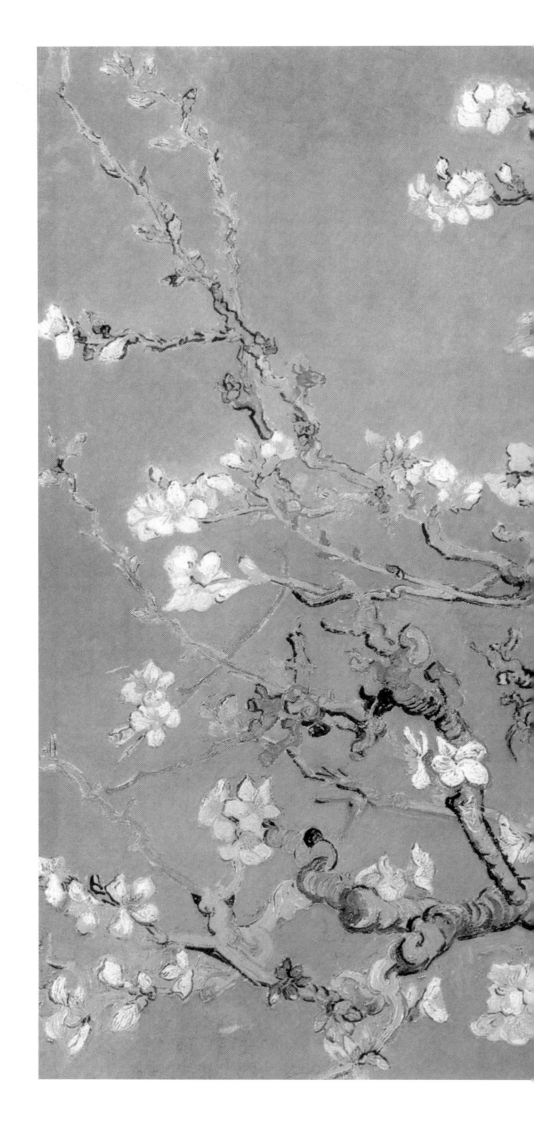

80. *Blossoming Almond Tree*
Saint-Rémy: February 1890
Oil on canvas, 73.5 x 92 cm
Amsterdam: Rijksmuseum
Vincent van Gogh,
Foundation Vincent van Gogh.

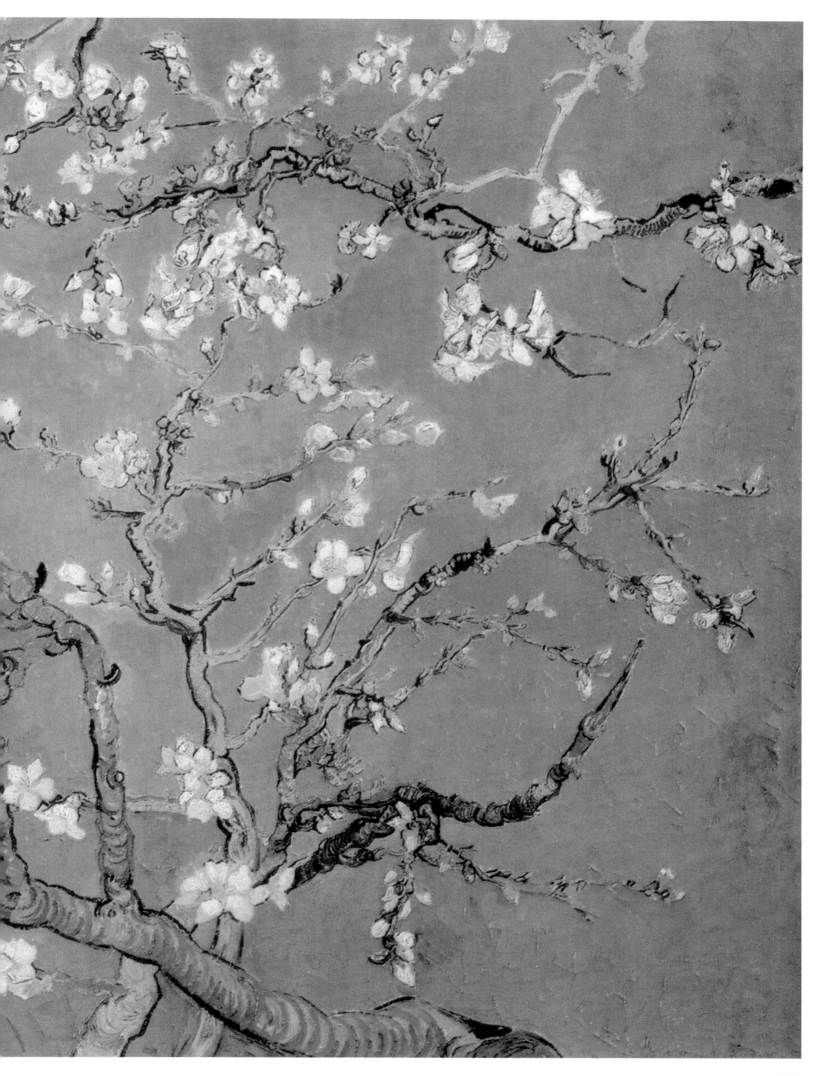

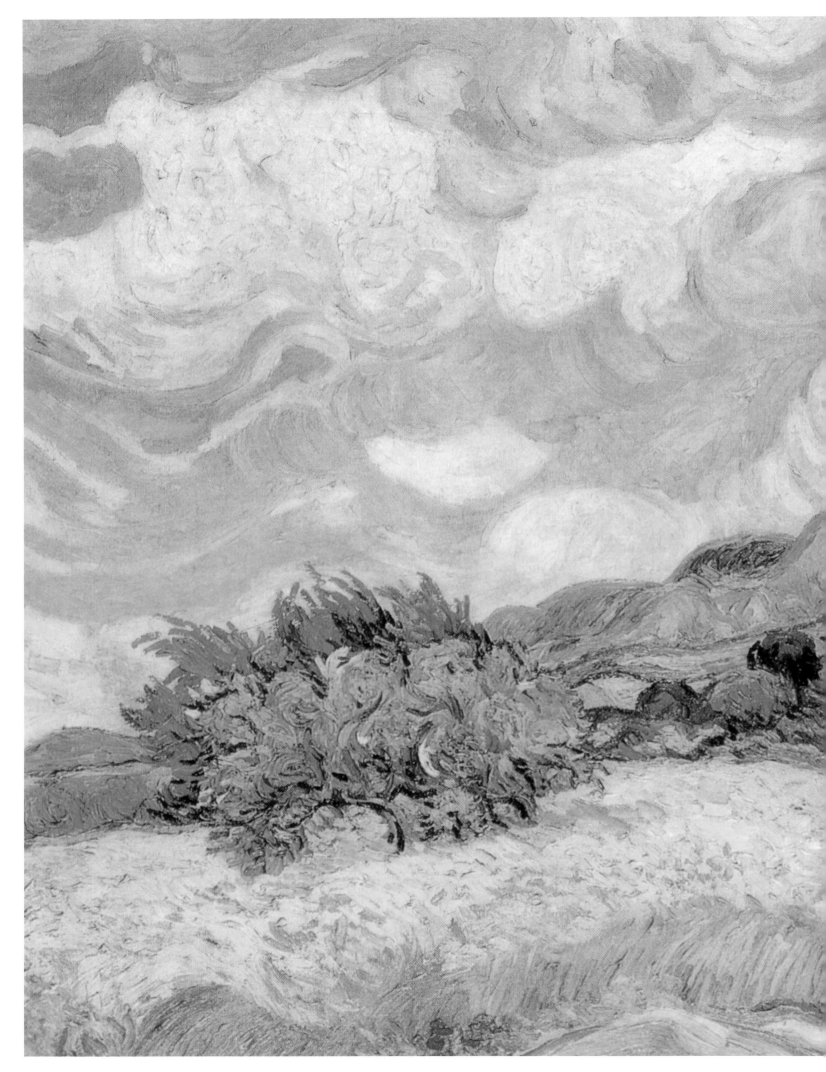

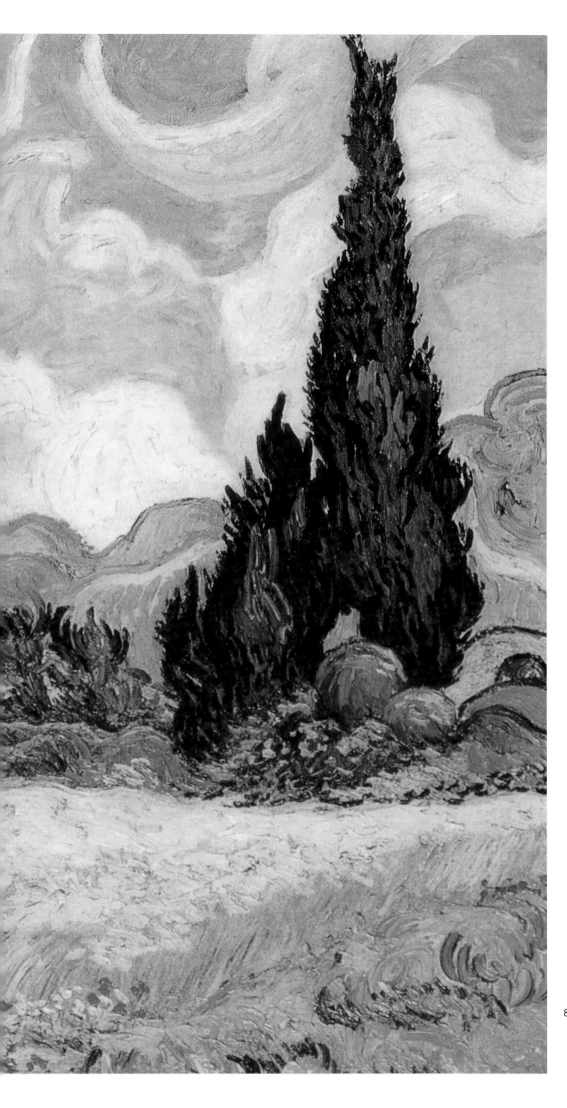

81. *Wheat Field with Cypresses at Haut Galline Near Eygalieres*
Saint-Rémy: late June 1889
Oil on canvas, 73.5 x 92.5 cm
Prague: Narodni Gallery.

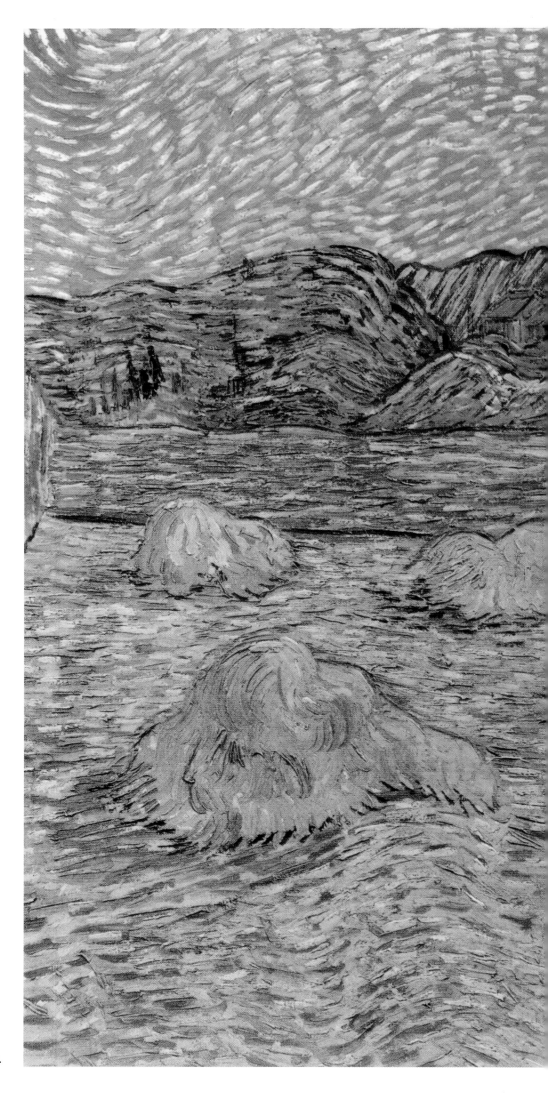

82. *Evening Landscape with Rising Moon*
Saint-Rémy: early July 1889
Oil on canvas, 73 x 91.5 cm
Otterlo: Rijksmuseum Kröller-Müller.

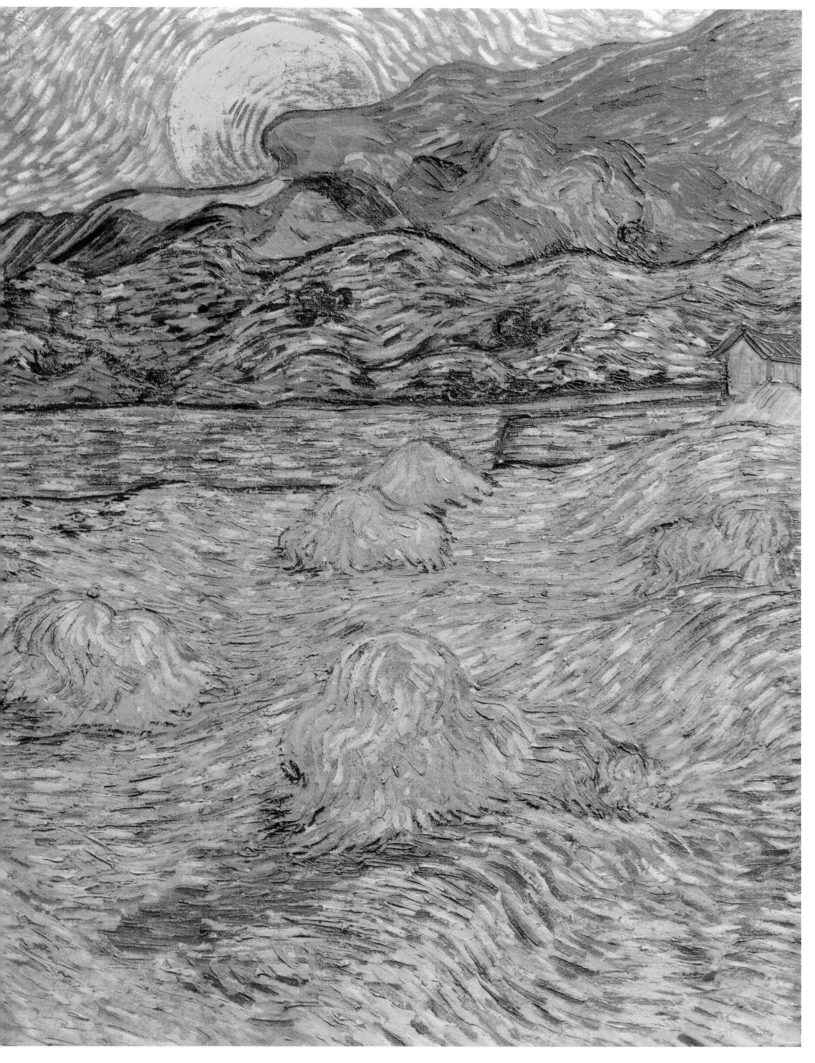

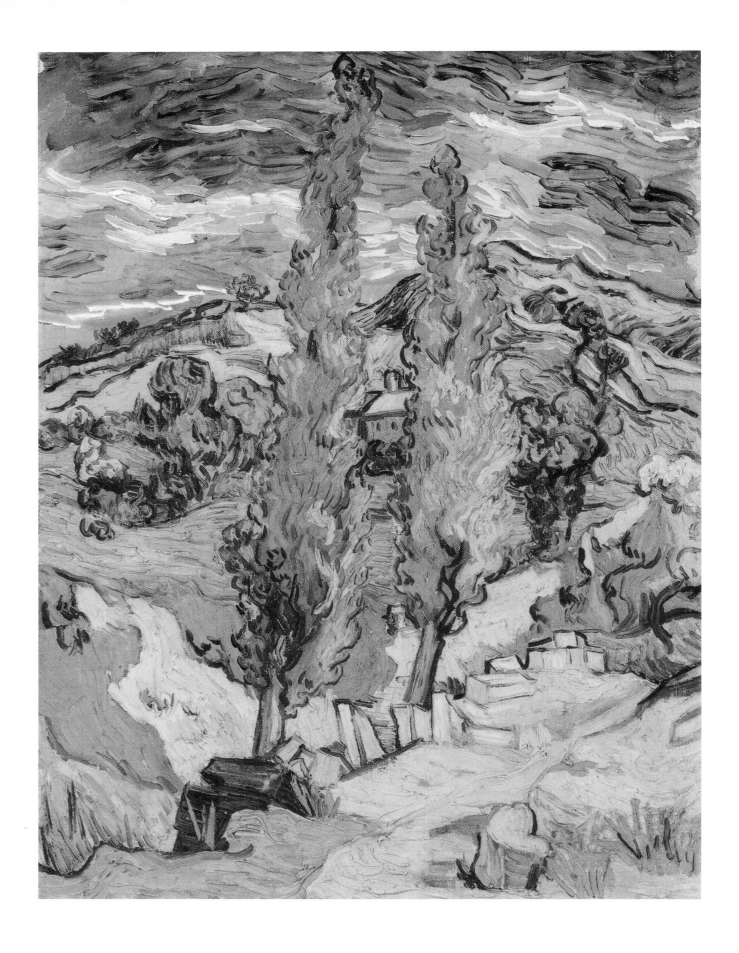

annoyed "to see these good women who believe in the Virgin of Lourdes, and make up things like that, and thinking that I am a prisoner under an administration, which very willingly fosters these sickly religious aberrations, whereas the right thing would be to cure them." Comparing the last attack with the first crisis in Arles, van Gogh decided that his illness seemed "to be caused more by some

83. *Two Poplars on a Road Through the Hills*
Saint-Rémy: early July 1889
Oil on canvas, 45.5 x 60 cm
Brussels: Private Collection.

84. *Self-Portrait*
Saint-Rémy: late August 1889
Oil on canvas, 57 x 43.5 cm
New York: Private Collection.

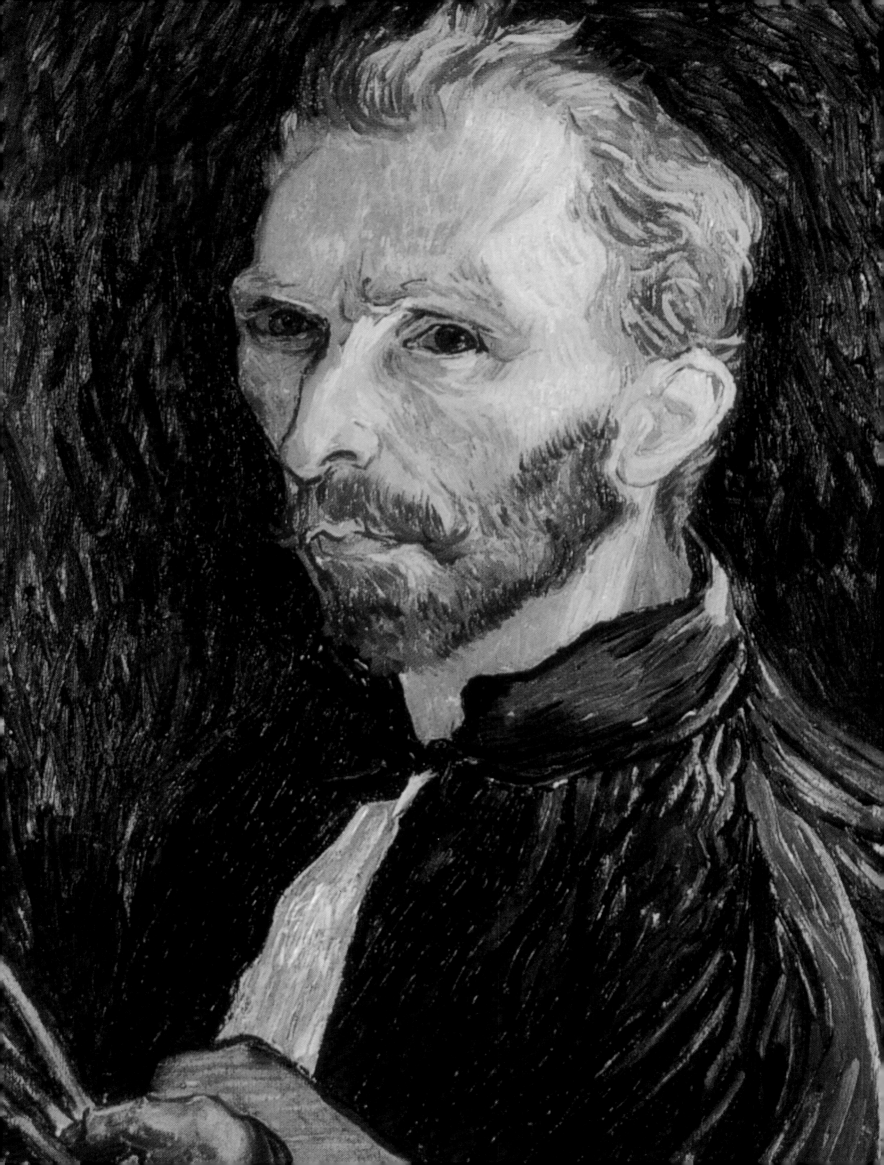

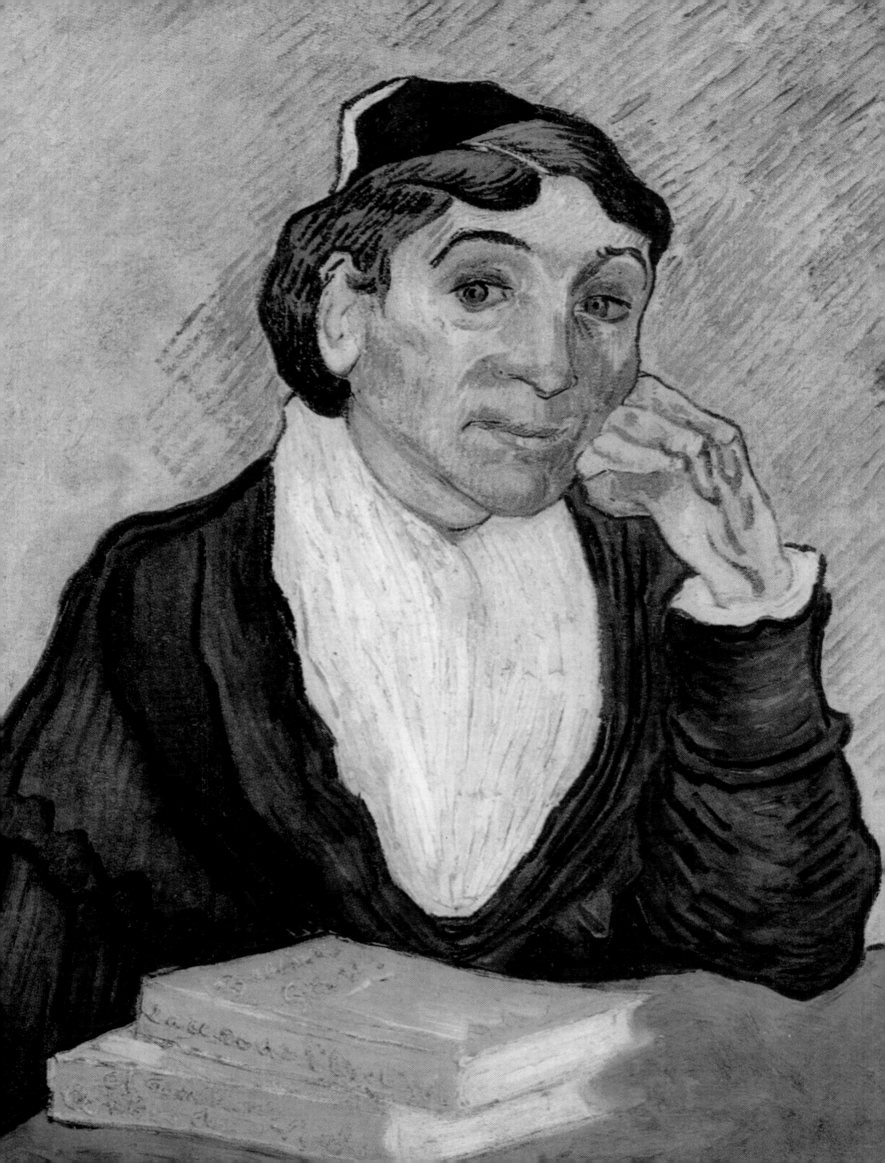

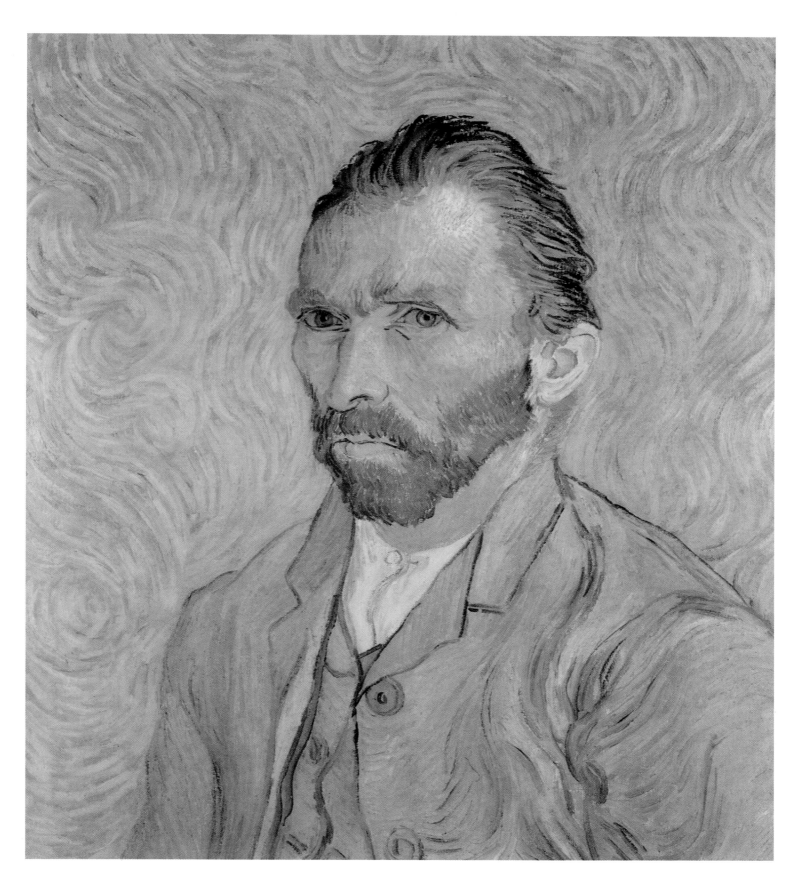

85. *L'Arlésienne (Madame Ginoux)*
Saint-Rémy: February 1890
Oil on canvas, 65 x 54 cm
São Paulo: Museu de Arte de
São Paulo.

86. *Self-Portrait*
Saint-Rémy: September 1889
Oil on canvas, 65 x 54 cm
Paris: Musée d'Orsay.

outside influence than by something within myself. I may be mistaken, but
however it may be, I think you will feel it quite right that I have rather a horror of
all religious exaggeration."[111] After the attack, van Gogh would no longer leave the
hospital to paint outdoors. It therefore became difficult for him to find subjects for

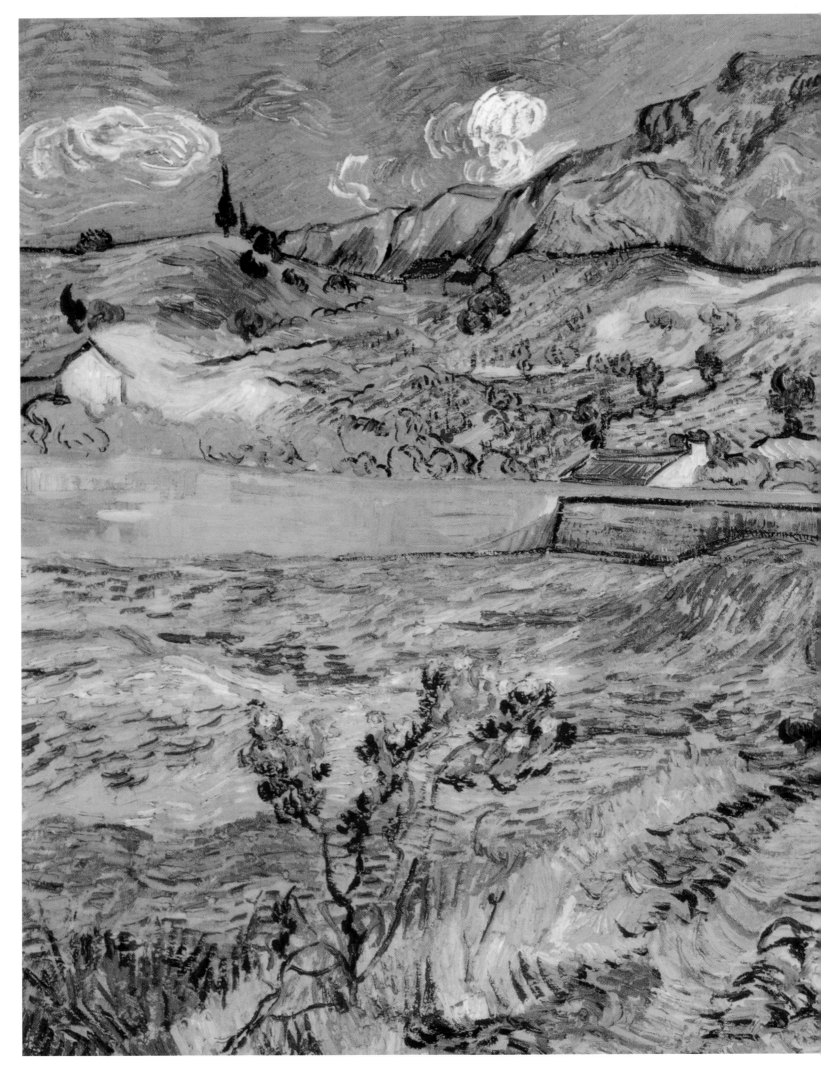

87. *Enclosed Wheat Field with Peasant*
Saint-Rémy: early October 1889
Oil on canvas, 73.5 x 92 cm
Indianapolis: Indianapolis
Museum of Art.

88. *Field with Ploughmen and Mill*
Saint-Rémy: October 1889
Oil on canvas, 54 x 67 cm
Boston: Museum of Fine Arts,
prepared by W. A. Coolidge.

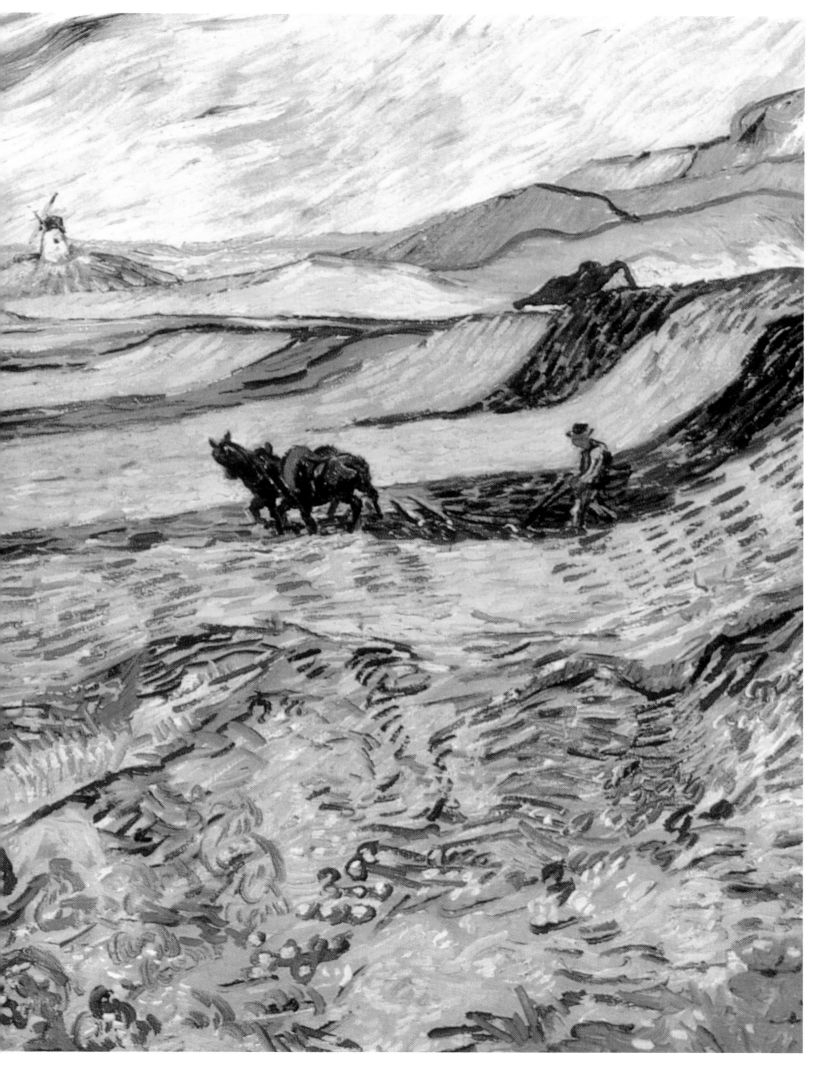

89. *The Mulberry Tree*
 Saint-Rémy: October 1889
 Oil on canvas, 54 x 65 cm
 Pasadena, California: Norton Simon
 Museum of Art.

his work. As an alternative he took himself as a model or copied one of the prints Theo had sent him from Paris. He 'repainted' the *Pièta* by Delacroix and *Prisoners' Round* by Gustave Doré.

A few weeks before he had asked himself: "What is the good of getting better?"[112]; now he had only one aim: "to recover like a man who meant to commit suicide and,

90. *View of the Church at Saint-Paul-de-Mausole*
Saint-Rémy: October 1889
Oil on canvas, 44.5 x 60 cm
United States: Collection Elizabeth Taylor.

91. *Trees in the Garden of Saint-Paul Hospice*
Saint-Rémy: October 1889
Oil on canvas, 90.2 x 73.3 cm
Los Angeles: The Armand Hammer Museum of Art.

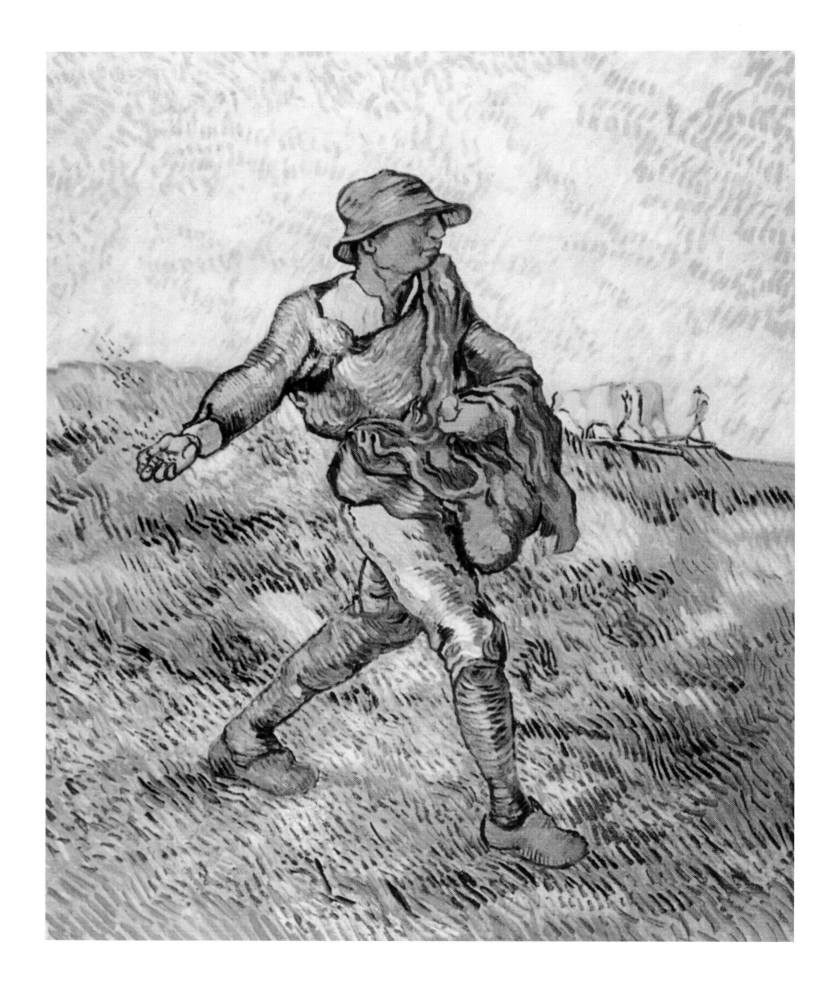

92. *The Sower (after Millet)*
Saint-Rémy: late October 1889
Oil on canvas, 80.8 x 66 cm
Collection Stavros S Niarchos.

120

93. *Trees in the Garden of Saint-Paul Hospice*
Hospice
Saint-Rémy: October 1889
Oil on canvas, 73 x 60 cm
United States: Private Collection.

94. *The Sheperd (after Millet)*
Saint-Rémy: November 1889
Oil on canvas, 52.7 x 40.7 cm
Tel Aviv: Tel Aviv Museum.

95. *The Good Samaritain*
 (after Delacroix)
 Saint-Rémy: May 1890
 Oil on canvas, 73 x 60 cm
 Otterlo: Rijksmuseum Kröller-Müller.

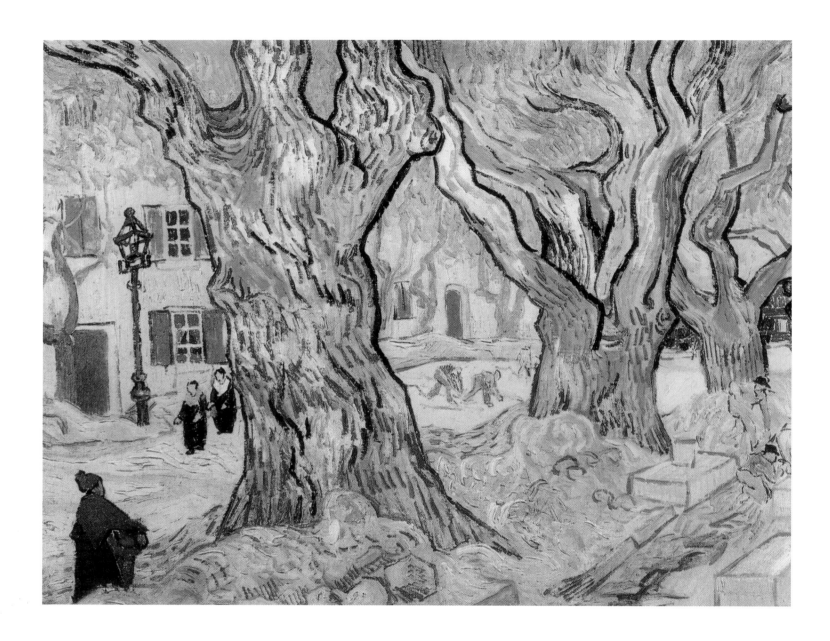

finding the water too cold, tries to regain the bank.["]113 Suddenly, he felt "a terrible desire [...] to see my friends and the northern countryside again."114 Van Gogh remained in the South for eight more months, chiefly because Theo didn't give him a clear sign to come to Paris. Theo's wife Johanna was pregnant, and van Gogh had to wait until the child was born and until his brother had found a doctor for him. When Dr. Paul Gachet, a well-known art lover who lived in Auvers-sur-Oise near Paris, agreed to treat the painter, van Gogh left Saint-Rémy. On May 16th, 1890 Dr. Peyron closed the record with a final note: 'cured.'

96. *The Roadmenders*
Saint-Rémy: November 1889
Oil on canvas, 71 x 93 cm
Washington: The Phillips Collection.

97. Self-Portrait
Saint-Rémy: September 1889
Oil on canvas, 51 x 45 cm
Oslo: Nasjonalgalleriet.

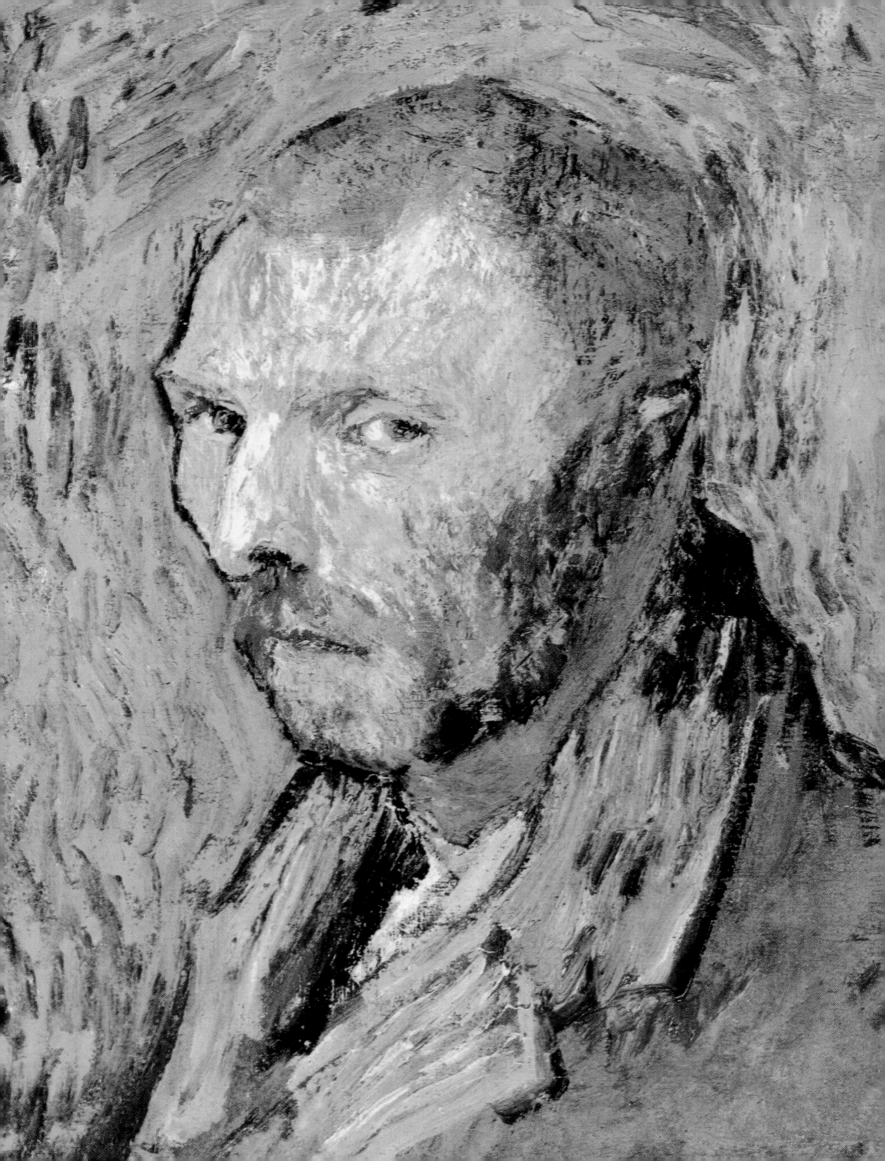

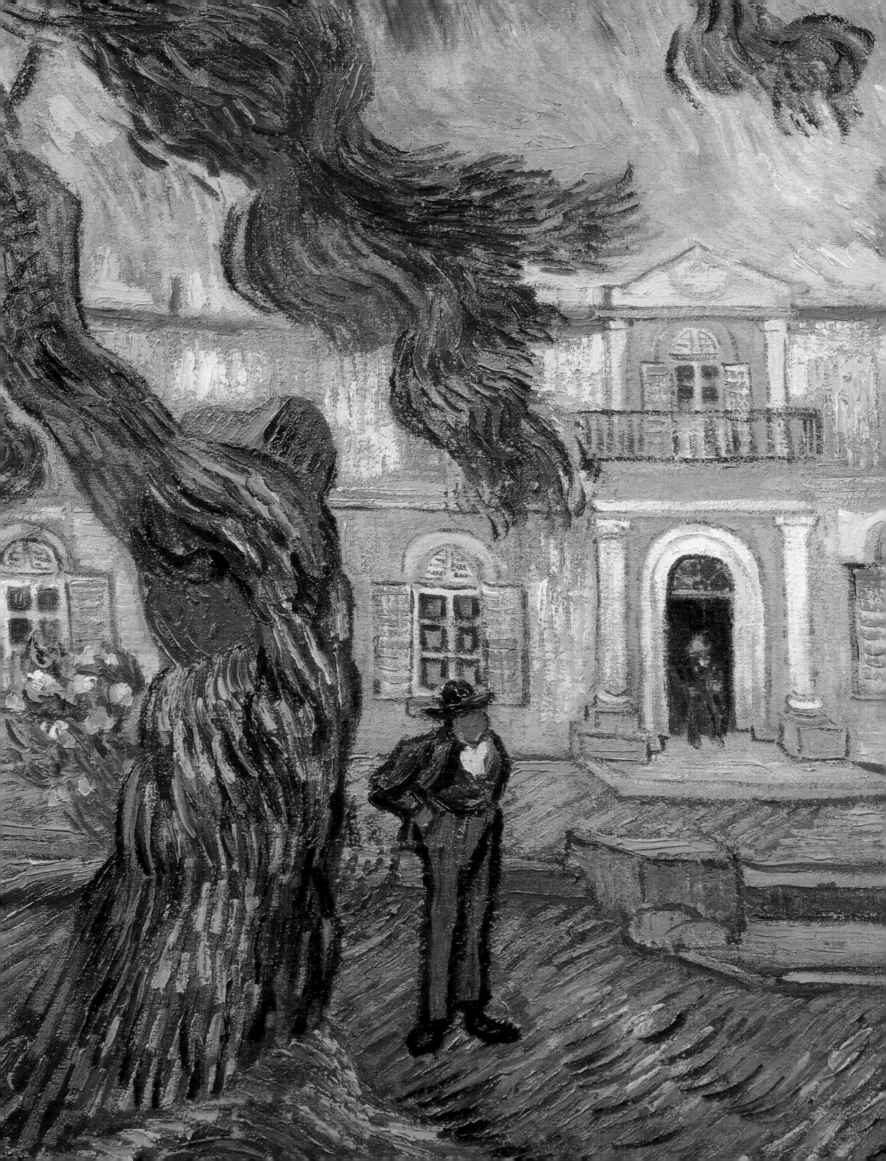

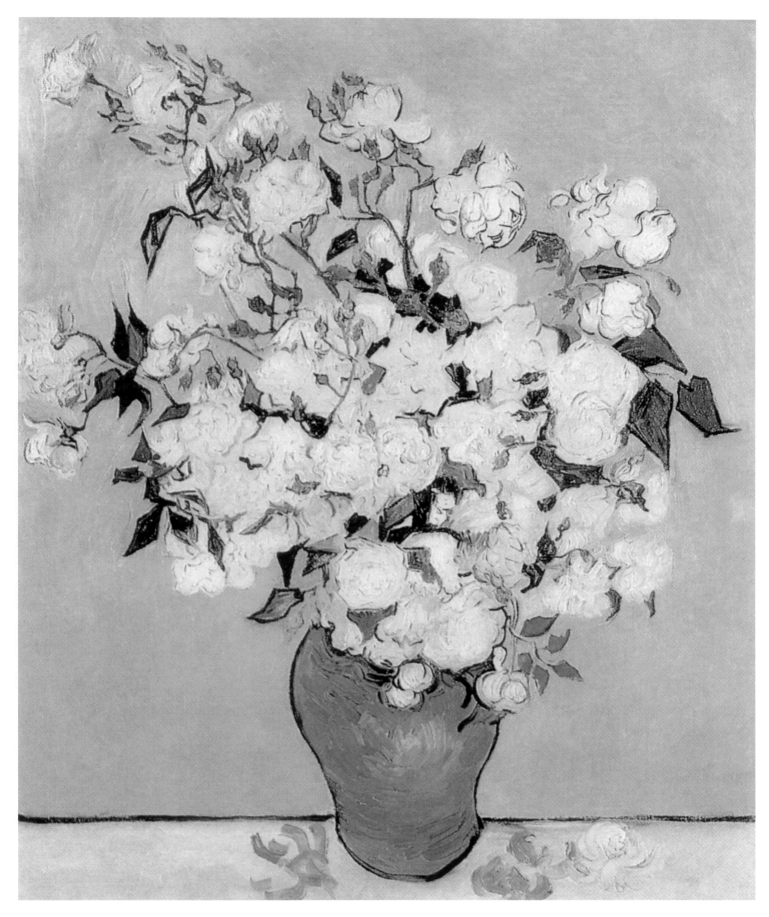

98. *Trees with Figure in the Garden of Saint-Paul Hospital*
Saint-Rémy: November 1889
Oil on canvas, 63 x 48 cm
Paris: Musée d'Orsay

99. *Still-Life: Pink Roses in a Vase*
Saint-Rémy: May 1890
Oil on canvas, 92.6 x 73.7 cm
Rancho Mirage, California: Mr. And
Mrs. Walter H. Annenberg Collection.

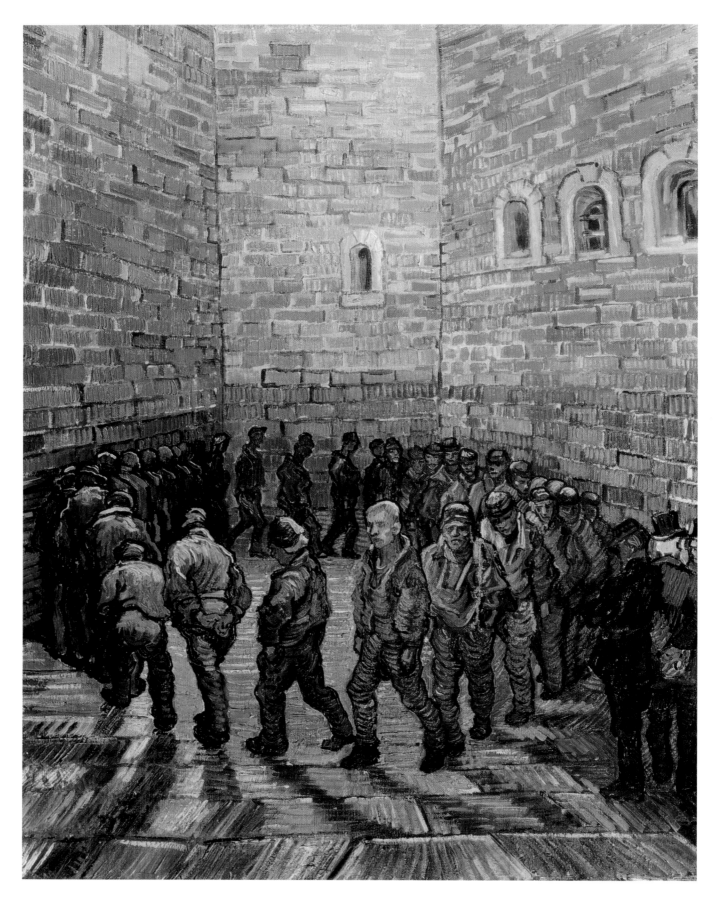

100. *Prisoner Rounds*
 (after Gustave Doré)
 Saint-Rémy: February 1890
 Oil on canvas, 80 x 64 cm
 Moscow: Pouchkin Museum.

101. *Pietà (after Delacroix)*
 Saint-Rémy: September 1889
 Oil on canvas, 73 x 60.5 cm
 Amsterdam: Rijksmuseum
 Vincent van Gogh,
 Foundation Vincent van Gogh.

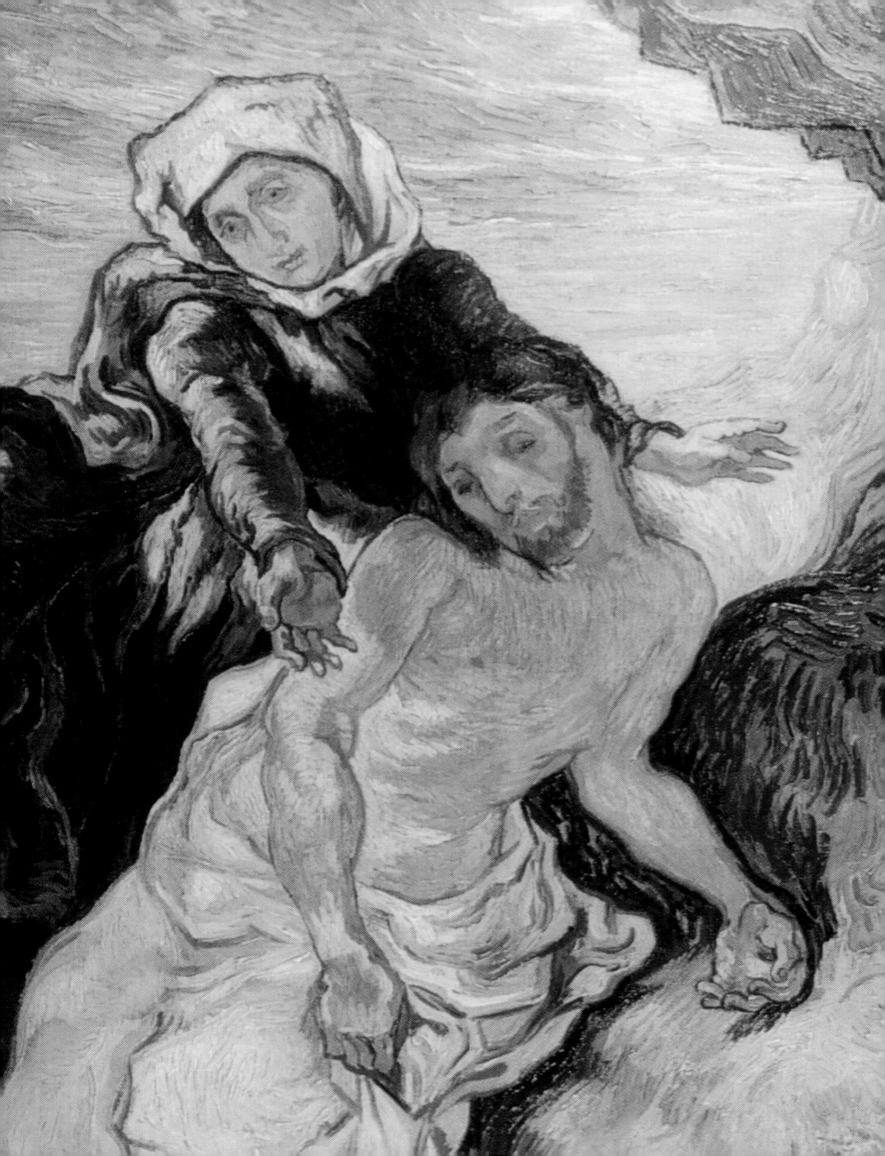

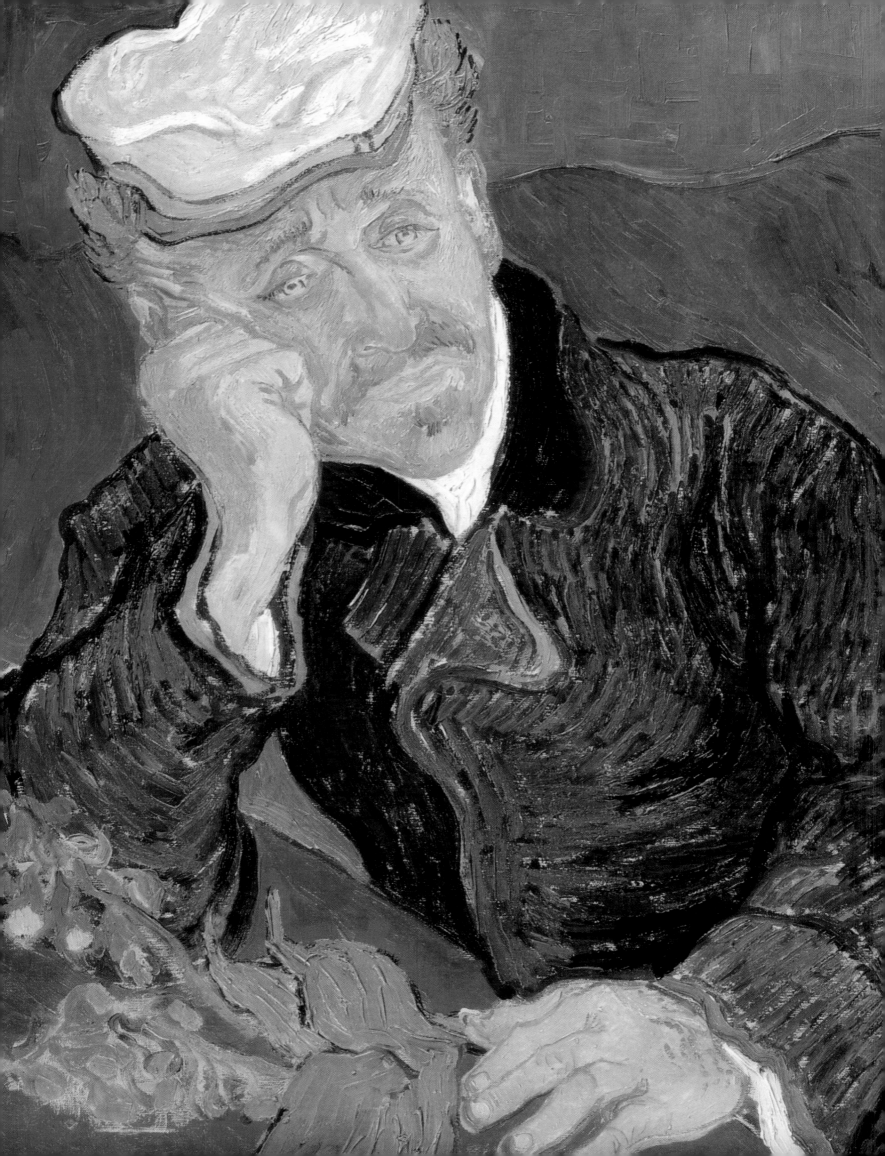

Auvers-sur-Oise: 1890

"But there's nothing sad in this death..."

Van Gogh stayed only three days with Theo and his family in Paris before leaving for Auvers-sur-Oise. The reason for his short stay may have been the quarrels between Theo and Johanna, which van Gogh later described in his letters. When he arrived in Auvers on May 21st, Vincent wrote to his brother: "Auvers is very beautiful, among other things a lot of old thatched roofs, which are getting rare. So, I should hope, that by settling down to do some canvases of this there would be chance of recovering the expenses of my stay – for really it is profoundly beautiful. It is the real country, characteristic and picturesque."[115]

Nature and work were, again, the twin supports in van Gogh's life. But there were no people around him. Dr. Gachet proved to be of little help. Van Gogh: "I think we must not count on Dr. Gachet at all. First of all, he is sicker than I am, I think, or shall we say just as much, so that's that. Now when one blind man leads another blind man, don't they both fall into the ditch?"[116] The 62-year-old specialist in heart conditions and nervous diseases was a great art lover. He was in contact with many painters, and his collections, which were later given to the Musée d'Orsay in Paris, included paintings by Cézanne, Pissarro – and van Gogh. The doctor was more interested in van Gogh as a painter than as a patient.

Van Gogh lived in the Ravoux inn. Adeline, the daughter of the owner, at this time thirteen years old, later remembered her parents' guest: "Van Gogh spent his days in a more or less uniform way: He ate breakfast, then around nine o'clock he left for the countryside with his easel and his paintbox, with his pipe in his mouth (which he never put down); he went to paint. He returned punctually at noon for lunch. In the afternoon he often worked on a painting-in-progress [...] After dinner he played with my little sister, drew his Sandman for her, and then went immediately up to his room."[117]

102. *Portrait of Doctor Paul Gachet*
Auvers-sur Oise: June 1890
Oil on canvas, 68 x 57 cm
Paris: Musée d'Orsay.

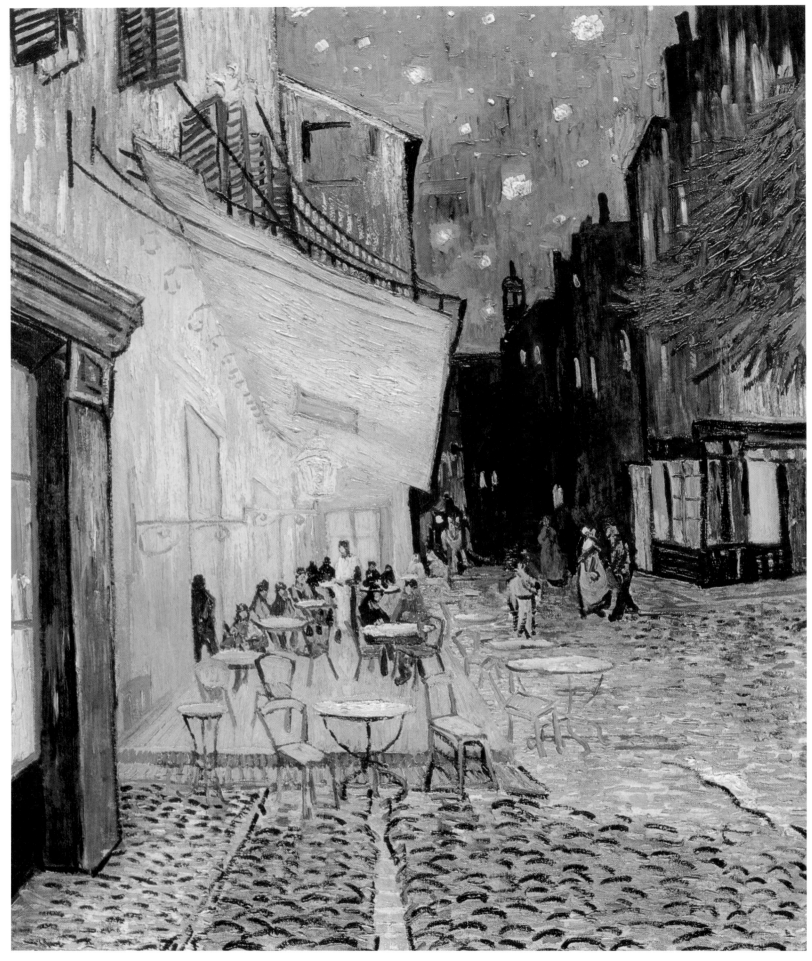

103. *The Café Terrasse on the Place du Forum, Arles at Night*
September 1888
Oil on canvas, 81 x 65.5 cm
Otterlo: Rijksmuseum Kröller-Müller.

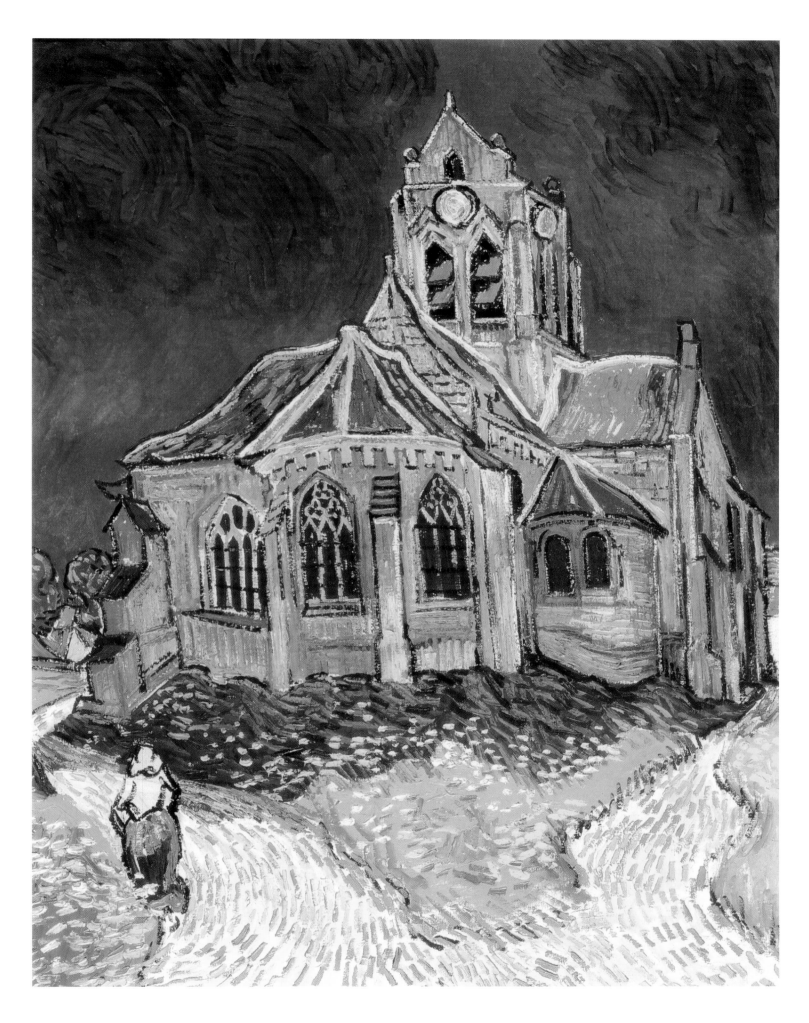

104. *The Church at Auvers-sur-Oise*
June 1890
Oil on canvas, 94 x 74 cm
Paris: Musée d'Orsay.

134

105. *Plain at Auvers with Cloudy Skies*
Auvers-sur-Oise: July 1890
Oil on canvas, 73 x 92 cm
Otterlo: Rijksmuseum Kröller-Müller.

Adeline sat for van Gogh. So did the twenty-one-year-old Marguerite Gachet. A close friend of the doctor's daughter later claimed that the painter and his model had fallen in love, and Dr. Gachet forbade van Gogh to come to his house any longer. Marguerite's brother confirmed the story in an interview, but changed it on one critical point: He said that his sister didn't return the affection of the 37-year-old painter. Obviously the friendship between van Gogh and Gachet broke up soon; after July 2nd, van Gogh stopped mentioning him in his letters. Adeline Ravoux reported that when Dr. Gachet was called in to examine him after van Gogh wounded himself with a revolver, both men behaved as if they had never met.

106. *Young Girl Standing Against a Background of Wheat Field*
Auvers-sur-Oise: late June 1890
Oil on canvas, 66 x 45 cm
Washington: National Gallery of Art.

107. *Portrait of Milliet, Lieutenant Under Zouaves*
Arles: September 1888
Oil on canvas, 81 x 65.5 cm
Otterlo: Rijksmuseum Kröller-Müller.

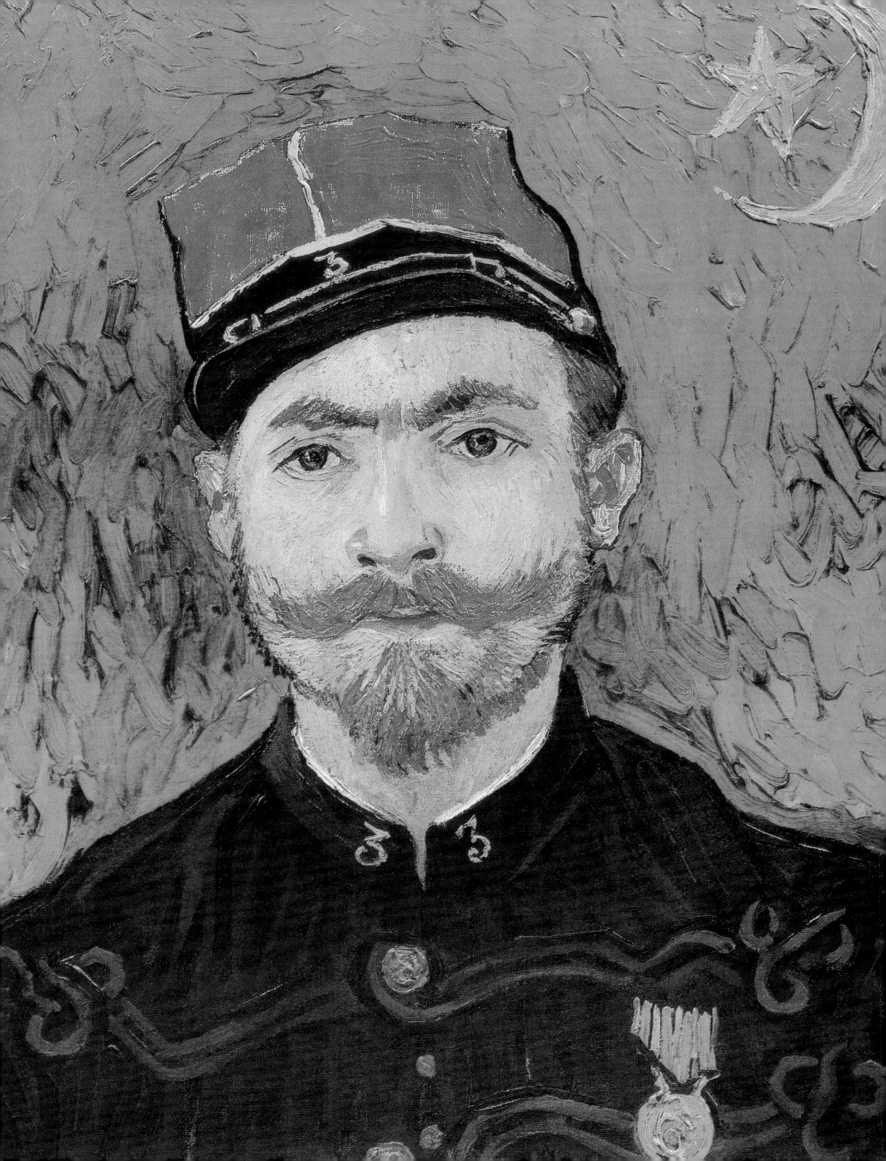

108. *Wheat Field with Crows*
June 1890
Oil on canvas, 50.5 x 105 cm
Amsterdam: Rijksmuseum
Vincent van Gogh,
Foundation Vincent van Gogh.

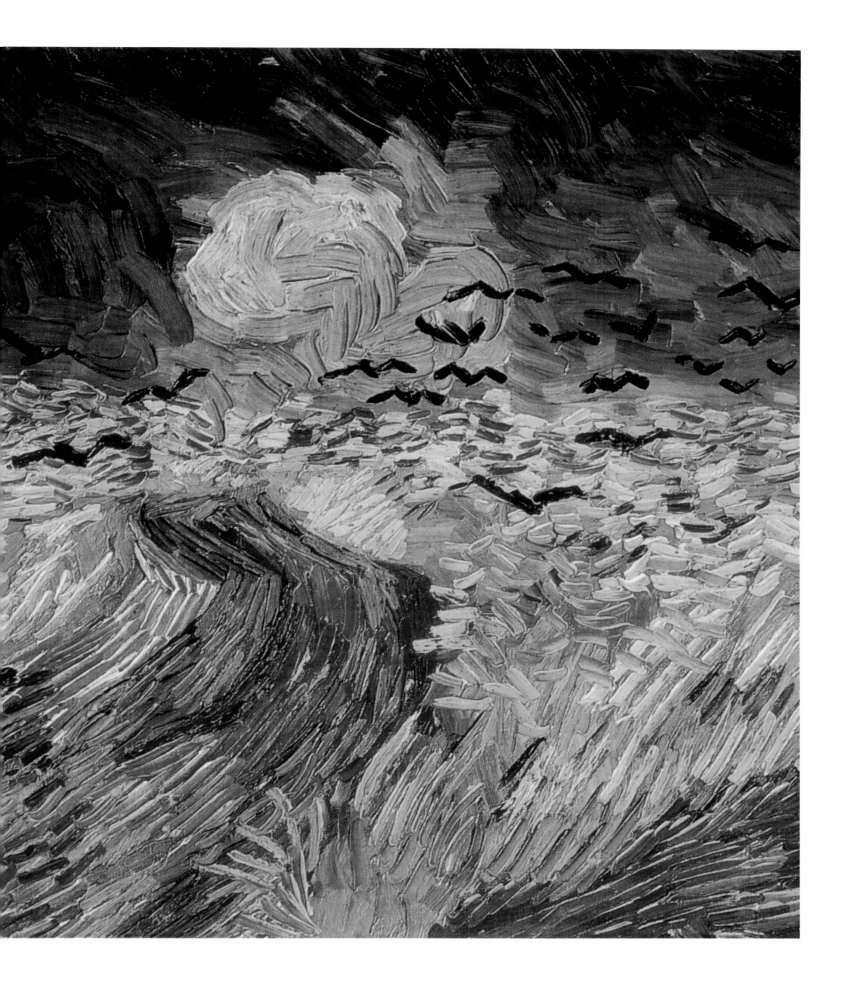

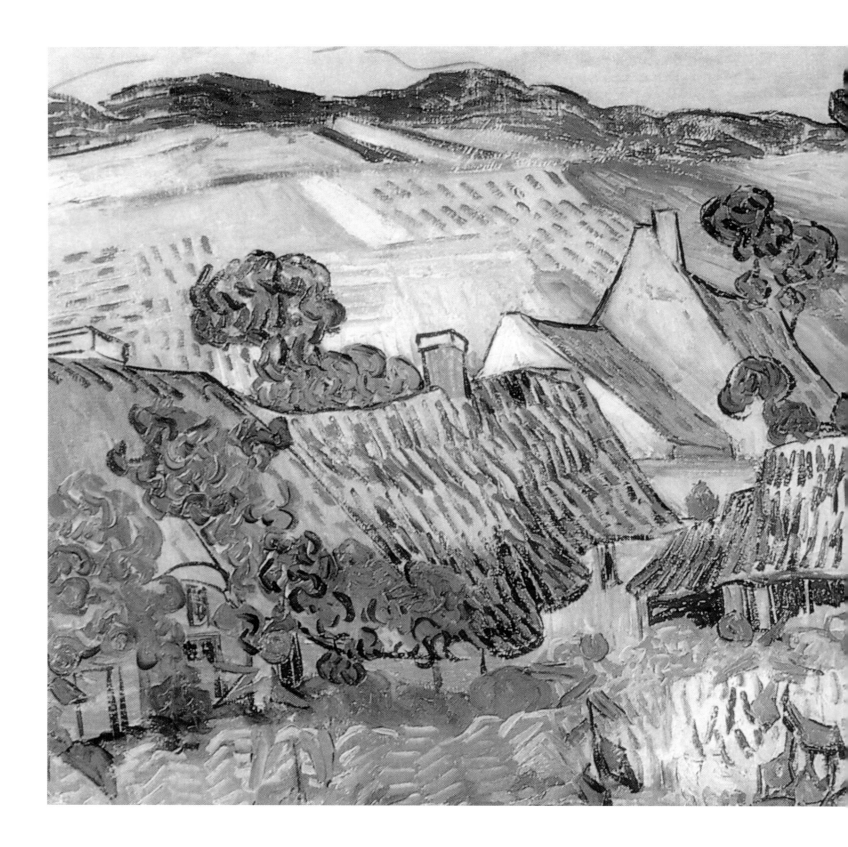

During the two and a half months that he spent in Auvers, van Gogh went through a cycle that he had already experienced several times. He tried to build up a regular life with work, but he lost sight of his security, of his nest. Increasingly, he felt that he was a burden for Theo. During a visit to Paris he was witness to a discussion between his brother and Johanna. Theo wanted to leave Goupil to found his own gallery; his wife preferred him to stay in the same position even though he did not earn enough money. Vincent was not the only relative Theo had to support; he regularly sent money to his mother and his sister Willemien.

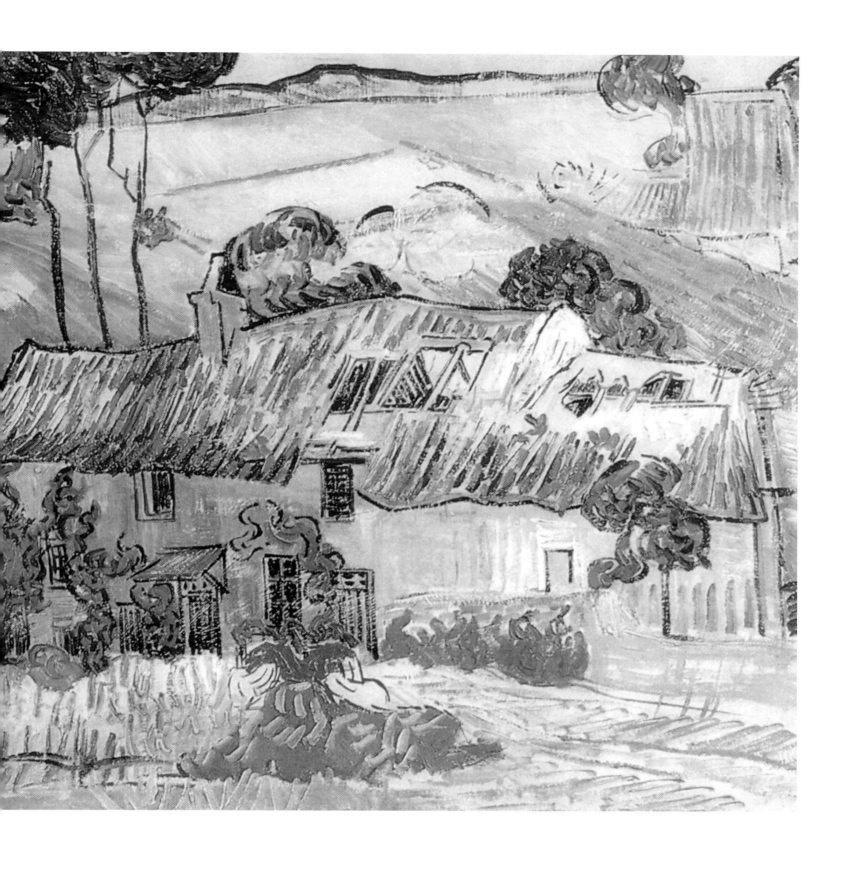

109. *Thatched Cottages by a Hill*
Auvers-sur-Oise: July 1890
Oil on canvas, 50 x 100 cm
London: Tate Gallery.

Ten years earlier, when van Gogh started to depend on his brother's money, he wrote: "If I had to believe that I were troublesome to you or to other people at home, or were in your way, of no good for anyone, and if I should be obliged to feel like an intruder or an outcast, so that I were better off dead [...] If it were indeed so, then I might wish that I had not much longer to live."[118] After his return from Paris van Gogh described the canvases he was working on to Theo and Johanna: "They are vast fields of wheat under troubled skies, and I did not need to go out of my way to try to express sadness and extreme loneliness. I hope you will see them soon [...],

141

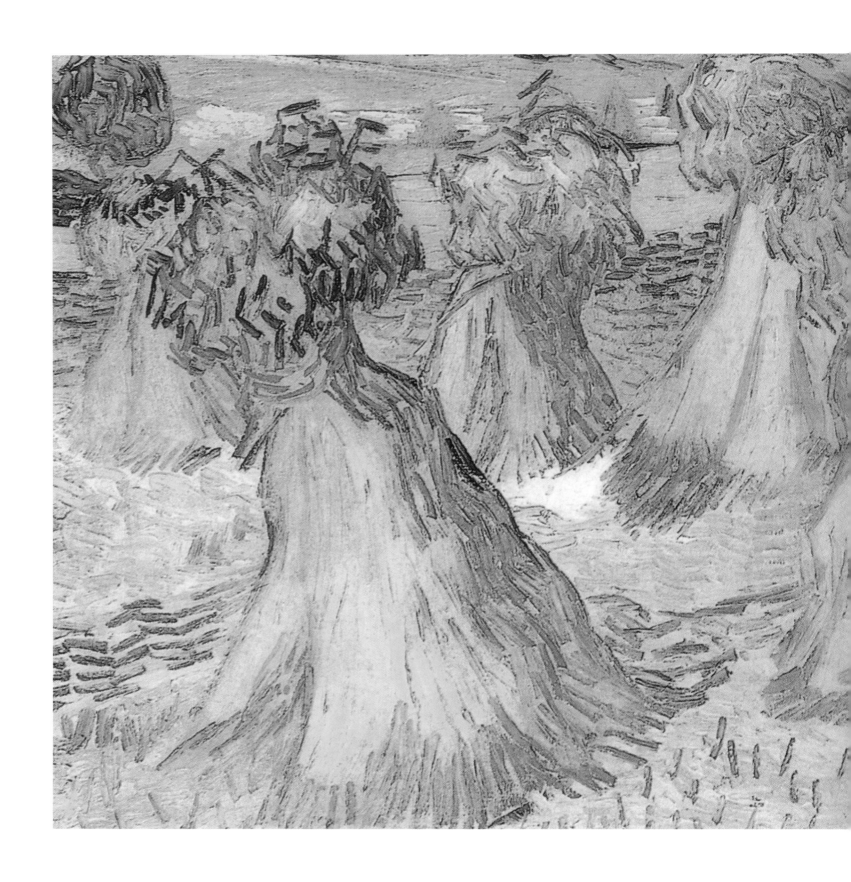

since I almost think that these canvases will tell you what I cannot say in words, the health and restorative forces that I see in the country."[119] This paradox – the sadness and health of the country – reflects van Gogh's own situation: Nature always was a kind of home for him – a home that he could never share with anyone else.

In Saint-Rémy, van Gogh had worked on a picture named *The Reaper*: "For I see in this reaper – a vague figure fighting like a devil in the midst of the heat to get to the

110. *Sheaves of Wheat*
Auvers-sur-Oise: July 1890
Oil on canvas, 50.5 x 101 cm
Dallas: Dallas Museum of Fine Arts.

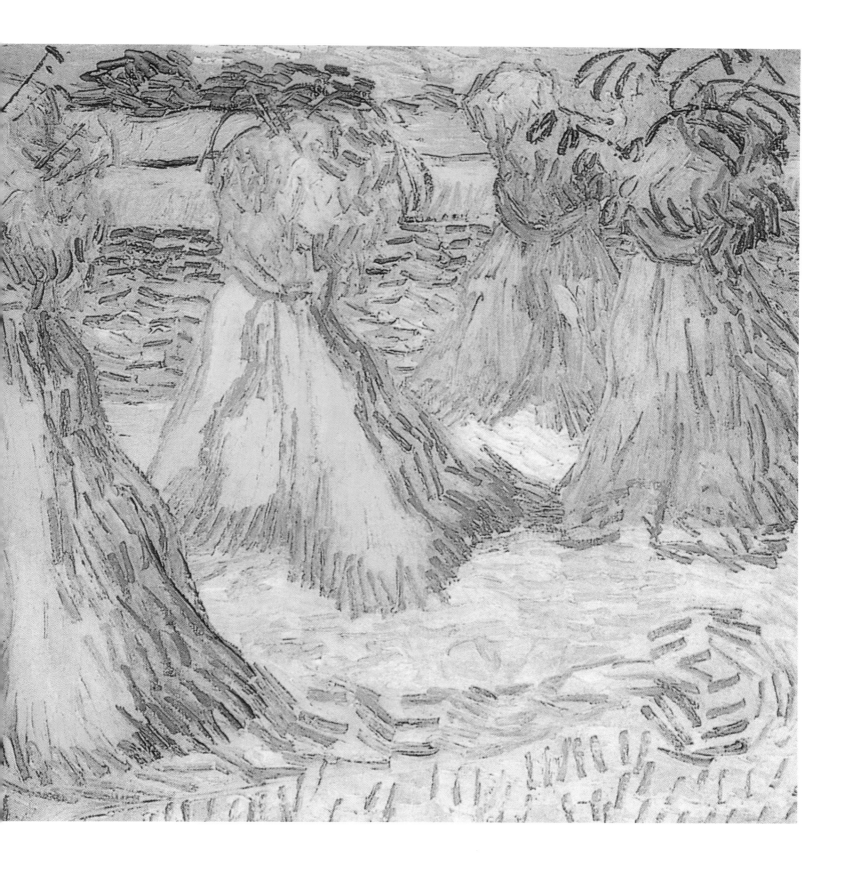

end of his task – I see in him the image of death, in the sense that humanity might be the wheat he is reaping. So it is – if you like – the opposite of that sower I tried to do before. But there's nothing sad in this death, it goes its way in broad daylight with the sun flooding everything with a light of pure gold."[120]

It is said that van Gogh shot himself in a field, but there is little proof. If he had chosen the 'pure gold' of the wheat for his suicide, he decided, at least, not to die

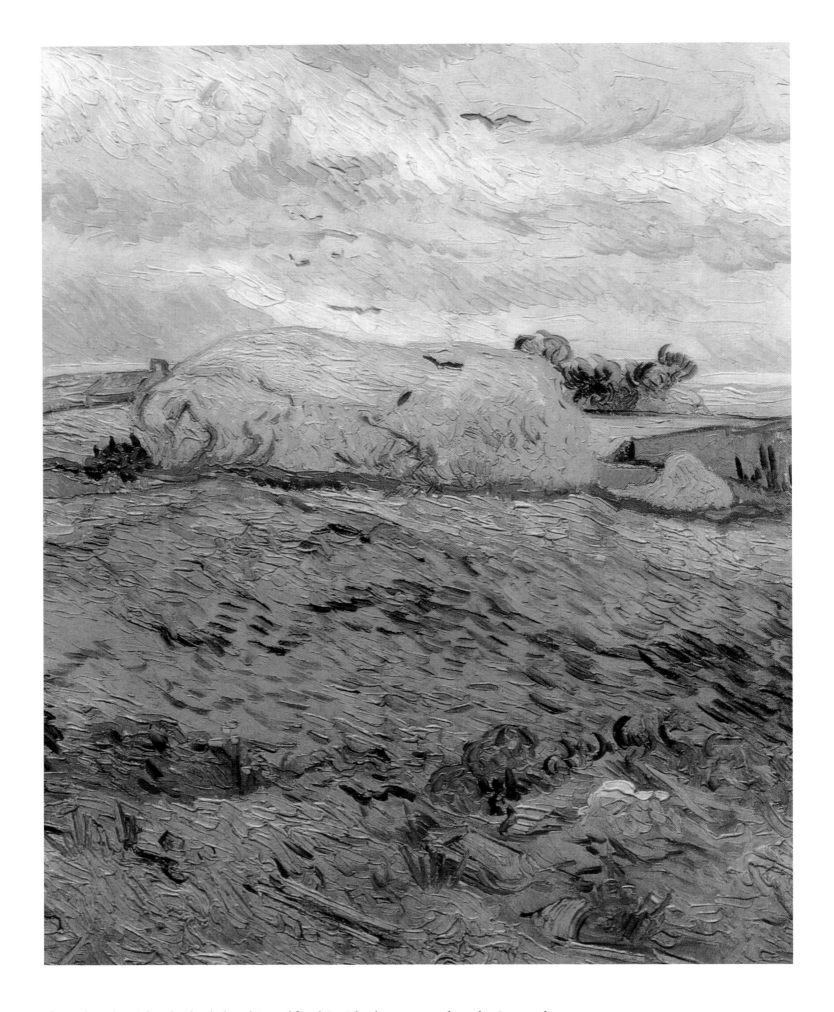

there lonely. After he had shot himself in his side, he returned to the inn and went to bed. The landlord informed Dr. Gachet and Theo. The brother described the last moments of van Gogh's life, which ended on July 29th, 1890: "I wanted to die. While I was sitting next to him promising that we would try to heal him […], he

111. *Haystacks on a Rainy Day*
Auvers-sur-Oise: July 1890
Oil on canvas, 64 x 52.5 cm
Otterlo: Rijksmuseum Kröller-Müller.

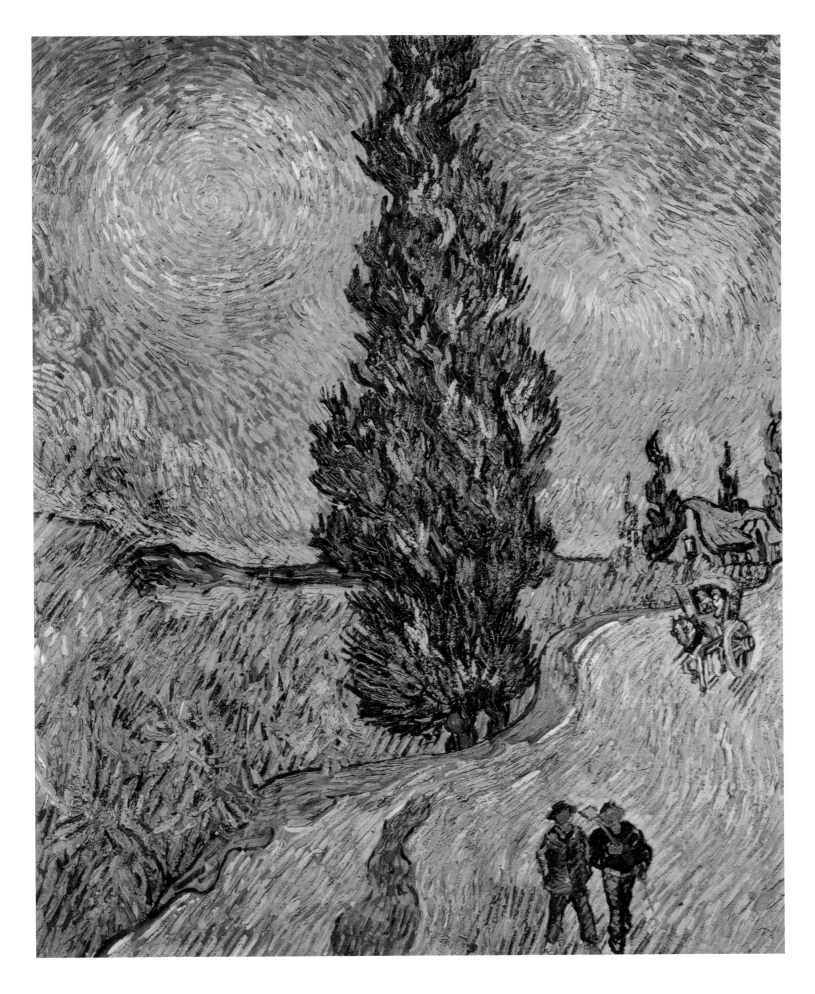

112. *Road with Cypress Trees and Starry Sky*
Auvers-sur-Oise: May 1890
Oil on canvas, 92 x 73 cm
Otterlo: Rijksmuseum Kröller-
Müller.

answered: 'La tristesse durera toujours.' [The sadness will last forever.][121] A few weeks before his suicide van Gogh had written to Theo: "Even if I have not succeeded, all the same I think that what I have worked at will be carried on. Not directly, but one isn't alone in believing in things that are true. And what does it

113. *La Méridienne (after Millet)*
Saint-Rémy: January 1890
Oil on canvas, 73 x 91 cm
Paris: Musée d'Orsay.

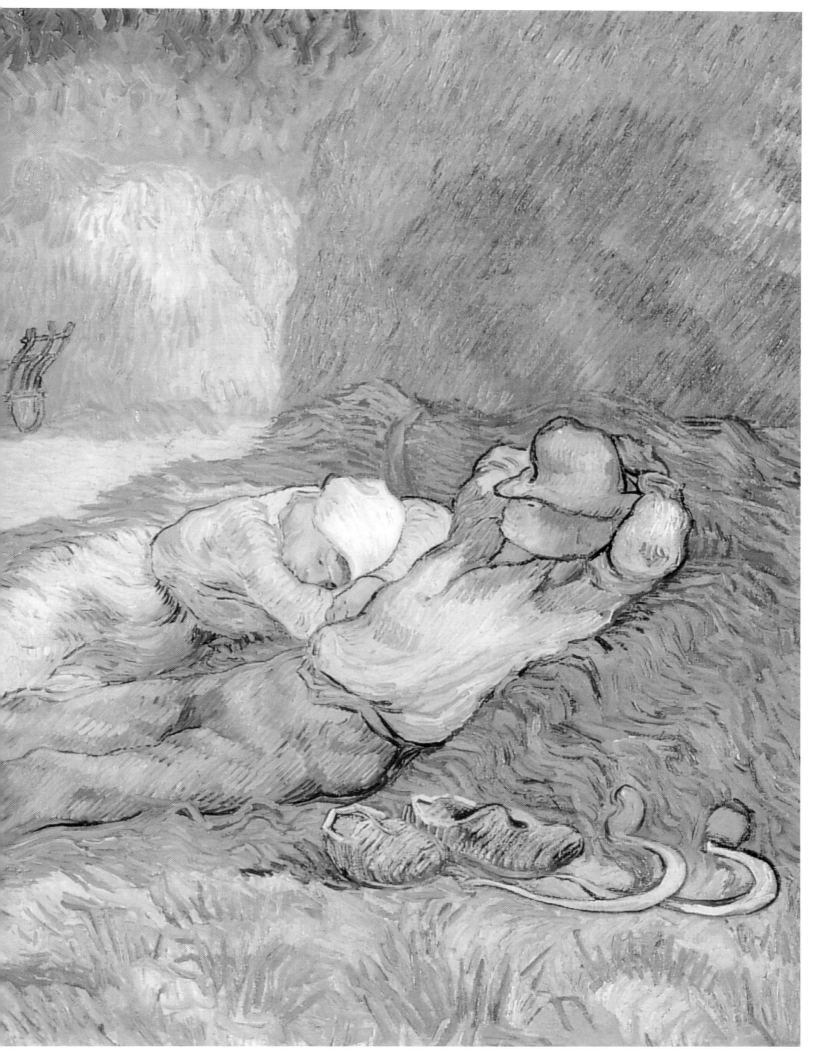

147

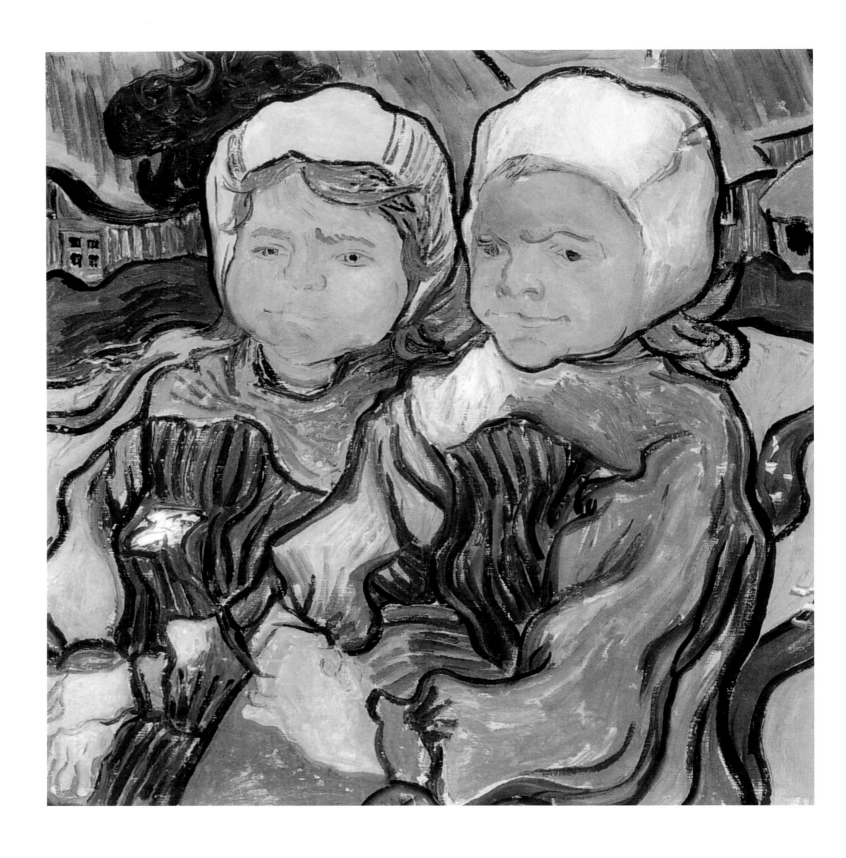

matter personally then! I feel so strongly that it is the same with people as it is with wheat, if you are not sown in the earth to germinate there, what does it matter? – In the end you are ground between the millstones to become bread. The difference between happiness and unhappiness! Both are necessary and useful, as well as death or disappearance... it is so relative – and life is the same."[122]

114. *Two Little Girls*
Auvers-sur-Oise: June 1890
Oil on canvas, 51.2 x 51.5 cm
Paris: Musée d'Orsay.

115. *The Old Sad Man*
Saint-Rémy: April–May 1890
Oil on canvas, 81 x 65 cm
Otterlo: Rijksmuseum Kröller-Müller.

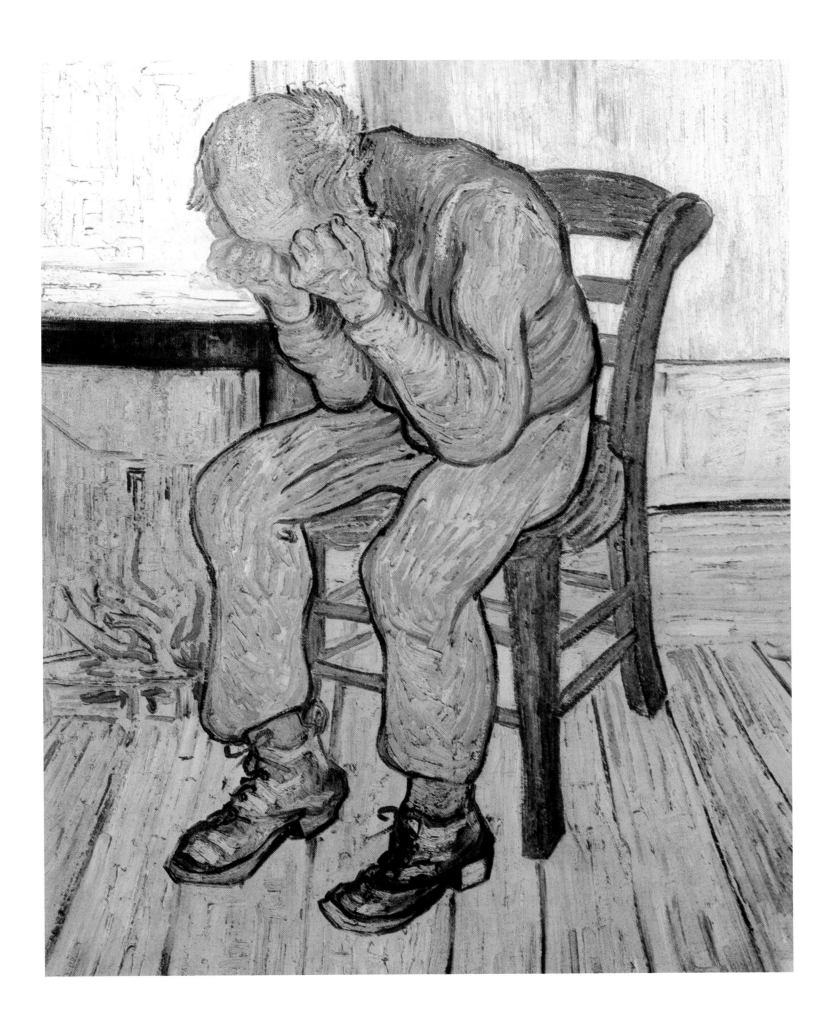

116. *Thatched Cottages at Cordeville*
Auvers-sur-Oise: June 1890
Oil on canvas, 73 x 94 cm
Paris: Musée d'Orsay.

NOTES

1 Aurier, Albert: "The isolated ones: Vincent van Gogh". In: *Van Gogh. A retrospective*. Edited by Susan Alyson Stein. New York 1988, p. 191.

2 Aurier, p. 191.

3 Aurier, p. 191.

4 Aurier, p. 191.

5 Aurier, p. 193.

6 Arnold, Matthias: *Vincent van Gogh*. Biographie, München 1993, p. 1011; my translation.

7 L 164, in: *The complete letters of Vincent van Gogh*, Boston 1978, I: 285.

8 L 476, in: *The complete letters...*, II: 544.

9 L 641a, in: *The complete letters...*, III: 282.

10 "Memoir of Vincent van Gogh" by Johanna van Gogh-Bonger, in: *The complete letters...*, I: XIX.

11 *Van Gogh, Vincent: Sämtliche Briefe in sechs Bänden* edited by Fritz Erpel: Berlin 1968, vol. 6: *Dokumente und Zeugnisse*, p. 93; my translation.

12 *The complete letters...*, III: 594.

13 *Memoir...*, p. XX.

14 Huberta du Quense-van Gogh: *Vincent van Gogh* (1910), in: *Van Gogh. A retrospective*, p. 32.

15 Van Gogh: *Sämtliche...*, 5: 257; my translation.

16 L 573, in: *The complete letters...*, III: 128.

17 L 418, in: *The complete letters...*, II: 397.

18 L 82 a, in: *The complete letters...*, I: 78.

19 *Memoir...*, p. XX.

20 L 266, in: *The complete letters...*, I: 539.

21 L 182, in: *The complete letters...*, I: 327.

22 L 133, in: *The complete letters...*, I: 194.

23 L 10, in: *The complete letters...*, I: 11.

24 L 9a, in: *The complete letters...*, I: 8.

25 L 332, in: *The complete letters...*, II: 163.

26 L 20, in: *The complete letters...*, I: 21 f.

27 L 157, in: *The complete letters...*, I: 265.

28 *The complete letters...*, I: 87.

29 L 94, in: *The complete letters...*, I: 105.

30 L 85, in: *The complete letters...*, I: 93.

31 L 94, in: *The complete letters...*, I: 105.

32 *The complete letters...*, III: 596 f.

33 *The complete letters...*, I: 169.

34 *The complete letters...*, I: 224.

35 see: Arnold: *Vincent...*, p. 257.

36 L 131, in: *The complete letters...*, I: 190.

37 L 132, in: *The complete letters...*, I: 192.

38 L 133, in: *The complete letters...*, I: 194.

39 L 133, in: *The complete letters...*, I: 194.

40 L 138, in: *The complete letters...*, I: 211.

41 L 159, in: *The complete letters...*, I: 269.

42 L 192, in: *The complete letters...*, I: 349.

43 L 212, in: *The complete letters...*, I: 396.

44 L 197, in: *The complete letters...*, I: 366.

45 R 8, in: *The complete letters...*, III: 323.

46 L 117, in: *The complete letters...*, I: 159 f.

47 L 182, in: *The complete letters...*, I: 328.

48 L 195, in: *The complete letters...*, I: 360.

49 L 345, in: *The complete letters...*, II: 227.

50 L 346, in: *The complete letters...*, II: 321.

51 L 347, in: *The complete letters...*, II: 234.

52 L 377, in: *The complete letters...*, II: 307.

53 L 375, in: *The complete letters...*, II: 303.

54 L 375, in: *The complete letters...*, II: 303.

55 L 375, in: *The complete letters...*, II: 304.

56 L 404, in: *The complete letters...*, II: 370.

57 L 459 a, in: *The complete letters...*, II: 515.

58 L 459 a, in: *The complete letters...*, II: 515.

59 L 459, in: *The complete letters...*, II: 511.

60 Arnold, *Vincent...*, p. 458; my translation.

61 Arnold: *Vincent...*, p. 478; my translation.

62 Arnold: *Vincent...*, p. 478; my translation.

63 W 1, in: *The complete letters...*, III: 426.

64 François Gauzi: Lautrec et son temps (1954), in: *Van Gogh. A retrospective*, p 71 f

65 A. S. Hartrick: A painter's pilgrimage through fifty years (1939), *Van Gogh. A retrospective*, p. 82.

66 W 1, in: *The complete letters...*, III: 435.

67 W 1, in: *The complete letters...*, III: 425 ff.

68 L 463, in: *The complete letters...*, II: 525.

69 L 470, in: *The complete letters...*, II: 534.

70 L 493, in: *The complete letters...*, II: 577.

71 L 438, in: *The complete letters...*, II: 454.

72 L 612, in: *The complete letters...*, III: 226.

73 L 534, in: *The complete letters...*, III: 30.

74 L 526, in: *The complete letters...*, III: 18 f.

75 L 504, in: *The complete letters...*, II: 600.

76 L 507, in: *The complete letters...*, II: 607.

77 L 557, in: *The complete letters...*, III: 92.

78 Paul Gauguin: *Avant et après* (1903), in: *Van Gogh. A retrospective,* p.124.

79 *Van Gogh. A retrospective*, p. 128.

80 Gauguin: *Avant...*, p. 124.

81 Gauguin: *Avant...*, p. 125.

82 L 532, in: *The complete letters...*, III: 25 f.

83 R 53, in: *The complete letters...*, III: 414.

84 *Van Gogh. A retrospective*, p. 130.

85 *Van Gogh. A retrospective*, p. 130.

86 Gauguin: *Avant...*, p. 125 ff.

87 L 569, in: *The complete letters...*, III: 113 f.

88 L 569, in: *The complete letters...*, III: 114.

89 Arnold: *Vincent...*, p. 724; my translation.

90 L 571, in: *The complete letters...*, III: 119 ff.

91 L 574, in: *The complete letters...*, III: 129

92 *The letters of Vincent van Gogh*, selected and edited by Ronald de Leeuw, translated by Arnold Pomerans, London 1996, p. 430.

93 L 576, in: *The complete letters...*, III: 134.

94 L 576, in: *The complete letters...*, III: 134.

95 Arnold: *Vincent...*, p. 751; my translation.

96 *Memoir...*, XLVII.

97 L 579, in: *The complete letters...*, III: 139.

98 Arnold: *Vincent...*, p. 257; my translation.

99 L 216, in: *The complete letters...*, I: 407.

100 L 216, in: *The complete letters...*, I: 408.

101 L 516, in: *The complete letters...*, III: 3.

102 L 581, in: *The complete letters...*, III: 144.

103 L 579, in: *The complete letters...*, III: 140.

104 L 579, in: *The complete letters...*, III: 140.

105 L 591, in: *The complete letters...*, III: 169.

106 L 592, in: *The complete letters...*, III: 175.

107 L 592, in: *The complete letters...*, III: 173.

108 L 592, in: *The complete letters...*, III: 174.

109 L 596, in: *The complete letters...*, III: 185.

110 L 601, in: *The complete letters...*, III: 194.

111 L 605, in: *The complete letters...*, III: 208 ff.

112 L 574, in: *The complete letters...*, III: 129.

113 L 605, in: *The complete letters...*, III: 207.

114 L 605, in: *The complete letters...*, III: 208.

115 L 635, in: *The complete letters...*, III: 273.

116 L 648, in: *The complete letters...*, III: 294.

117 Adeline Ravoux Carrié: Les cahiers de van Gogh, in: *Van Gogh. A retrospective*, p. 213 f.

118 L 132, in: *The complete letters...*, I: 193.

119 L 649, in: *The complete letters...*, III: 295.

120 L 604, in: *The complete letters...*, III: 202.

121 *Sämtliche Briefe*, 6: 52.

122 L 607, in: *The complete letters...*, III: 218.

Oil on canvas, 61 x 46 cm
Amsterdam: Rijksmuseum
Vincent van Gogh,
Foundation Vincent van Gogh.

31. *Portrait of Eugène Boch*
 Arles: September 1888
 Oil on canvas, 60 x 45 cm
 Paris: Musée d'Orsay.

32. *Portrait of Armand Roulin*
 Arles: November–December 1888,
 Oil on canvas, 65 x 54 cm
 Rotterdam: Musée Boymans-van Beuningen.

33. *Asnières Bridge*
 Paris: Summer 1897
 Oil on canvas, 53 x 73 cm
 Houston: Dominique de Menil Collection.

34. *An Old Woman from Arles*
 Arles: February 1888
 Oil on canvas, 58 x 42.5 cm
 Amsterdam: Rijksmuseum
 Vincent van Gogh, Foundation Vincent van
 Gogh.

35. *Three White Cottages in Saintes-Maries*
 Arles: early June 1888
 Oil on canvas, 33.5 x 41.5 cm
 Zurich: Kunsthaus Zurich (loan).

36. *Haystacks in Provence*
 Arles: June 1888
 Oil on canvas, 73 x 92.5 cm
 Otterlo: Rijksmuseum Kröller-Müller.

37. *Fishing Boats on the Beach at Saintes-Maries*
 Arles: End of June 1888
 Oil on canvas, 65 x 81.5 cm
 Amsterdam: Rijksmuseum Vincent van Gogh,
 Foundation Vincent van Gogh.

38. *Still Life: Vase with Fifteen Sunflowers*
 Arles: August 1888
 Oil on canvas, 93 x 73 cm
 London: National Gallery.

39. *Still-Life: Drawing Board with Onions*
 Arles: January 1889
 Oil on canvas, 50 x 54 cm
 Otterlo: Rijksmuseum Kröller-Müller.

40. *L'Arlésienne: Madame Ginoux wtih Books*
 Arles: November 1888
 Oil on canvas, 91.4 x 73.7 cm
 New York: The Metropolitan Museum of Art.

41. *The Sower*
 Arles: November 1888

Oil on canvas, 32 x 40 cm
Amsterdam: Rijksmuseum
Vincent van Gogh, Foundation Vincent van
Gogh.

42. *Madam Roulin Rocking the Cradle (La Berceuse)*
 Arles: January 1889
 Oil on canvas, 92 x 73 cm
 Otterlo: Rijksmuseum Kröller-Müller.

43. *Self-portrait with Bandaged Ear*
 Arles: January 1889
 Oil on canvas, 60 x 49 cm
 London: Courtauld Institute.

44. *Portrait of Doctor Félix Rey*
 Arles: January 1889
 Oil on canvas, 64 x 53 cm
 Moscow: Pouchkin Museum.

45. *Self-Portrait*
 Arles: November–December 1888
 Oil on canvas, 46 x 38 cm
 New York: The Metropolitan Museum of Art.

46. *Portrait of the Artist's Mother*
 Arles: October 1888
 Oil on canvas, 40.5 x 32.5 cm
 Pasadena, California: Norton Simon
 Museum of Art.

47. *Langlois Bridge at Arles*
 Arles: April 1888
 Oil on canvas, 60 x 65 cm
 Paris: Private collection.

48. *La Mousmé*
 Arles: July 1888
 Oil on canvas, 74 x 60 cm
 Washington: National Gallery of Art.

49. *Almond Tree in Blossom*
 Arles: April 1888
 Oil on canvas, 48.5 x 36 cm
 Amsterdam: Rijksmuseum Vincent van Gogh,
 Vincent van Gogh Foundation.

50. *Café at Night*
 Arles: September 1888
 Watercolour, 44 x 63 cm
 Berne: Private Collection.

51. *Street in Saintes-Maries*
 Arles: early June 1888
 Oil on canvas, 38 x 46.1 cm
 Private Collection
 (sold, Christie's, New York, 19. 05. 1981).

52. *Portrait of Patience Escalier*

Arles: August 1888
Oil on canvas, 69 x 56 cm
Collection Stavros S. Niarchos.

53. *The Zouave* half-length
 Arles: June 1888
 Oil on canvas, 65 x 54 cm
 Amsterdam: Rijksmuseum
 Vincent van Gogh,
 Foundation Vincent van Gogh.

54. *Portrait of Postman Joseph Roulin*
 Arles: early August 1888
 Oil on canvas, 81.2 x 65.3 cm
 Boston: Museum of Fine Arts.

55. *Starry Night over the Rhone*
 Arles: September 1888
 Oil on canvas, 72.5 x 92 cm
 Paris: Musée d'Orsay.

56. *The Green Vineyard*
 Arles: September 1888
 Oil on canvas, 72 x 92 cm
 Otterlo: Rijksmuseum Kröller-Müller.

57. *Portrait of a Patient in Saint-Paul Hospital*
 Saint-Rémy: October 1889
 Oil on canvas, 32.5 x 23.5 cm
 Amsterdam: Rijksmuseum
 Vincent van Gogh, Vincent van Gogh
 Foundation.

58. *Self-Portrait with Bandaged Ear and Pipe*
 Arles: January 1889
 Oil on canvas, 90 x 49 cm
 London: Courtauld Institute.

59. *Les Alyscamps*
 Arles: late October 1888
 Oil on canvas, 93 x 72 cm
 Lausanne: Collection
 Basil P. and Elise Goulandris.

60. *Crab on its Back*
 Arles: January 1889
 Oil on canvas, 38 x 46.5 cm
 Amsterdam: Rijksmuseum
 Vincent van Gogh,
 Foundation Vincent van Gogh.

61. *Poppies and Butterflies*
 Saint-Rémy: April–May 1890
 Oil on canvas, 34.5 x 25.5 cm
 Amsterdam: Rijksmuseum
 Vincent van Gogh, Foundation
 Vincent van Gogh.

62. *Still-Life: Vase with Twelve Sunflowers*
Arles: January 1889
Oil on canvas, 92 x 72.5 cm
Philadelphia: The Philadelphia Museum of Art.

63. *The Poet's Garden*
Arles: September 1888
Oil on canvas, 73 x 92 cm
Chicago: The Art Institute of Chicago.

64. *Olive Grove*
Saint-Rémy: mid-June 1889
Oil on canvas, 72 x 92 cm
Otterlo: Rijksmuseum Kröller-Müller.

65. *Ward in the Hospital in Arles*
April 1889
Oil on canvas, 74 x 92 cm
Winterthur, Collection Oskar Reinhart.

66. *Pollard Willows*
Arles: April 1889
Oil on canvas, 55 x 65 cm
Collection Stavros S. Niarchos.

67. *Chestnut Tree in Blossom*
Auvers-sur-Oise: May 1890
Oil on canvas, 70 x 58 cm
South America: Pivate Collection.

68. *The Red Vineyard*
Arles: November 1888
Oil on canvas, 75 x 93cm
Moscow: Pouchkin Museum.

69. *Cypresses with Two Female Figures*
Saint-Rémy: June 1889
Oil on canvas, 92 x 73 cm
Otterlo: Rijksmuseum Kröller-Müller.

70. *Landscape of Auvers in the Rain*
Auvers-sur-Oise: July 1890
Oil on canvas, 50 x 100 cm
Cardiff: National Museum of Wales.

71. *Green Wheat Field with Cypress*
Saint-Rémy: mid-June 1889
Oil on canvas, 73.5 x 92.5 cm
Prague: Narodni Gallery.

72. *A Meadow in the Mountains: Le Mas de Saint-Paul*
Saint-Rémy: mid-June 1889
Oil on canvas, 73 x 91.5 cm
Otterlo: Rijksmuseum Kröller-Müller.

73. *Pine Tree against a Red Sky with Setting Sun*
Saint-Rémy: November 1889
Oil on canvas, 92 x 73 cm
Otterlo: Rijksmuseum Kröller-Müller.

74. *Wooden Sheds*
Saint-Rémy: December 1889
Oil on canvas, 45.5 x 60 cm
Brussels: Private Collection.

75. *Les Peiroulets Ravine*
Saint-Rémy: December 1889
Oil on canvas, 72 x 92 cm
Otterlo: Rijksmuseum Kröller-Müller.

76. *The Garden of Saint-Paul's Hospital*
Saint-Rémy: May 1889
Oil on canvas, 95 x 75.5 cm
Otterlo: Rijksmuseum Kröller-Müller.

77. *Morning: Peasant Couple Going to Work (after Millet)*
Saint-Rémy: January 1890
Oil on canvas, 73 x 92 cm
St. Petersburg: The Hermitage Museum.

78. *Olive Trees with the Alpilles in the Background*
Saint-Rémy: June 1889
Oil on canvas, 72.5 x 92 cm
New York: Collection Mrs. Jonh Hay Whitney.

79. *Cypress and Two Women*
Saint-Rémy: February 1890
Oil on canvas, 43.5 x 27 cm
Amsterdam: Rijksmuseum Vincent van Gogh, Foundation Vincent van Gogh.

80. *Blossoming Almond Tree*
Saint-Rémy: February 1890
Oil on canvas, 73.5 x 92 cm
Amsterdam: Rijksmuseum Vincent van Gogh, Foundation Vincent van Gogh.

81. *Wheat Field with Cypresses at Haut Galline Near Eygalieres*
Saint-Rémy: late June 1889
Oil on canvas, 73.5 x 92.5 cm
Prague: Narodni Gallery.

82. *Evening Landscape with Rising Moon*
Saint-Rémy: early July 1889
Oil on canvas, 73 x 91.5 cm
Otterlo: Rijksmuseum Kröller-Müller.

83. *Two Poplars on a Road Through the Hills*
Saint-Rémy: early July 1889
Oil on canvas, 45.5 x 60 cm
Brussels: Private Collection.

84. *Self-Portrait*
Saint-Rémy: late August 1889
Oil on canvas, 57 x 43.5 cm
New York: Private Collection.

85. *L'Arlésienne (Madame Ginoux)*
Saint-Rémy: February 1890
Oil on canvas, 65 x 54 cm
São Paulo: Museu de Arte de São Paulo.

86. *Self-Portrait*
Saint-Rémy: September 1889
Oil on canvas, 65 x 54 cm
Paris: Musée d'Orsay.

87. *Enclosed Wheat Field with Peasant*
Saint-Rémy: early October 1889
Oil on canvas, 73.5 x 92 cm
Indianapolis: Indianapolis Museum of Art.

88. *Field with Ploughmen and Mill*
Saint-Rémy: October 1889
Oil on canvas, 54 x 67 cm
Boston: Museum of Fine Arts, prepared by W. A. Coolidge.

89. *The Mulberry Tree*
Saint-Rémy: October 1889
Oil on canvas, 54 x 65 cm
Pasadena, California: Norton Simon Museum of Art.

90. *View of the Church at Saint-Paul-de-Mausole*
Saint-Rémy: October 1889
Oil on canvas, 44.5 x 60 cm
United States: Collection Elizabeth Taylor.

91. *Trees in the Garden of Saint-Paul Hospice*
Saint-Rémy: October 1889
Oil on canvas, 90.2 x 73.3 cm
Los Angeles: The Armand Hammer Museum of Art.

92. *The Sower (after Millet)*
Saint-Rémy: late October 1889
Oil on canvas, 80.8 x 66 cm
Collection Stavros S Niarchos.

93. *Trees in the Garden of Saint-Paul Hospice*
Saint-Rémy: October 1889
Oil on canvas, 73 x 60 cm
United States: Private Collection.

94. *The Sheperd (after Millet)*
Saint-Rémy: November 1889
Oil on canvas, 52.7 x 40.7 cm
Tel Aviv: Tel Aviv Museum, prepared by Moshe Mayer, Geneva.

95. *The Good Samaritain (after Delacroix)*
Saint-Rémy: May 1890
Oil on canvas, 73 x 60 cm
Otterlo: Rijksmuseum Kröller-Müller.

96. *The Roadmenders*
Saint-Rémy: November 1889
Oil on canvas, 71 x 93 cm
Washington: The Phillips Collection.

97. Self-Portrait
Saint-Rémy: September 1889
Oil on canvas, 51 x 45 cm
Oslo: Nasjonalgalleriet.

98. *Trees with Figure in the Garden of Saint-Paul Hospital*
Saint-Rémy: November 1889
Oil on canvas, 63 x 48 cm
Paris: Musée d'Orsay

99. *Still-Life: Pink Roses in a Vase*
Saint-Rémy: May 1890
Oil on canvas, 92.6 x 73.7cm
Rancho Mirage, California: Mr. And Mrs. Walter H. Annenberg Collection.

100. *Prisoner Rounds*
(after Gustave Doré)
Saint-Rémy: February 1890
Oil on canvas, 80 x 64 cm
Moscow: Pouchkin Museum.

101. *Pietà (after Delacroix)*
Saint-Rémy: September 1889
Oil on canvas, 73 x 60.5 cm
Amsterdam: Rijksmuseum
Vincent van Gogh, Foundation
Vincent van Gogh.

102. *Portrait of Doctor Paul Gachet*
Auvers-sur-Oise: June 1890
Oil on canvas, 68 x 57 cm
Paris: Musée d'Orsay.

103. *The Cafe Terrasse on the
Place du Forum, Arles at Night*
September 1888
Oil on canvas, 81 x 65.5 cm
Otterlo: Rijksmuseum Kröller-Müller.

104. *The Church at Auvers-sur-Oise*
June 1890
Oil on canvas, 94 x 74 cm
Paris: Musée d'Orsay.

105. *Plain at Auvers with Cloudy Skies*
Auvers-sur-Oise: July 1890
Oil on canvas, 73 x 92 cm
Otterlo: Rijksmuseum Kröller-Müller.

106. *Young Girl Standing Against a
Background of Wheat Field*
Auvers-sur-Oise: late June 1890
Oil on canvas, 66 x 45 cm
Washington: National Gallery of Art.

107. *Portrait of Milliet, Lieutenant
Under Zoaves*
Arles: September 1888
Oil on canvas, 81 x 65.5 cm
Otterlo: Rijksmuseum Kröller-Müller.

108. *Wheat Fields with Crows*
June 1890
Oil on canvas, 50.5 x 105cm
Amsterdam: Rijksmuseum
Vincent van Gogh, Foundation
Vincent van Gogh.

109. *Thatched Cottages by a Hill*
Auvers-sur-Oise: July 1890
Oil on canvas, 50 x 100 cm
London: Tate Gallery.

110. *Sheaves of Wheat*
Auvers-sur-Oise: July 1890
Oil on canvas, 50.5 x 101 cm
Dallas: Dallas Museum of Fine Arts.

111. *Haystacks on a Rainy Day*
Auvers-sur-Oise: July 1890
Oil on canvas, 64 x 52.5 cm
Otterlo: Rijksmuseum Kröller-Müller.

112. *Road with Cypress Trees and
Starry Sky*

Auvers-sur-Oise: May 1890
Oil on canvas, 92 x 73 cm
Otterlo: Rijksmuseum Kröller-Müller.

113. *La Méridienne (after Millet)*
Saint-Rémy: January 1890
Oil on canvas, 73 x 91 cm
Paris: Musée d'Orsay.

114. *Two Little Girls*
Auvers-sur-Oise: June 1890
Oil on canvas, 51.2 x 51.5 cm
Paris: Musée d'Orsay.

115. *The Old Sad Man*
Saint-Rémy: April–May 1890
Oil on canvas, 81 x 65 cm
Otterlo: Rijksmuseum Kröller-Müller.

116. *Thatched Cottages at Cordeville*
Auvers-sur-Oise: June 1890
Oil on canvas, 73 x 94 cm
Paris: Musée d'Orsay.

INDEX OF WORKS REPRODUCED

Vincent